THE FRENCH CAT

Rachael Hale

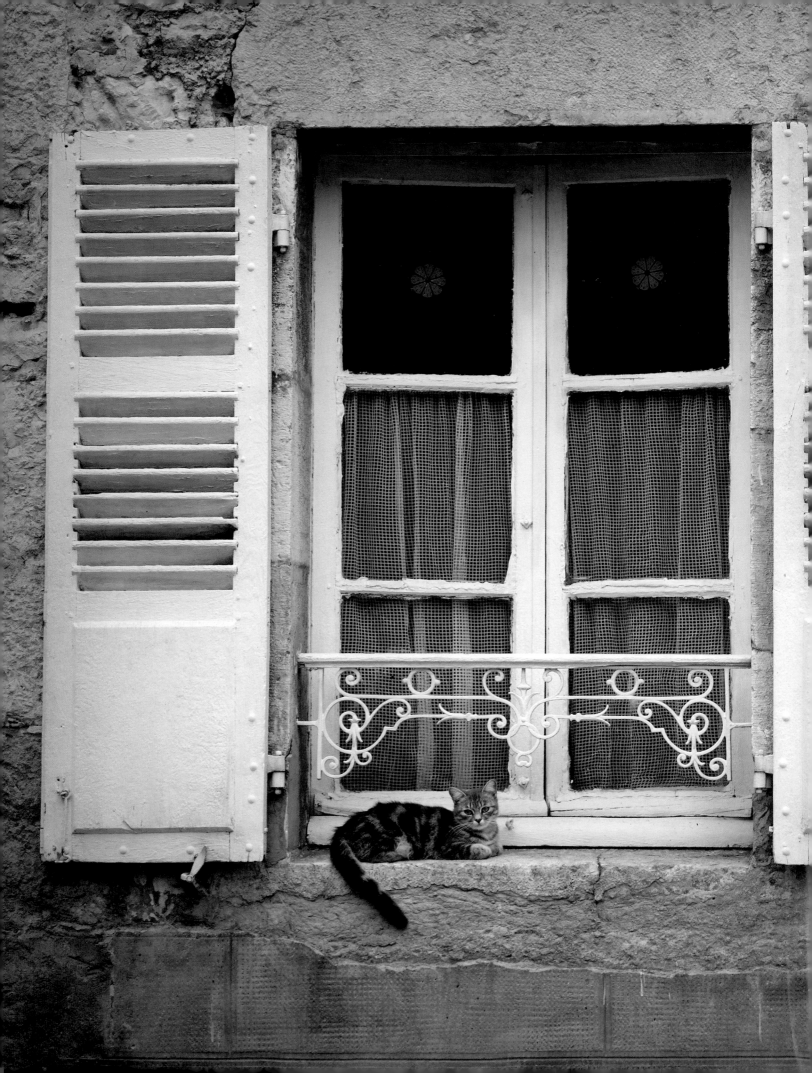

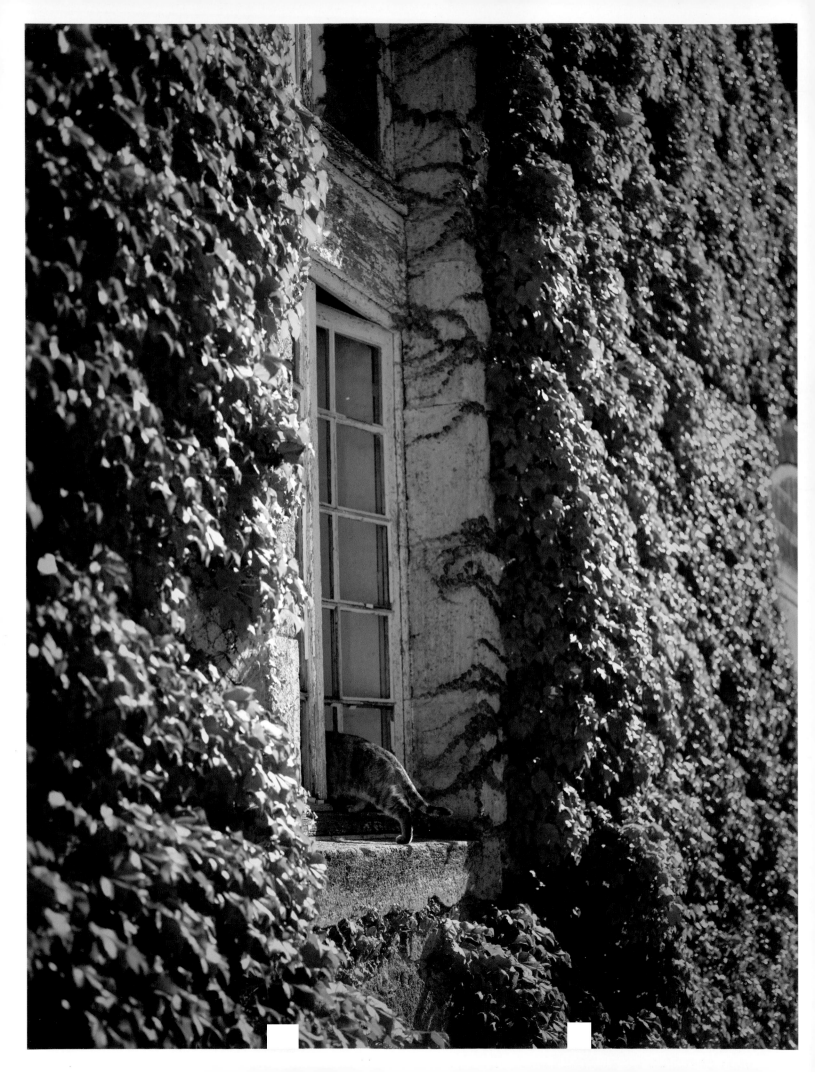

THE FRENCH CAT

Rachael Hale

Stewart, Tabori & Chang
in association with PQ Blackwell

Sur les routes de France

Cats make their own decisions, follow their own instincts. They may be cuddly if it suits them, but basically they're designed to hunt. French cats are probably the most independent and enigmatic of them all.

Cats, with their snooty, beautiful faces, their sensuous bodies, their lethal paw swipes, snuggly purrs, and aloof, unreadable natures, are a challenge to any photographer. Cats make their own decisions, follow their own instincts. They may be cuddly if it suits them, but basically they're designed to hunt. French cats are probably the most independent and enigmatic of them all. You don't see many overbred pedigree cats in the villages of France. These cats are mostly moggies, and, like their owners, they are allowed to remain singular, self-contained, and standoffish.

French village cats live much of their lives perched on ramparts above street level. They appear on rooftops and slinking along the windowsills and ledges, looking down imperiously at their canine counterparts roaming the streets. Certainly cats love to climb, but these cats make it look as though they choose to lead the high life never hinting they may be compelled to do so. Take Romeo, who sleeps on a fence post as though it is the most comfortable bed in the village (see page 112).

Most of these cats have owners who treat them like treasured, indulged pets. But in nearly every village there's a pack of "gutter cats" too. Some are unwanted strays; others' owners have died or moved away. Regardless, there's always someone who feeds and looks after them. I remember finding a gang of stray cats in a back alley of Pouzolles, waiting patiently outside the house of the old lady who feeds them. As she opened her shutters, their heads turned and looked up. I could see the joy in their eyes at the thought of their *petit déjeuner*!

City cats have a very different, interior life. In Paris, for example, there are no cats to be found on the streets because their owners are fined if their cats are caught outside. Many cats become strays, chased away by the city's cat catchers. But French cats are clever. Today, hundreds of them hang out in the huge Montmartre Cemetery, where they prowl among the graves and sit on the headstones of famous former Parisians.

Every corner I turn . . . makes my mind and eyes explode with inspiration. The light is wonderful. The only sound I hear out in the fields is the swish of the grass as I walk.

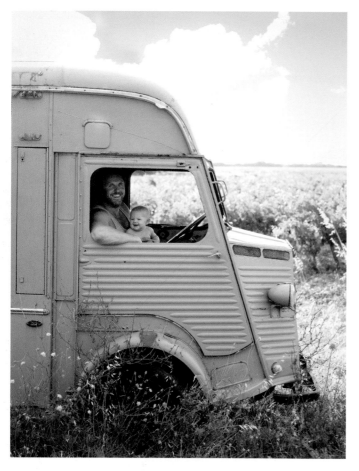

And such is the French way—even these cats are well looked after. Every day around noon, a man (Saujot, a true cat lover) arrives at the cemetery hauling fifty-five pounds of cat food on a little trolley. He walks four miles from home and pays for the food himself out of donations from cat lovers. Meanwhile, the cats, most of them tabbies or pure blacks, are sleek and well fed. Every day they appear from their hiding places behind the tombstones to gobble up their rations. Goodness knows who the gendarmes fine if the strays of Montmartre decide to scale the high wall around the cemetery and go rat hunting through the back alleys of Pigalle and the Marais during the midnight hours.

The other wonderful thing about French cats is that they occupy one of the most beautiful countries in the world. Artists through the ages have relished France for its old-world villages, rustic charm, and, most of all, for the luminous quality of its light. French light, especially in the south, has a shimmering, almost milky quality you don't find in other parts of the world—and certainly not in my home country, New Zealand. There's the hazy light caused by the sheer heat of summer days; the soft, filtered light of early morning; and the dry, dusty light of the Languedoc.

The sheer glory of the French countryside thrills me too. I love the way the mist rises off the Canal du Midi; the sunlight that turns a new-leaf tree into an explosion of lime green; the spindly French forests that cause the light to dapple through the trees; the endless lavender fields of Provence; sunflowers; and, especially, the smell of the sun warming the morning dew, which is so typically French.

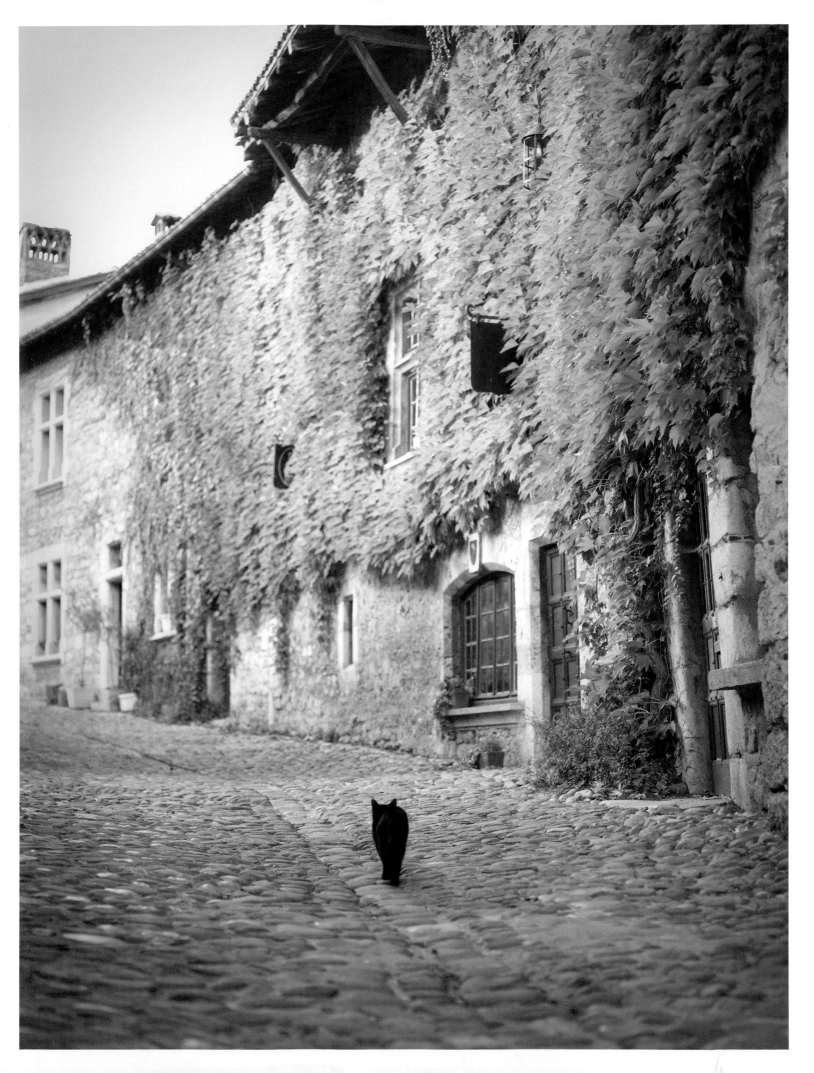

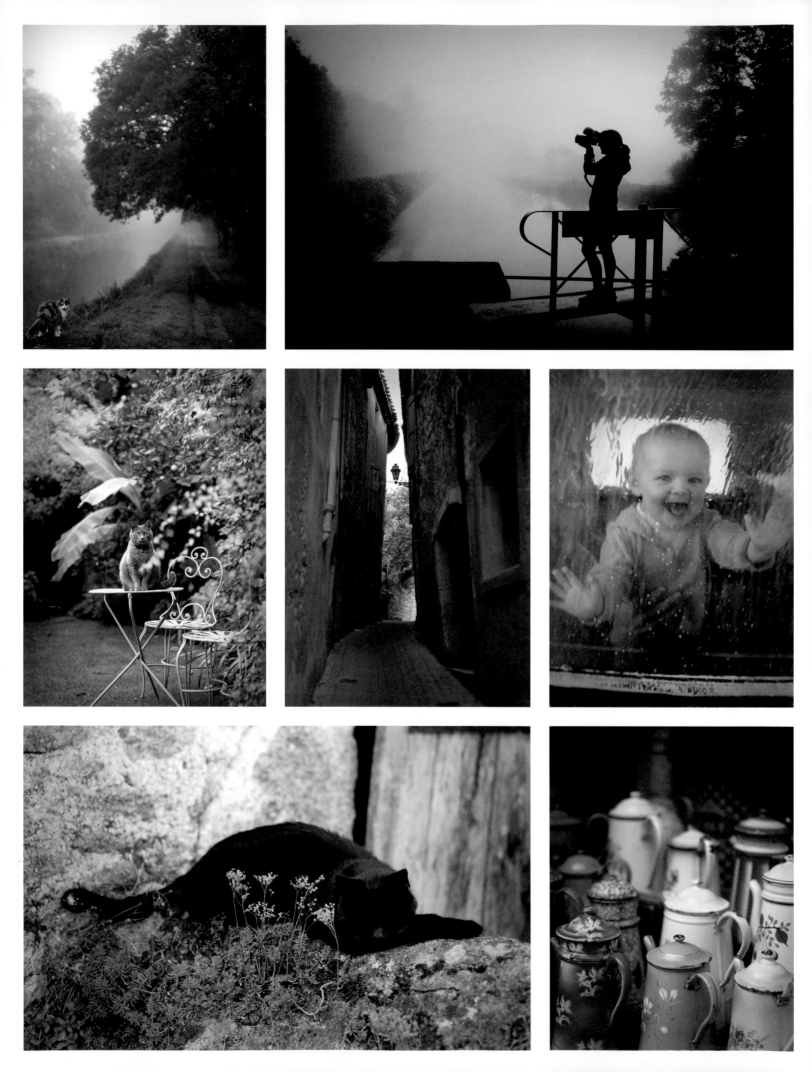

I'd dreamed about photographing animals in their natural habitat "just doing their thing" for years.

Then there's the battered, weathered charm of village architecture. The fact that they preserve it against newcomers is an inspiration. Apart from an occasional coat of whitewash in spring, houses remain as they have for centuries. Ancient velvet curtains probably stay tied back for years. Window boxes of red geraniums and ivy splash color against stone, providing a unique background to photograph cats against.

The French let things be. Impossibly narrow village streets built for horses and carts remain intact. Houses still open straight onto the street. Their owners still drag out a chair and sit there on the cobbles, chatting to their neighbors. French drivers, who have a special control to fold in their outside mirrors, buy small cars.

The textures are marvelous. Gnarled old olive trees, only good for shade, are left for kids and cats to climb. Floor tiles wear down to clay. Paint peels, copper corrodes, and, somehow, probably because of the dryness of the climate, it works. Even grand châteaux let their elegant gardens relax into a glorious mix of the overmanicured and overgrown. The very thought of trying to capture it on film inspires and excites me.

I'd dreamed about photographing animals in their natural habitat "just doing their thing" for years. But for many reasons I'd been tied to the studio—working with animals of course—but under the hot lights and constraints of indoor photography. My first big break came in 1995, when I was twenty-three and I won a local competition for professional photographers with an image of a pig wearing a watch.

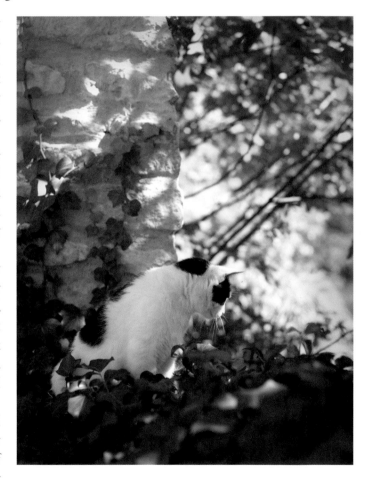

The other wonderful thing about French cats is that they occupy one of the most beautiful countries in the world. Artists through the ages have relished France for its old-world villages, rustic charm, and, most of all, for the luminous quality of its light.

The only stipulation had been that the image entered include a watch. The pig was a kunekune named Pixie, and the watch, which was fastened around Pixie's chubby neck, was made out of an old alarm clock, an ancient leather belt, and some massive fake diamantés. The prize was a set of studio lights, and they were just what I needed to set up my own studio. Now I could spend my days consumed with my two passions: photography and animals.

Twelve years later I was beginning to get bogged down. All the studio work was eating away at my creativity. Even though I'd been photographing animals, including cats, most of them were trained and groomed for the camera, and I was worried that the photos themselves were starting to become formulaic. I realized that the way forward was to just do what I'd always believed to be my destiny: work with animals in their own environment, in the wild, using natural light. Even more exciting, I'd met the love of my life. Within a year of meeting,

we were married, I was expecting a baby, and plans to move to France were underway. It gave me the perfect opportunity to leave the Rachael Hale part of my life behind me and start again as photographer Rachael McKenna.

In May 2009, two months after our marriage, Andy and I set off for France. We were both excited to get going. I'd sold my house in Auckland, New Zealand, which gave us enough money to purchase a house in France. Our dream house turned out to be an old French "do-up"—an eighteenth-century *maison de maître* (master's house) in the tiny village of Causses-et-Veyran in the Languedoc region in the southwest of France. Causses-et-Veyran is in the heart of the Saint-Chinian region on the Mediterranean coast, so the weather's good, and the light is beautiful. The village itself is tiny, with only 1,200 residents and a visiting *boulangerie* van, but is only five minutes to the bigger village of Murviel-lès-Béziers (literally, "the old walls of Béziers") and the city of

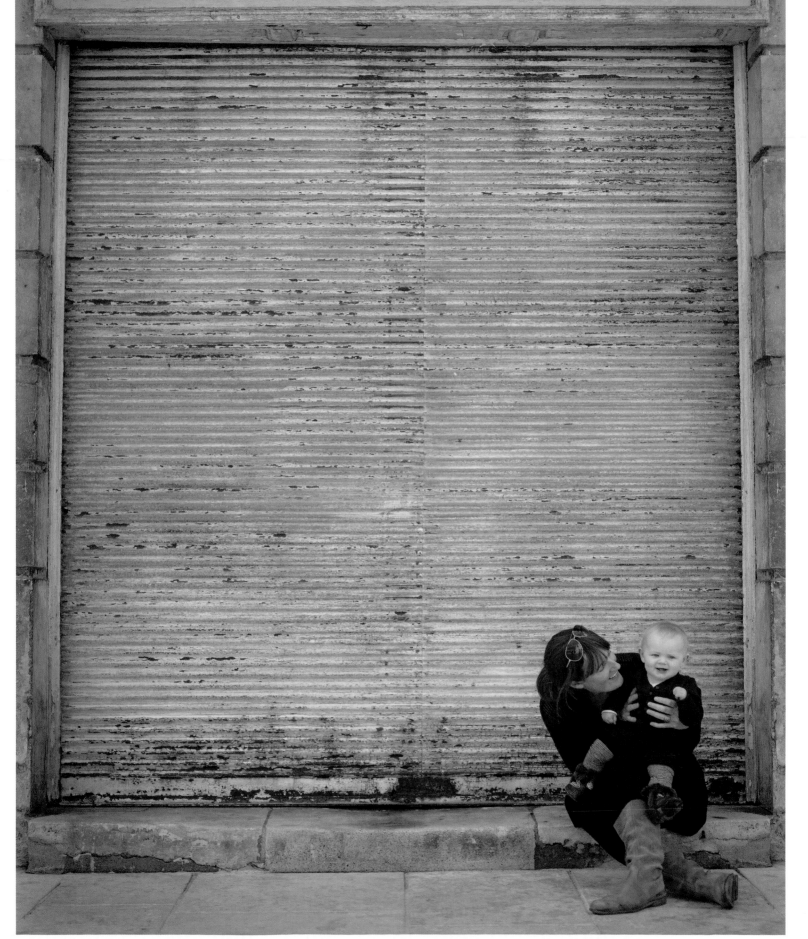

For me the assignment was like a love affair. I just loved being out on location and capturing cats showing their true personalities in their own environment.

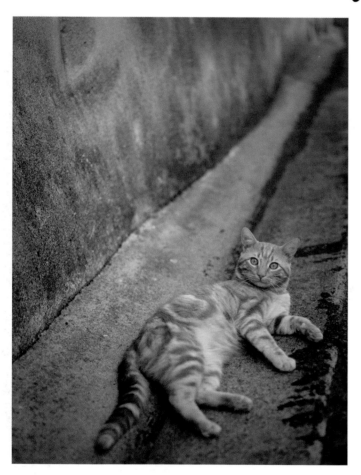

Béziers itself. Everything is new and beautiful. Every corner I turn, whether walking the streets or striding through the vineyards within yards of our home, makes my mind and eyes explode with inspiration. The light is wonderful. The only sound I hear out in the fields is the swish of the grass as I walk.

In December our beautiful daughter, Charlize Mila McKenna, was born, and six months later the three of us set off to begin this book. For me, the assignment was like a love affair. I just loved being out on location and capturing cats showing their true personalities in their own environment. I was also determined to do this as authentically as possible. There were no zoom lenses and almost no use of Photoshop. This meant I needed to befriend almost every cat I photographed. And to find them in the first place, I had to get out there at daybreak. So I'd put the baby in the backpack or leave her with Andy, and set off at dawn to wander those romantic, ethereal, empty streets.

The cats were always awake, if hiding. French cats tend to be *trés timide* (very timid), so often I had to tempt them with my feather teaser and handfuls of cat treats. It's amazing how a couple of green feathers tied to a stick are irresistible to even the coyest cats. What I did was to wiggle the teaser a bit to get my potential star interested, then use the teaser and a trickle of treats to lure her or him into position. Often it took both of us—Andy and me, plus a baby treat to keep Charlize quiet—to achieve this but, usually, finally, the cat would follow me down the road to a setting I'd chosen and then, hopefully, click!

Other days I'd wait for hours for the moment when a ray of sun settled on an old, peeling, battered door, and by the time I'd composed the scene and set the correct exposure—which only takes a few seconds—the cat was gone. Vanished!

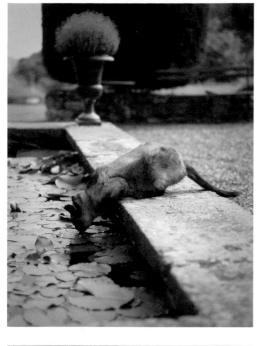
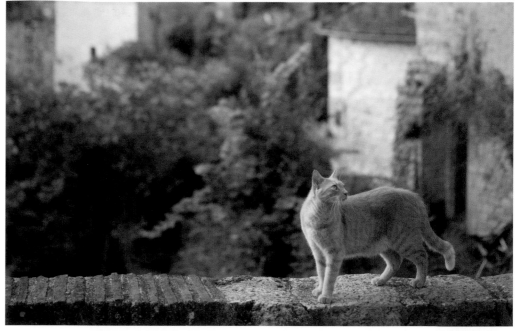

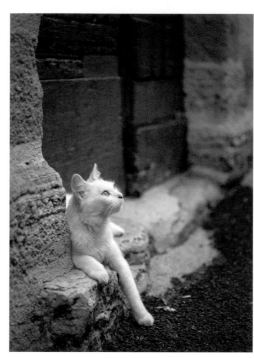

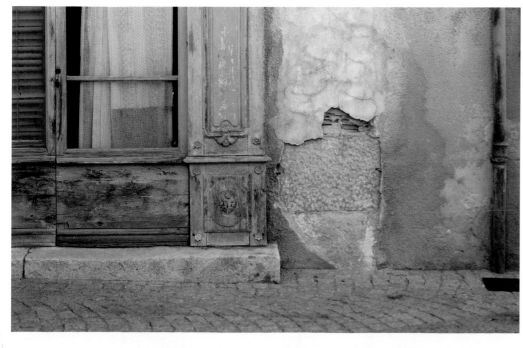
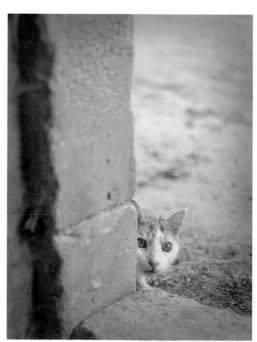

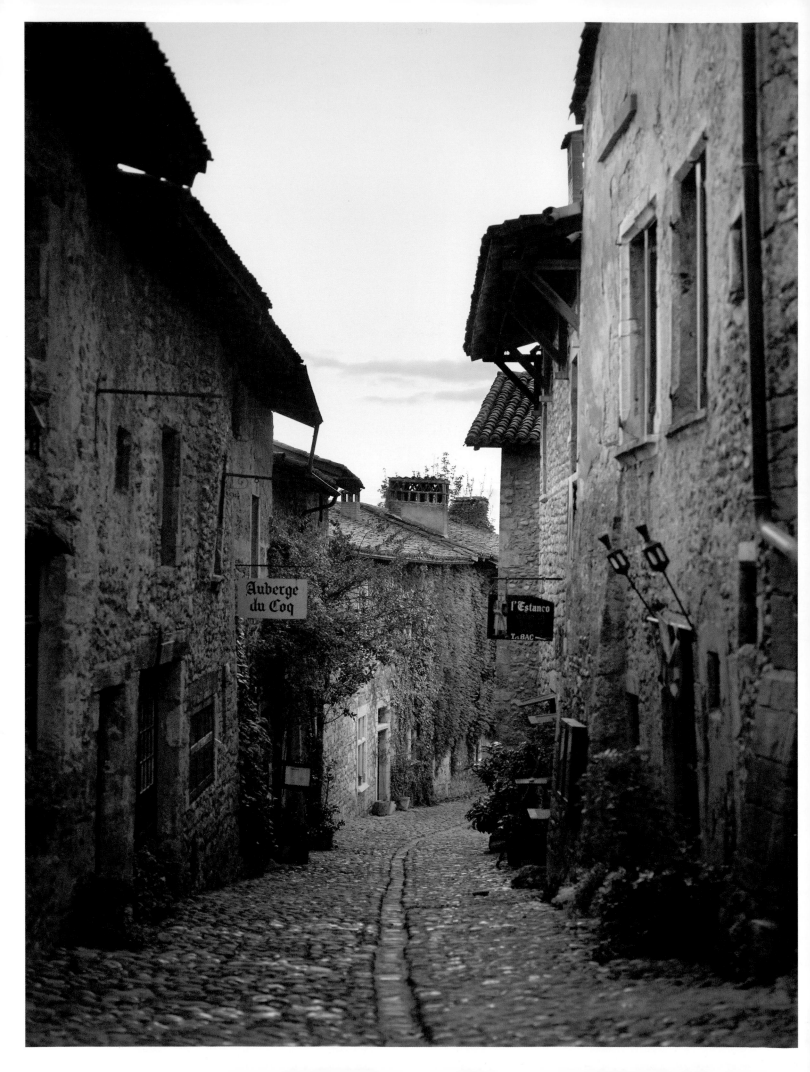

I found myself peering through cracks and standing on tiptoes to see over a wall, in search of cats to entice out to play.

Mostly, the cats were photographed exactly where I found them. Some villages had lots of cats, others only a few. I'm convinced there were many more, resting peacefully behind those rustic doors I had come to love. I found myself peering through cracks and standing on tiptoes to see over a wall, in search of cats to entice out to play.

Evening cat shoots were quite different. Because these were Mediterranean cats, keen on a post-lunch siesta, it was best to wait until late afternoon before we hit the roads again. By then the villages were humming with activity. Even the cats seemed less timid and ready to play ball, while their French owners, when they gathered in the village square, were keen to talk too. I often wonder if they gossiped about me: "Did you see that woman photographing this morning? She was quite strange. She carries a feather on a stick?"

Some of them, of course, knew what I was up to. If I spied a particularly pretty or interesting cat in its own home, I had to ask permission. So, in my slowly improving French, I explained who I am and what I was doing, and asked, "Puis-je photographier votre chat, s'il vous plaît?" (Can I please photograph your cat?) There hasn't been a "no" yet from any owners, but there have been quite a few from the cats . . .

I had to try harder with my French on evening shoots, when most people had probably had an *apéritif* or two. But when I did manage to explain the reason behind my pursuit of cats, their owners became intrigued and enthusiastic. They usually wanted their feline family members to be involved and often invited us in for an *apéritif* or to come back for a *café* the next day.

To round off the experience—and get a good cross section of cat personalities and backgrounds—I'd also arranged to photograph cats from some of France's elegant châteaux. Would these privileged pussies be more prince- and princess-like than village cats? Myrtille, the resident cat at Château de Varenne in Provence, certainly was. Myrtille had been inherited by the current owners, Sylvie and Didier, and obviously considered herself the rightful ruler of the thirty-room French provincial château. Even Sylvie wasn't able to settle her on a bed in one of the guest rooms for me to photograph. And when I tried, she wrapped her body around my arm in protest: all four paws and teeth as well. My first cat wound. She was quite charming, however, when left alone, sitting at the foot of her baronial staircase (see page 86).

In my slowly improving French, I explained who I am and what I was doing, and asked, "Puis-je photographier votre chat, s'il vous plaît?" There hasn't been a "no" yet from any owners, but there have been quite a few from the cats . . .

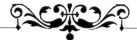

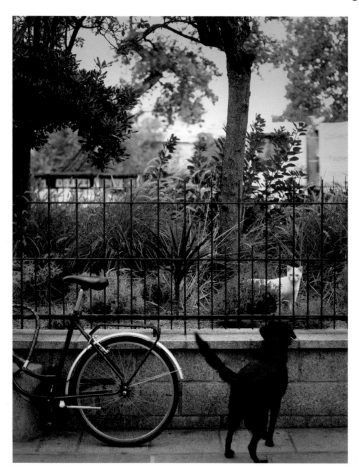

At Château de Beauregard, a privately owned château on the outskirts of Jonquières, it was the dogs who really ran the place. The château was beautiful, and we were met at the gate by six dogs and Delta, a fellow animal lover, who greeted us with open arms (literally) and told us to make ourselves at home. So while Andy nursed a sprained ankle and looked after Charlize, I photographed Hercules and Miss France, the château's much-loved tabbies, who lead a double life being chased by Jake and Elvis, the château's pair of Jack Russells, outside and reigning supreme within. Miss France, for example, liked to spend her time in the library, where she'd taken over Delta's desk (see page 48). Hercules just posed naturally wherever I asked him (pages 142–43) (and kept the dogs at bay)!

Thank goodness the French are so friendly and love their cats so much! They also give them great names. I particularly like Fan Fan La Mère and Sephora, Hercules, Mouchette, Toffu . . .

I hope this book gives you as much pleasure to look at and read as I had taking the photographs. I also hope that it goes some way to explain the rhythm of French life, the moody beauty of the countryside, the luminosity of its light, and the unusual, enigmatic character of *le beau chat Français*. Most of all, I hope the images I have created here leave you with a feeling of serenity and calm—which for me is the real essence of life in France.

A Rural Road in France

WHY FRANCE? I suppose the main reason was for a change ... and an inspiration! I love New Zealand, and can't say I won't move back there one day, but there comes a time when all creatives need to challenge themselves and move on and my new venture was the project. So in May 2009, newly married, pregnant and knowing little more than a few sentences of pidgeon French, we left New Zealand undeterred.

It has been a challenging but extremely rewarding time in France so far. We have tackled the French bureaucracy and successfully purchased a house in the quaint village of Caux et Veyran in the Languedoc Region of the South of France...

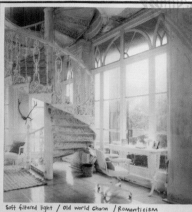

I am an amazing opportunity to discover France and for me to challenge and hopefully reinvent myself as Rachael McKenna creating the images for this latest project "FRENCH ARISTOCATS". My challenge is to capture fresh and characteristic images of cats (and a few dogs on the way!) displaying them in the beautiful and iconic landscape of France...

Now it is my turn to illustrate France through my eyes...

France is so full of inspiration!

IDEAS

Les Vieilles portes

- Cats in window boxes
- Cats sitting in windows
- Antique store ... cat amongst antiques
- Cat in Bookstore ← confirmed 'Shakespeare & Company' PARIS. Have a resident cat. contact: Sylvia
- Cats in old Barns
- Village Streets
- Staircases
- Beautiful grand Mantle over fireplace
- Cats in Ruins
- Lavender Field (South)
- Garden Gate
- Tractor - cat sitting on top!
- Cat inside dark shed - ray of light
- Old Door with cats face showing in hole
- Cats in shops & Restaurants / cafés
- Find a 'church' cat
- Cats in wine cellars

My FAVOURITE Door in St Antonin de Pontdit

OLD DOORS WALLS & GARDENS

CHATEAUX
Contact chateau owners to find out who owns cats and who would allow us to photograph the cats for the book!
Relais & Châteaux - luxury hotels and gourmet restaurants.
www.relaischateaux.com
Bienvenue Chateaux - privately owned chateaux
www.bienvenueauchateau.com

INSPIRATION

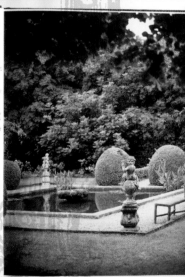

Soft filtered light / Old world charm / Romanticism

Cats love to climb. Create images of cats on staircases, sitting on walls, up high on window sills. Capture the rustic, historic charm of France. Capture the 'classic' French chateaux etc that people 'imagine' France to be ... plus capture the 'Real' France ... more modest and basic. Very simple living in contrast to the life in grand chateaux.

FRANCE IS FULL OF INSPIRATION.....

the LIGHT is beautiful...

- the busy lights caused by the Summer days
- the dry, dusty landscape of the Languedoc Region
- the Romanesque chateaux
- Wine Domaines **TEXTURES**
- Stone, crumbling Ruins
- Village Streets
- Ancient Gardens
- Chateaux with views
- French life, relaxed, friendly
- Vegetable Gardens
- Stray cats
- Food & Wine

'Stray Cats in South' Provence

'Street cats of Pouzolles waiting for their morning breakfast.'

See that woman photographing this morning ; quite strange, she carries a feather on a stick!? Nothing stays quiet in a French village ... they love to talk. Some locals who own cats that are actually at home, get to meet me...

I explain who I am and what I am doing and ask hoping 'Puis-je photographie de votre chat s'il vous plait? Please can I photograph your cat?'...

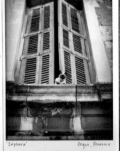

'Séphora' Organ, Provence

très timide (very timid) and I am often left feeling extremely frustrated when I see the 'perfect shot' and by the time I have composed the composition and set the correct exposure, which only takes a few seconds, the cat is gone ... and I am left with yet another beautiful French setting and no cat !!!...

'Persian'

Ventabren, Provence

↖ Romeo, the cat that followed me everywhere in Ventabren.

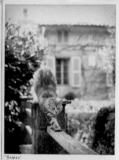

'Romeo'

The evenings are another story ; the villagers are humming with activity, the sun is still heating the streets and cats are offered more abundant ; they have been sleeping all day and are now ready to play again. With more activity in the early evenings it is safe for Andie to venture out with me...

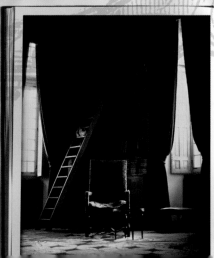

The French are very friendly and thankfully too are they are great lovers of cats!

Oustau de Baumanière Le Baux de Provence

Wow ... what an experience! We were lucky enough to spend a couple of days at this stunning hotel in Le Baux de Provence, a village nestled in the heart of Les Alpilles Mountains. The whole experience was magical, the area of Le Baux de Provence is spectacular, the ancient village is perched high on a cliff top overlooking the surrounding properties, Oustau being one of them...

'Toto'

Oustau de Baumanière

LESSON LEARNT: always check for wasps before retreating into a bush !!!

SO AFTER TWO DAYS OF LUXURY, A PURE TREAT AFTER SPENDING OUR FIRST MONTH ON THE ROAD IN A TENT. ANDY, CHARLIZE & I, WITH VERY SATISFIED TUMMYS AND A HANDFUL MORE IMAGES FOR THE BOOK, PACKED OUR BAGS YET AGAIN ... AND HIT THE ROAD

Oustau de Baumanière

Andy & Charlize by the pool at Oustau

Château de Saint Loup

Saint-Loup-Lamairé Loire Valley, France

Owner: Charles-Henri de Barbizat
www.chateaudesaint-loup.com

As I sit on the floor in 'La Chambre de Voltaire', our home for 4 days while visiting the Loire Valley, the only sounds I hear are the squawking of the crows overhead and the chimes of the village set as the clock strikes the hour...

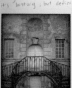

… the rhythm of French life, the moody beauty of the countryside, the luminosity of its light, and the unusual, enigmatic character of *le beau chat Français.*

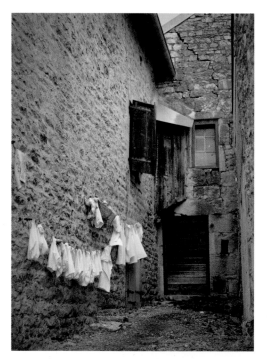
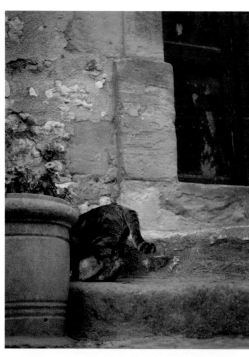

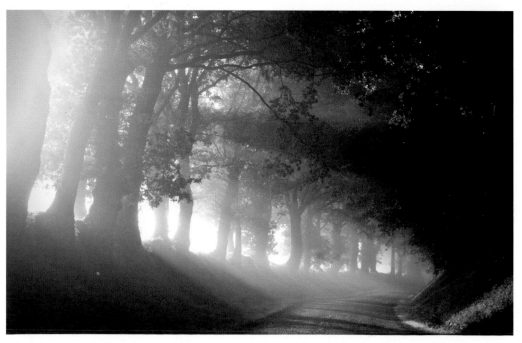
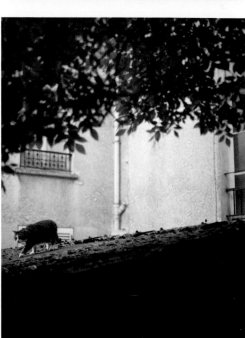

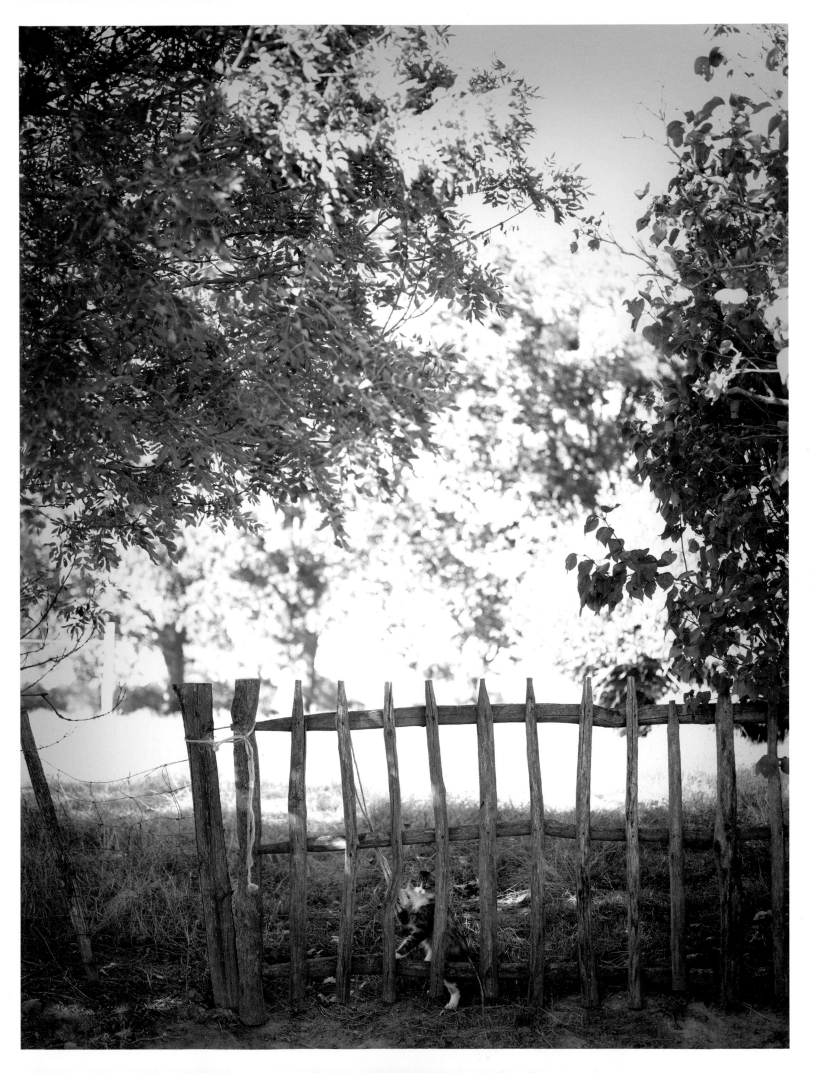

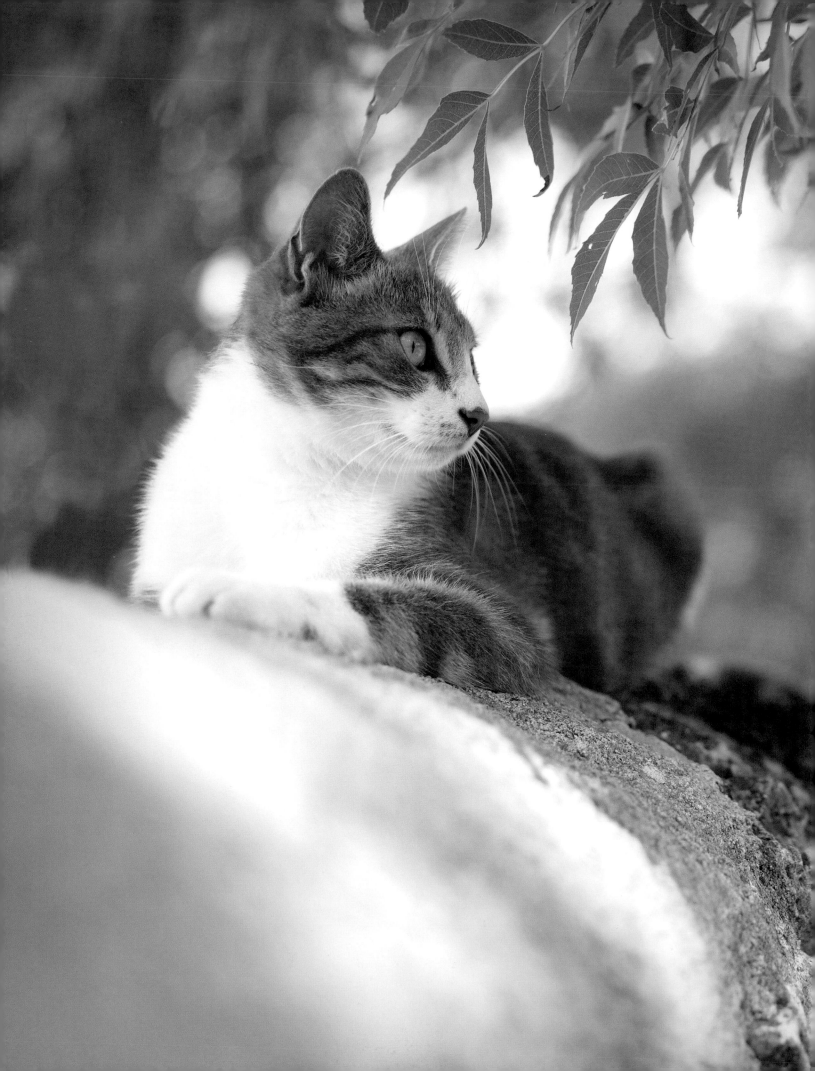

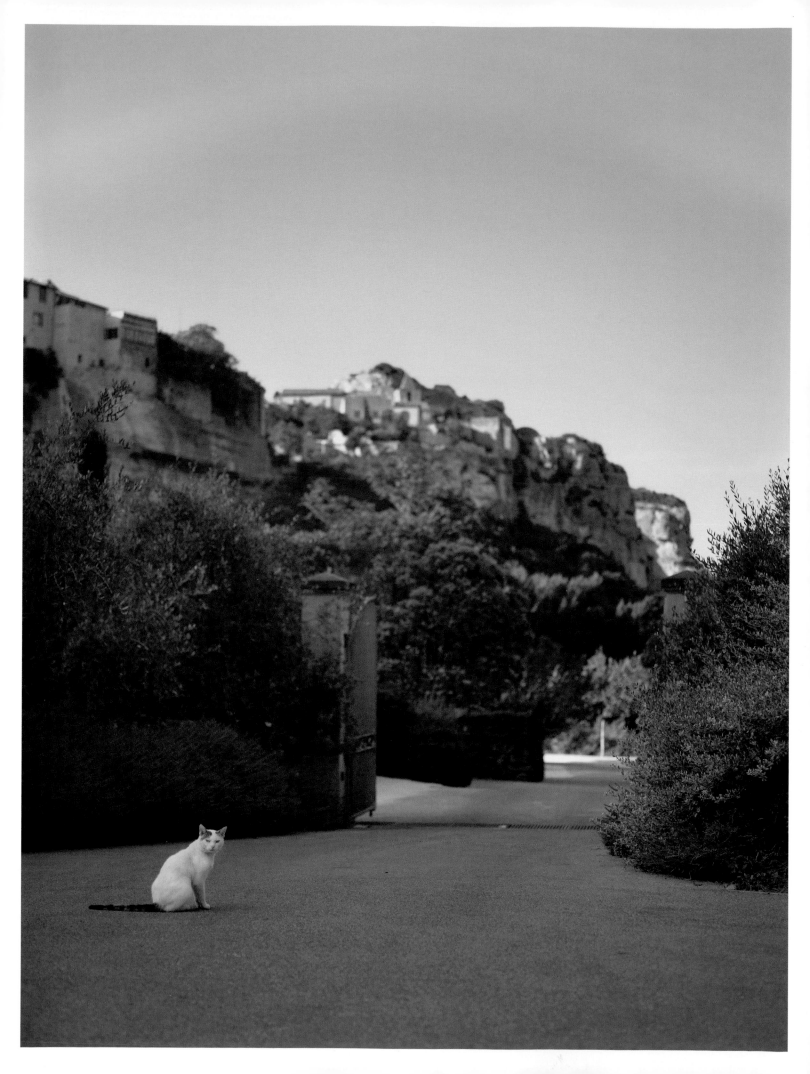

Abi

Abi was slightly *sauvage* (wild) so it took a while to get him to relax, with me stalking him and pointing the camera. The sun was rising over Les Baux de Provence when he finally settled, making the glowing sky the exact shade to complement the lavender lining this driveway—but not enough to steal the show from Abi.

The cat is a dilettante in fur.

Théophile Gautier
(1811–1872, French poet, novelist, journalist, and critic)

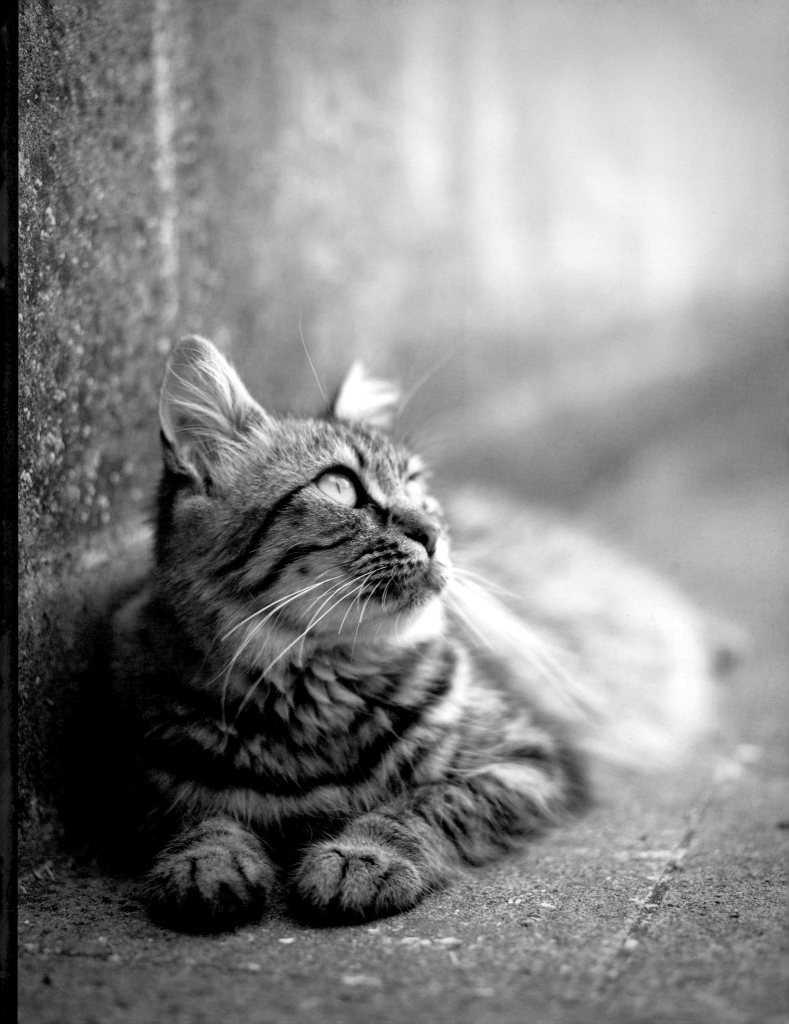

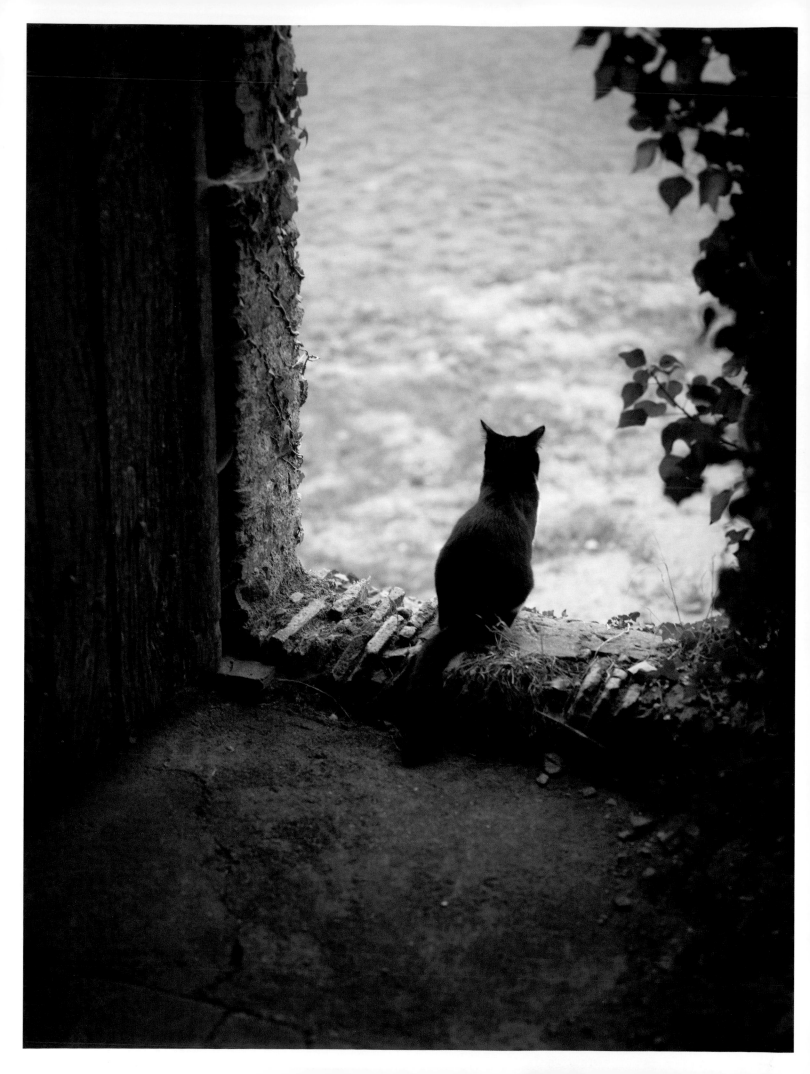

Everybody has noticed the way cats stop and loiter in a half-open door. Hasn't everyone said to a cat: "For heaven's sake, why don't you come in?" With opportunity half-open in front of them, there are men who have a similar tendency to remain undecided between two solutions, at the risk of being crushed by fate abruptly closing the opportunity. The overprudent, cats as they are, and because they are cats, sometimes run more danger than the bold.

Victor Hugo
(1802–1885, French poet, novelist, playwright, and statesman)
From *Les Misérables*, 1862

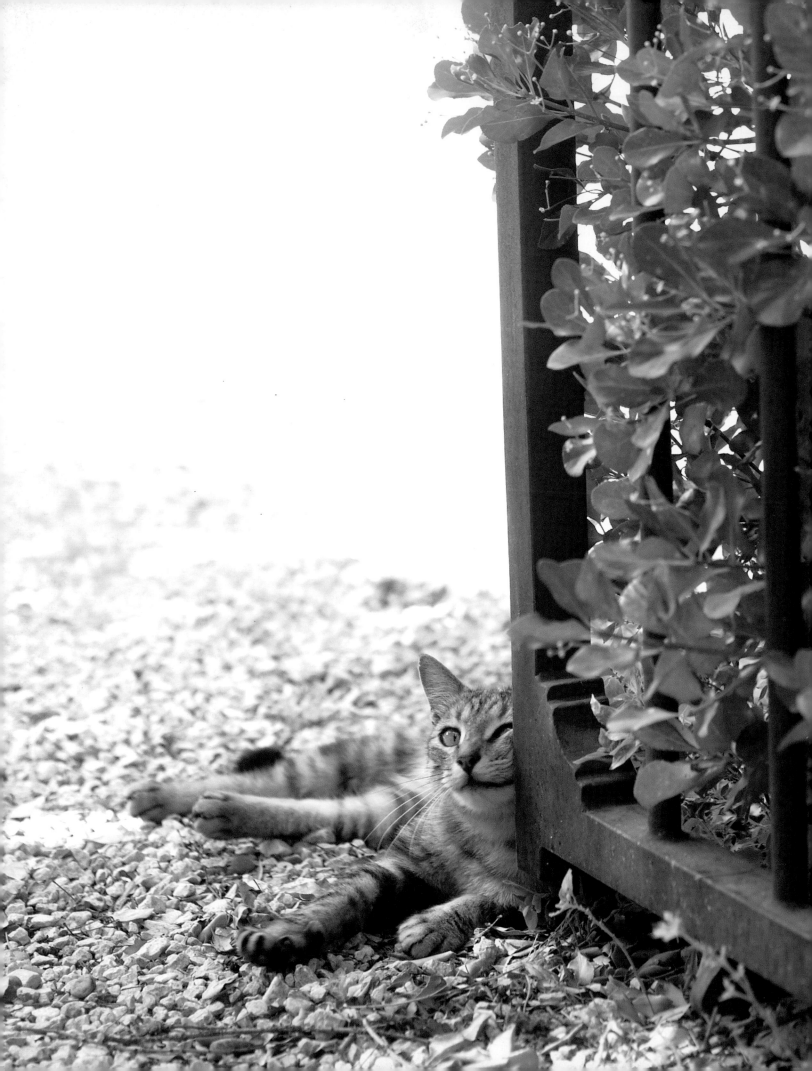

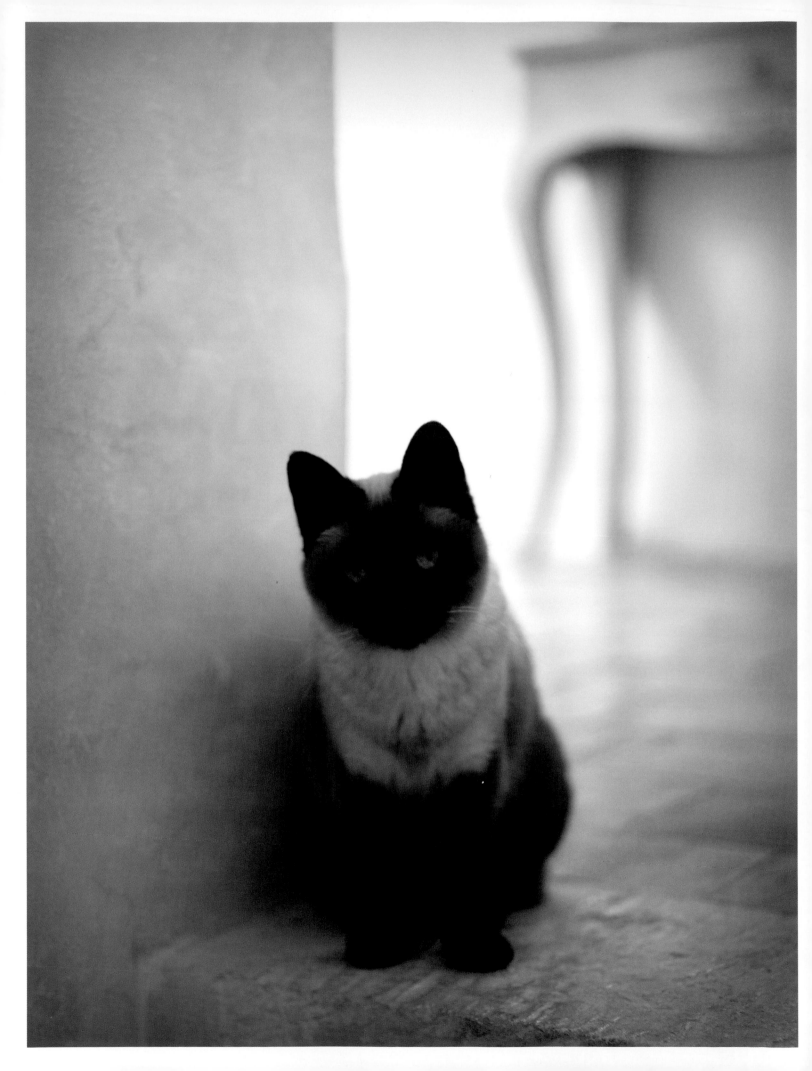

Craquette

Craquette, the much-loved resident cat at Le Mas de la Rose in Orgon, delights in resting under the sun lounger on the roof terrace. As she is older, I was not sure if she was annoyed, intrigued, or amused when I lay down on the terrace beside her and tried to entice her to a more convenient place. Eventually she warmed to me and moved from the heat to the cool tiles inside. With me sitting on the stairs below, constantly stroking her while she purred in reply, I was able capture her endearing personality.

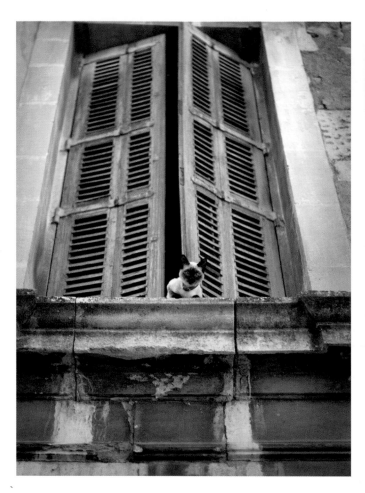

To me, this image portrays so much about French life. It was the rustic charm of this house that first caught my eye, but then I came across a gem: a playful little kitten observing us from a window ledge above the front door. The owner of the house was sitting in the street, as is the custom around here, so I introduced myself, explained about the cat project and asked if I could photograph his cat. "Bien sûr!" (Of course!) he said. Sephora was his daughter's kitten, but she would not mind. As I was photographing, the family's other cat, Fan Fan La Mère, who was hovering nearby, wandered in and positioned herself perfectly in the shot.

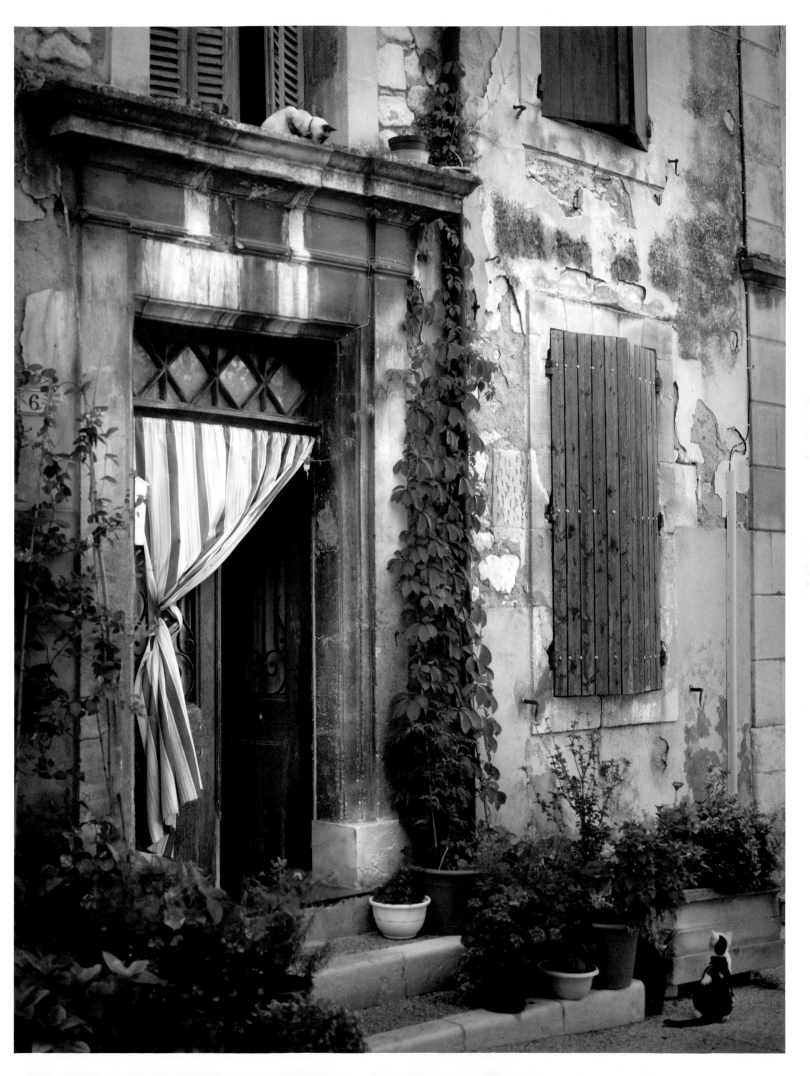

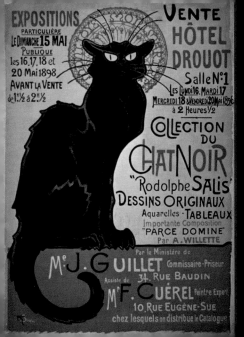

Théophile-Alexandre Steinlen (1859–1923)
Tournée du Chat Noir
1896

Le Chat Noir (The Black Cat) is considered
to be the first "cabaret" in France. Opened in
1881 by artist Rodolphe Salis, this tiny venue
in bohemian Montmarte, Paris, became a
celebrated meeting place for artists, writers,
and musicians. The cabaret also produced a
self-titled journal of illustrations and stories.
Swiss-born art nouveau painter Théophile-
Alexandre Steinlen was commissioned by
Salis to produce drawings of cats for the
club interior, and created this iconic painting
for one of Le Chat Noir company tours.

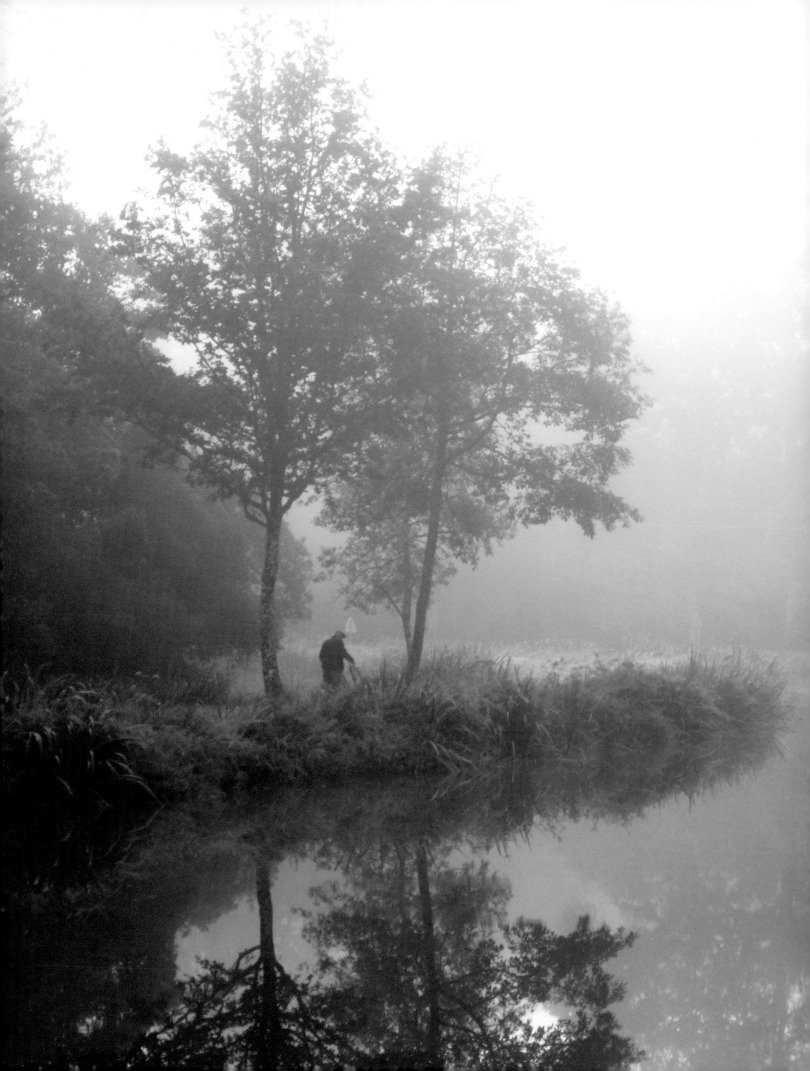

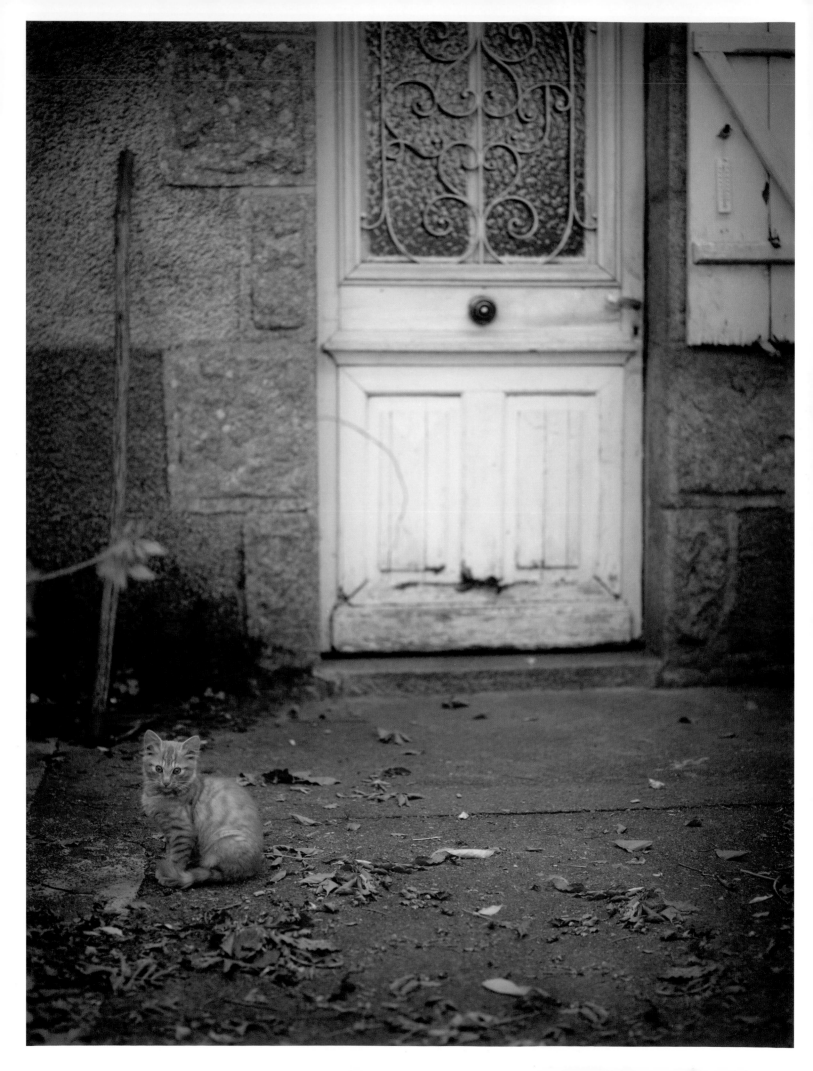

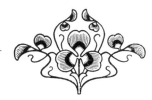

The evening before I captured this image I'd been wandering the streets of this rural village and noticed a highly anxious adult cat almost hidden in someone's garden. I tried the gate, but it was locked. A passing local told me that the old man who lived there was ill in the hospital. The cat was a stray and lived in the garden with her kittens. The next day I returned armed with cat treats, which I proceeded to throw through the gate onto the front path. Eventually three of the kittens emerged, but they scampered away as soon as I made the slightest move, even to focus my camera. After what seemed like an eternity holding my heavy camera steady through the garden gate, the forlorn little ginger kitten relaxed enough for me to capture his image.

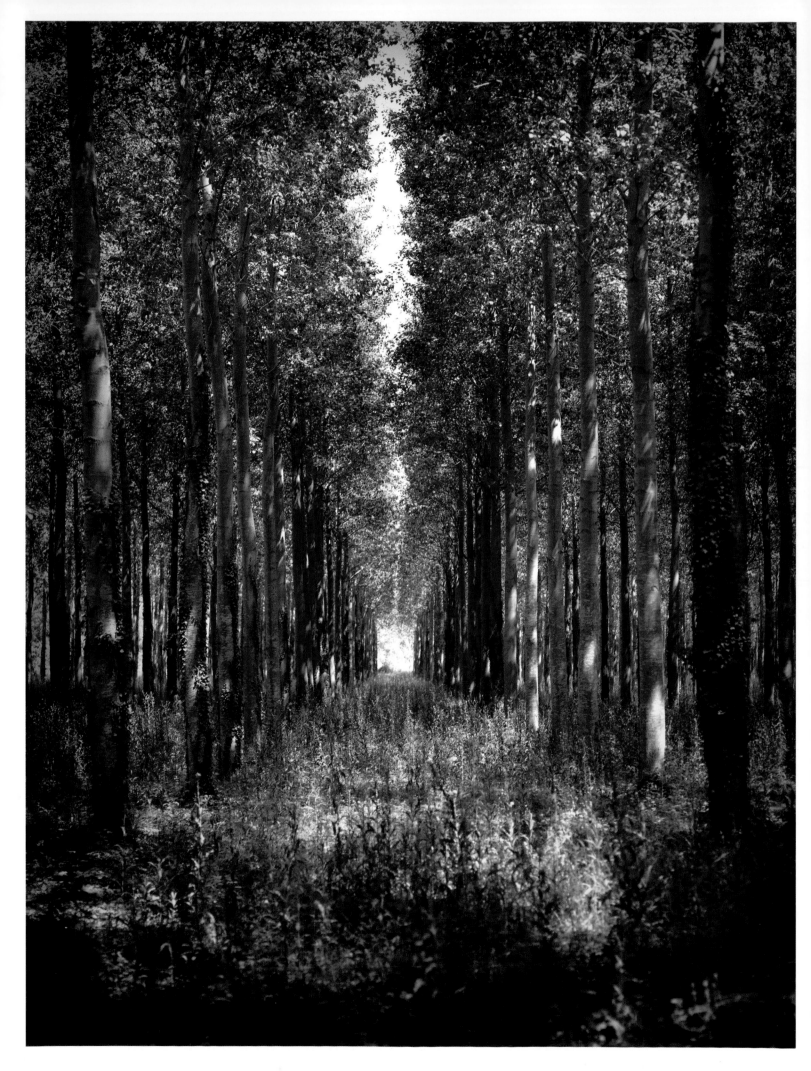

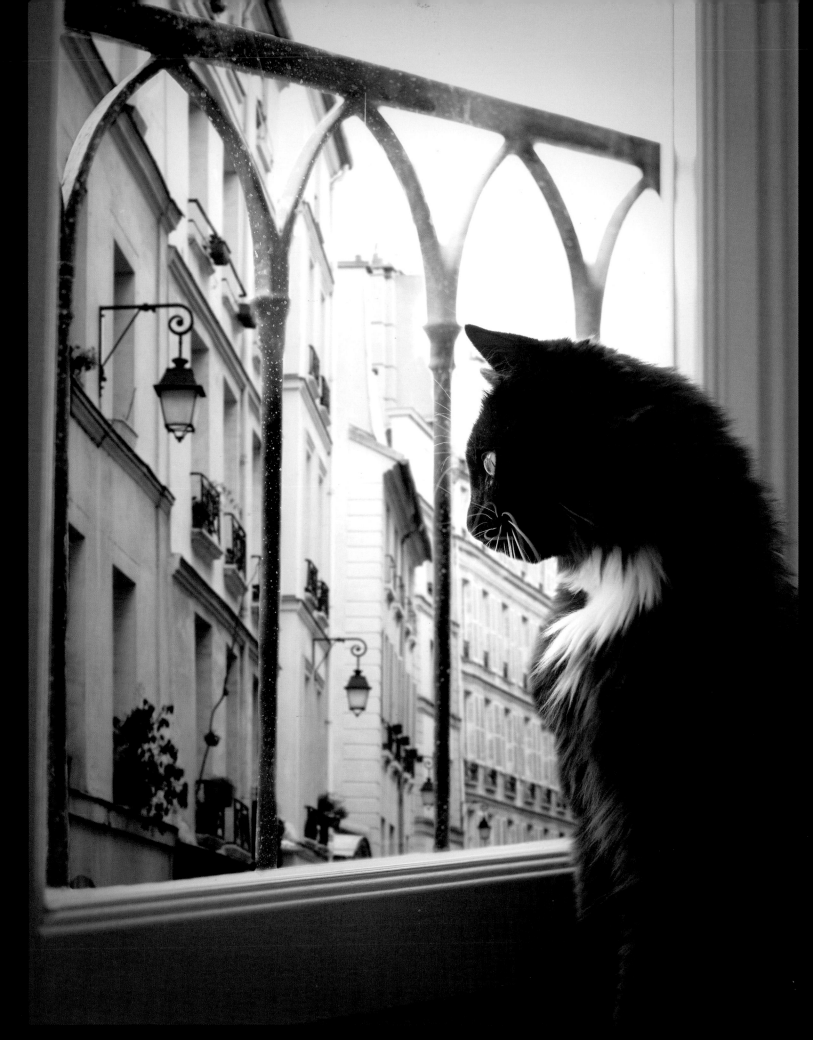

They stray about the house with velvety tread, like the genius loci; or sit beside the writer's table companioning his thought, gazing at him from the depths of their golden eyes, with intelligent tenderness and intuitive penetration . . .

———————————

Théophile Gautier
(1811–1872, French poet, novelist, journalist, and critic)

The textures are marvelous. Gnarled old olive trees, only good for shade, are left for kids and cats to climb. Floor tiles wear down to clay.

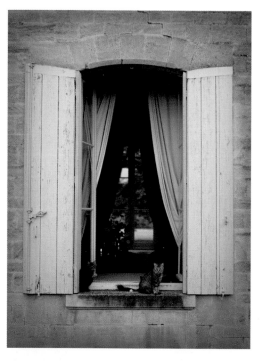

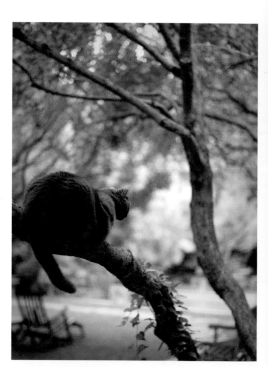

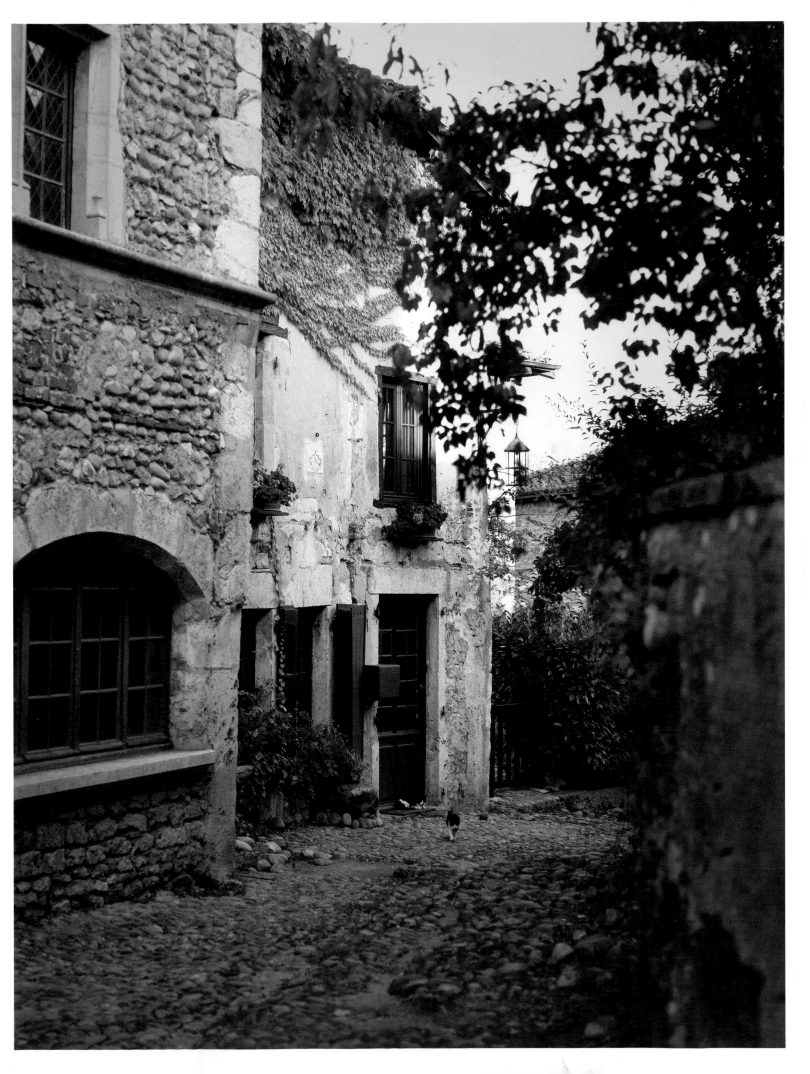

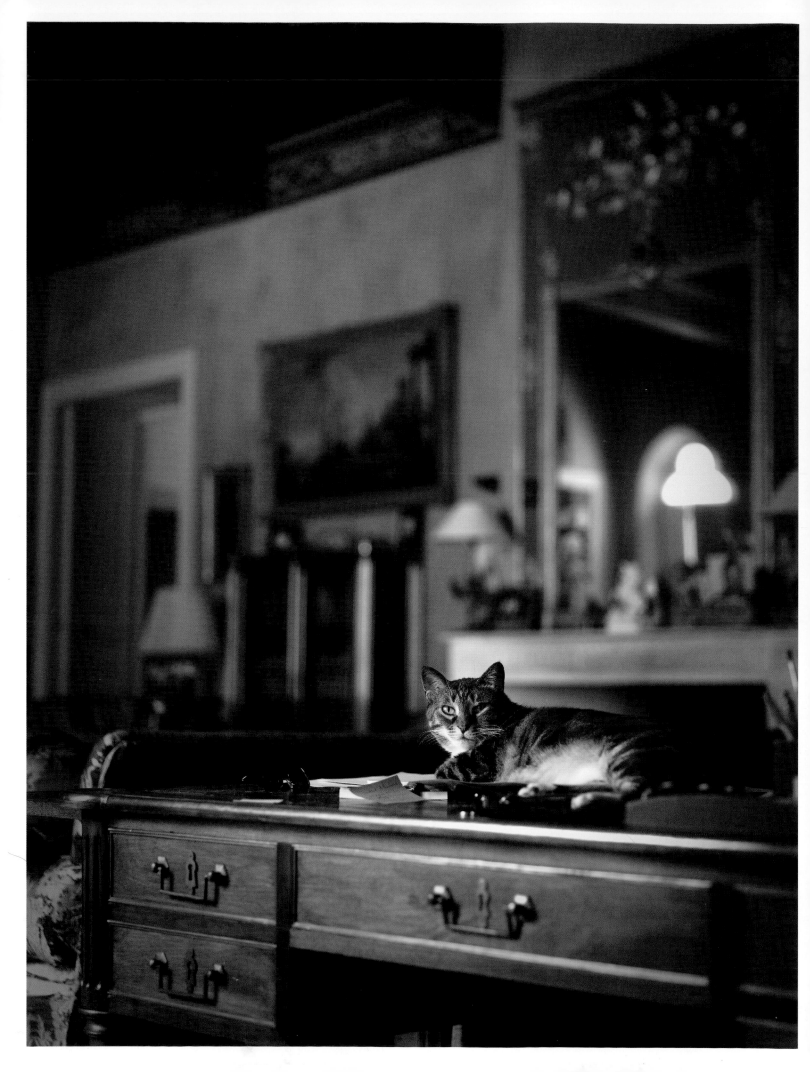

Miss France

I think in images, so when I heard about Miss France of Château de Beauregard I immediately visualized a petite, shy cat curled tightly at the back of a beautiful wooden box, resting on top of an antique desk in a dark room with light filtering through the window . . . Miss France turned out to be not so petite, and the box was not wooden, but she was indeed shy. Only with the help of Delta, her ever-patient owner, did I manage to capture her on her favorite antique desk in what was an exceptionally beautiful room.

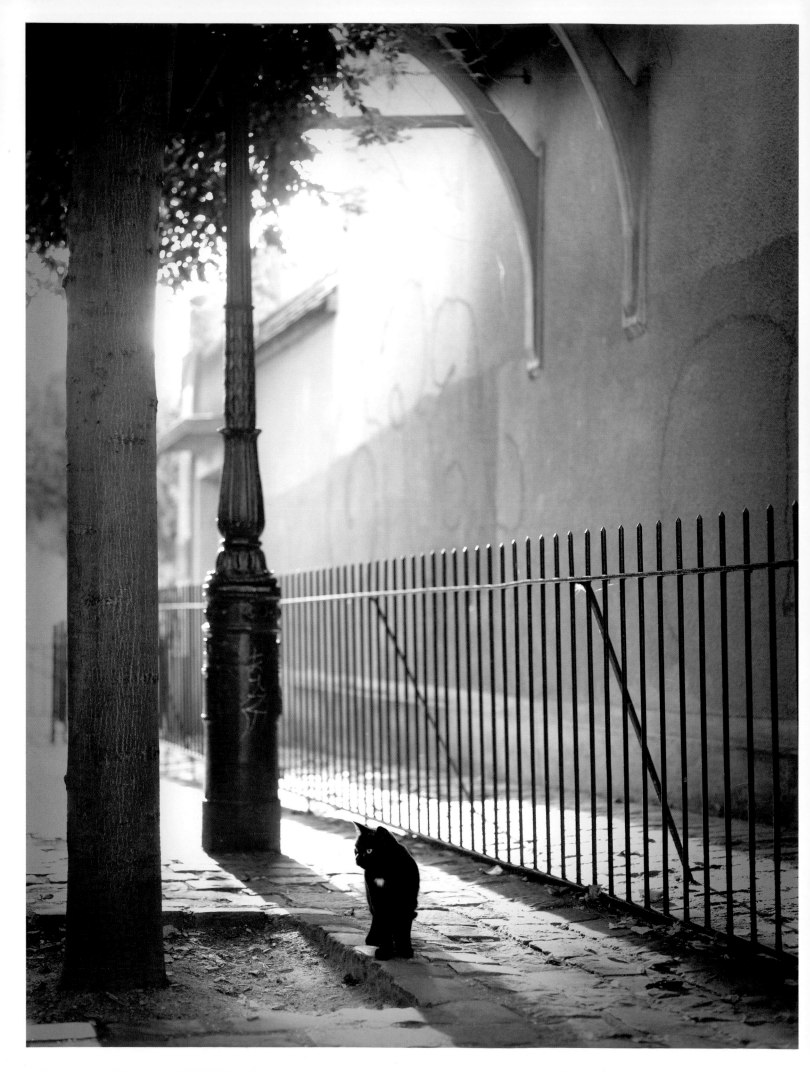

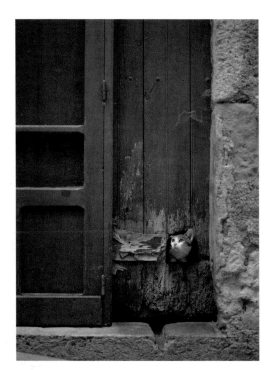 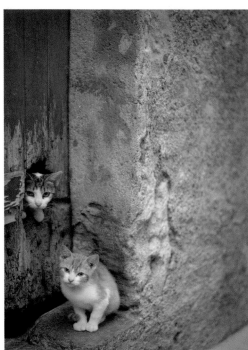 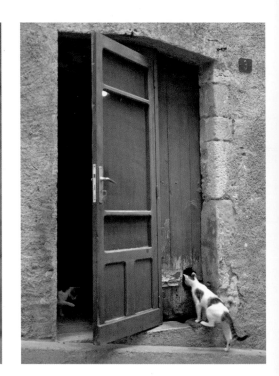

Maurice Ravel (1875–1937, French classical composer)

Ravel loved cats and kept several Siamese at his house Le Belvédère, near Paris. In 1925, he completed the opera *L'enfant et les sortilèges (The Child and the Spells)* in collaboration with Sidonie-Gabrielle Colette, who wrote the libretto. The opera features "Duo miaulé," a duet by the tomcat and female cat in their own wordless feline language.

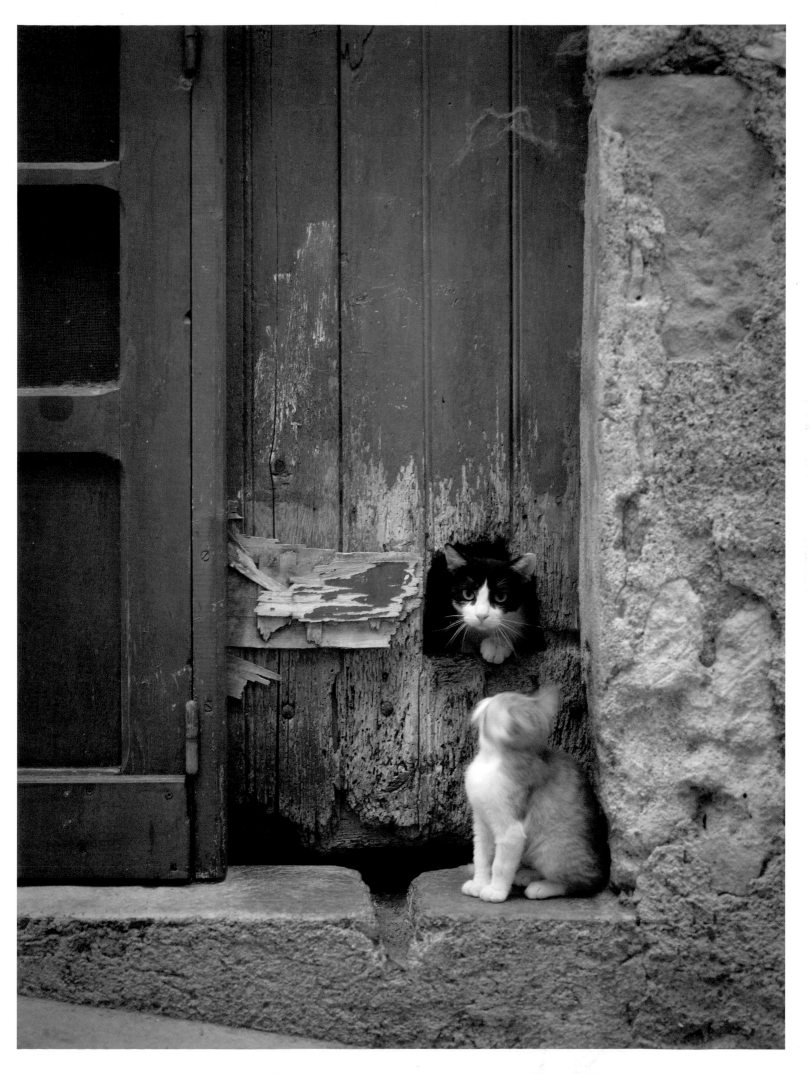

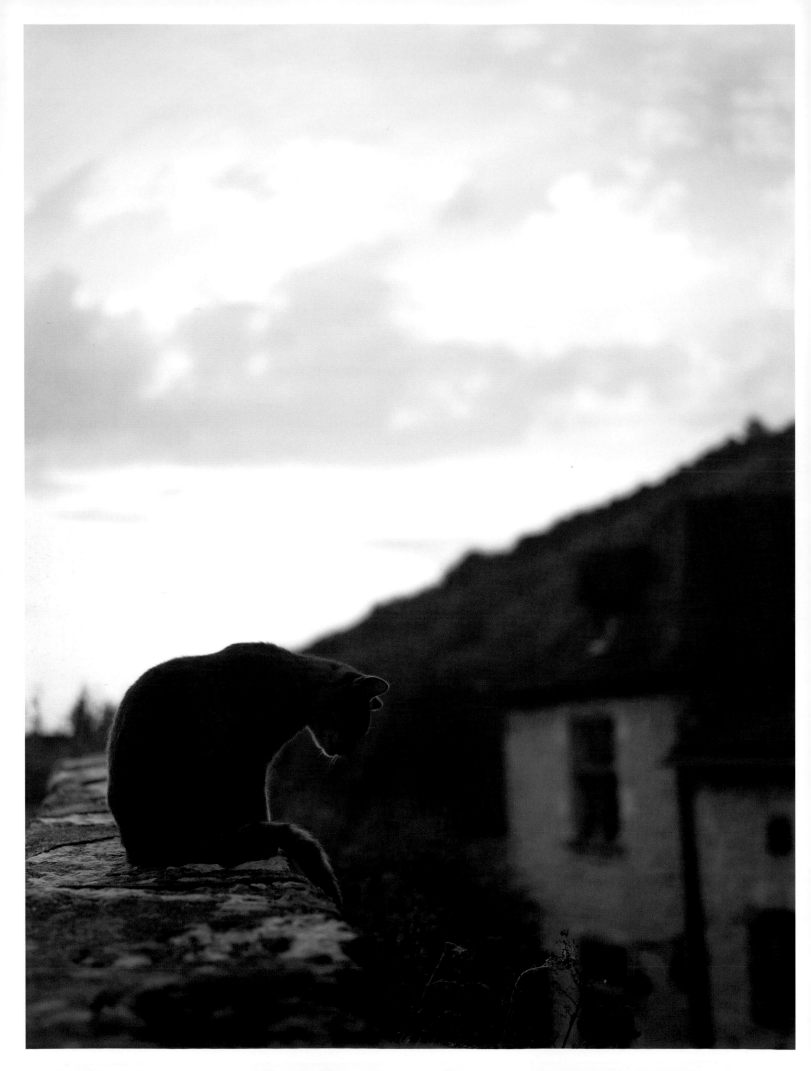

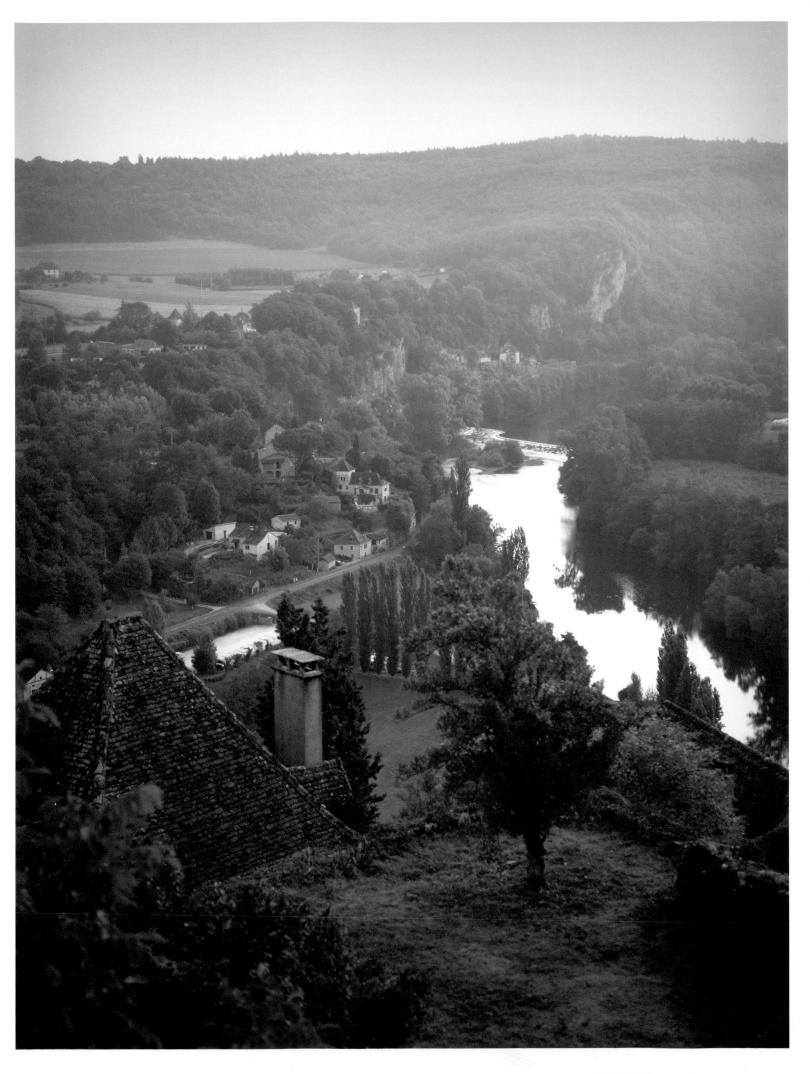

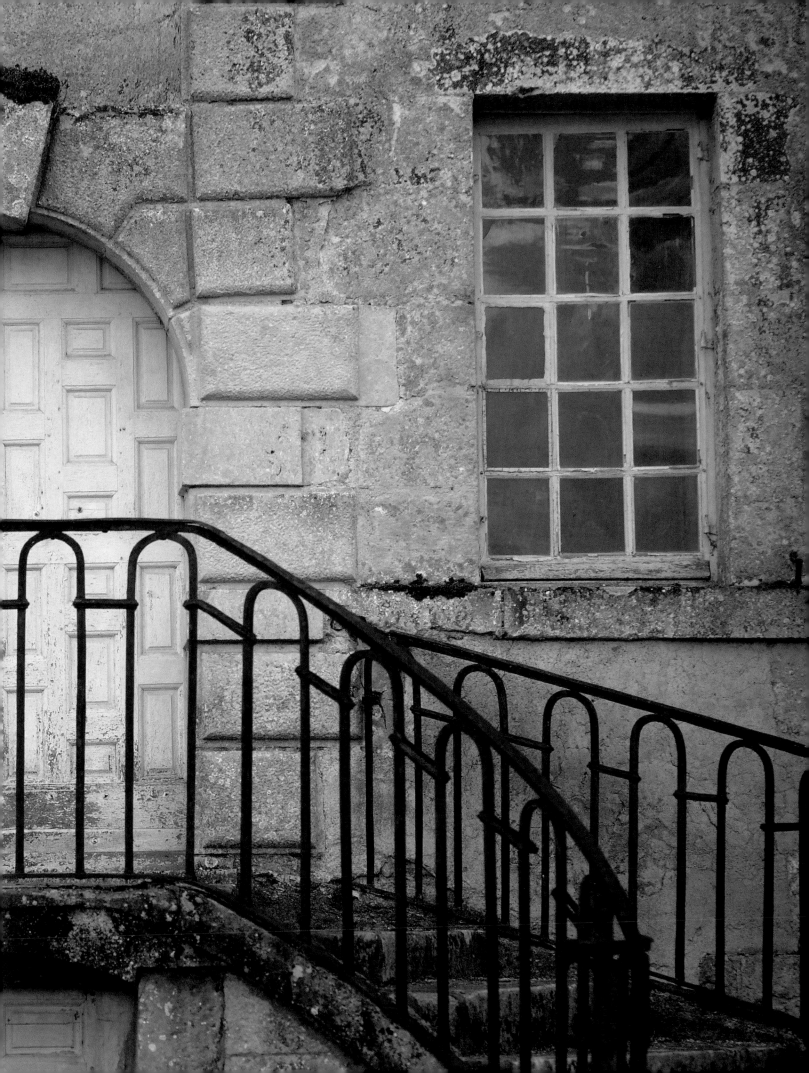

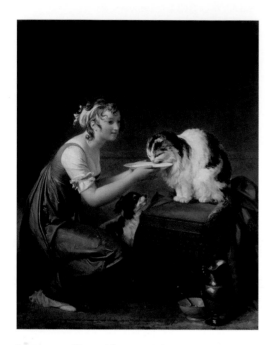

Marguerite Gérard (1761–1837)
The Cat's Lunch

It seemed almost surreal to be photographing Caramel scampering around in the library of this virtually untouched seventeenth-century château. She was totally oblivious to the pulls her claws were making in the fabric of a possibly priceless antique chair. I couldn't help but wonder about the characters who had climbed this ladder and sat in this chair, contributing to the permanent indentations in the seat. I was also amazed that Caramel sat still long enough for me to capture a sharp image.

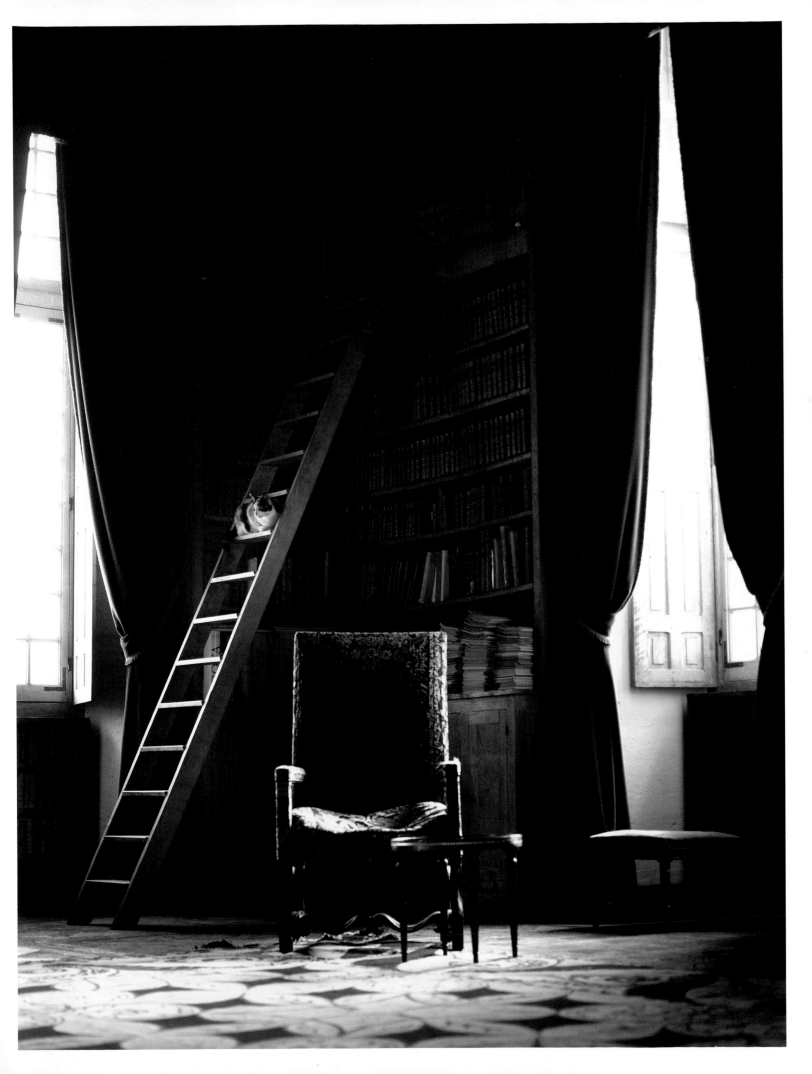

The cat is a drawing-room tiger.

Victor Hugo

(1802–1885, French poet, novelist, playwright, and statesman)

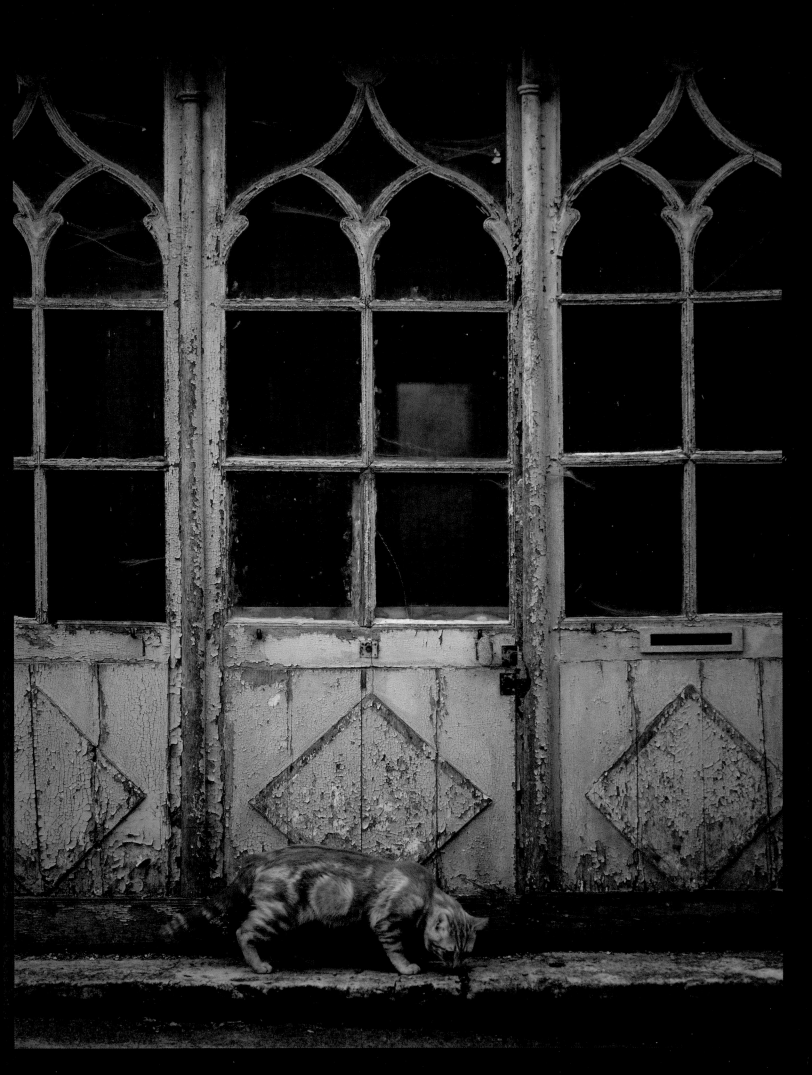

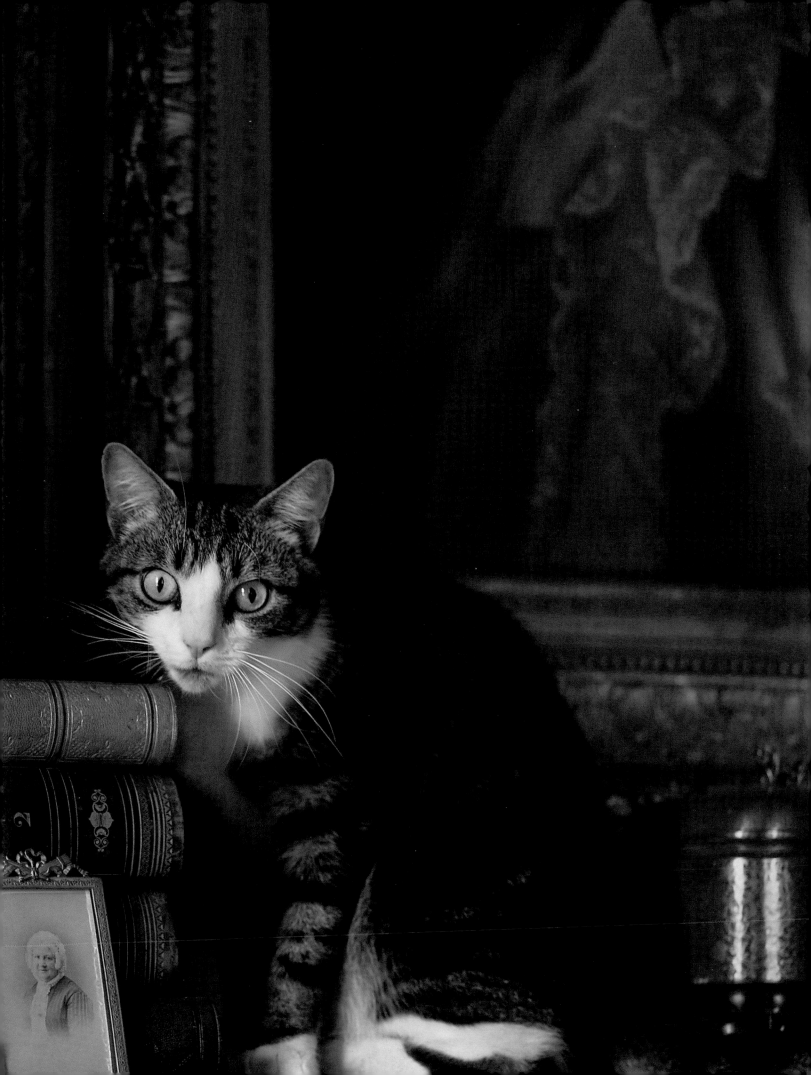

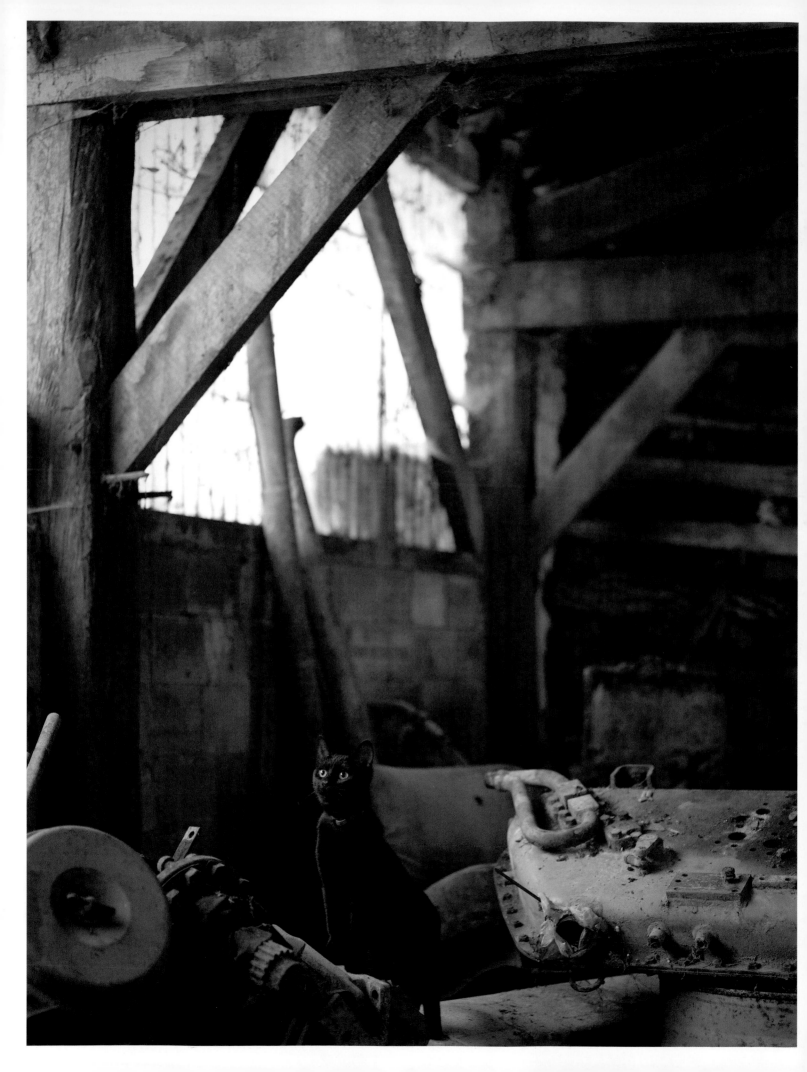

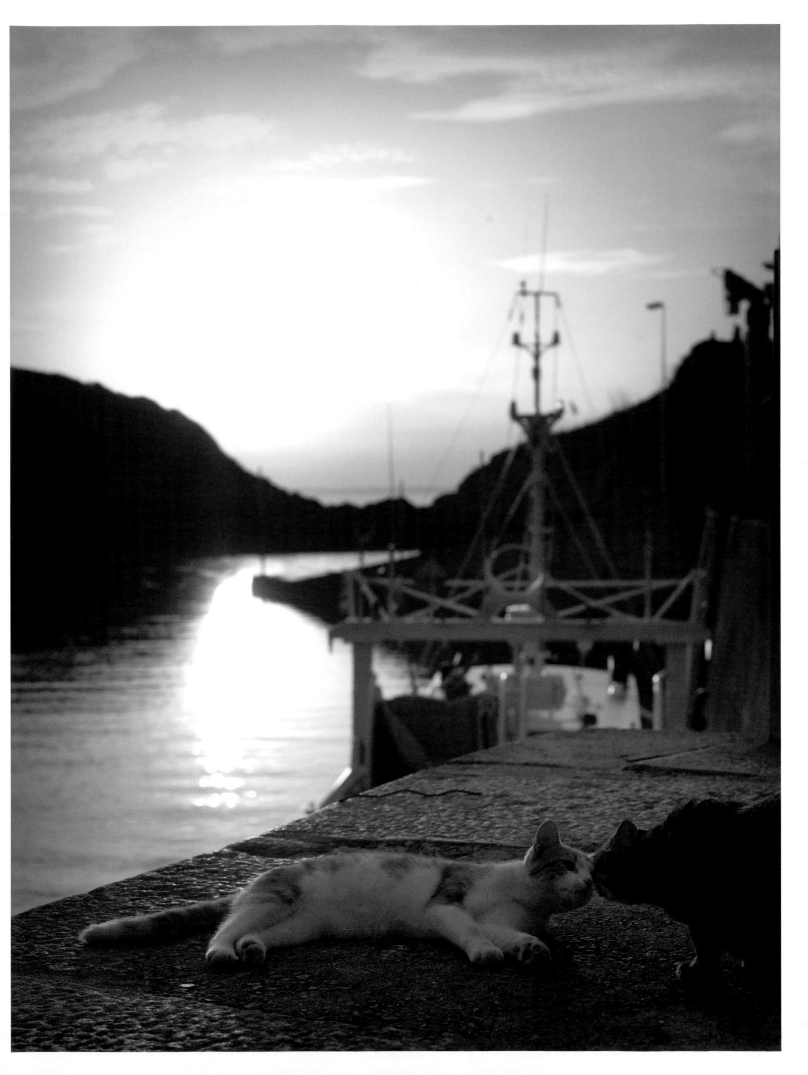

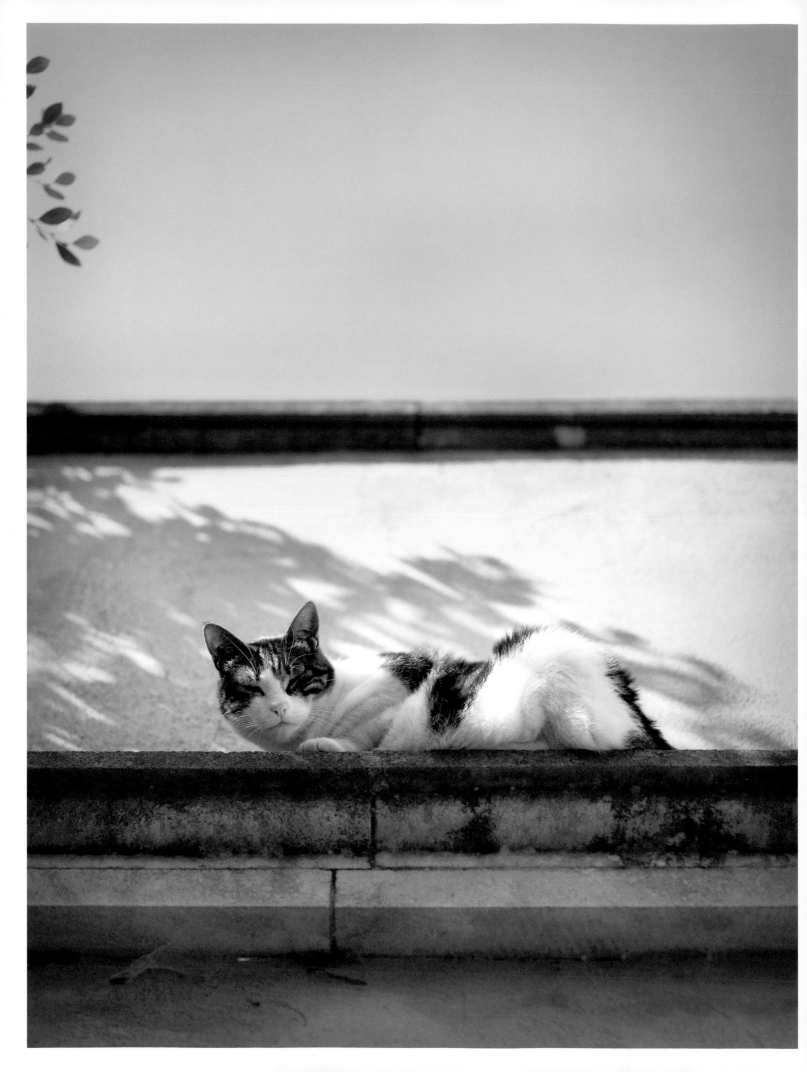

Marilou

It is amazing the places you find cats perched in France. The old buildings with their ledges, windows, and balconies are perfect for those who need to get away from dogs and busy streets and get a bird's-eye view at the same time. Within a few days of cat tracking I'd become accustomed to looking up—and there, perched on a ledge at Oustau de Baumanière, was Marilou, watching from her haven of safety as guests came and went.

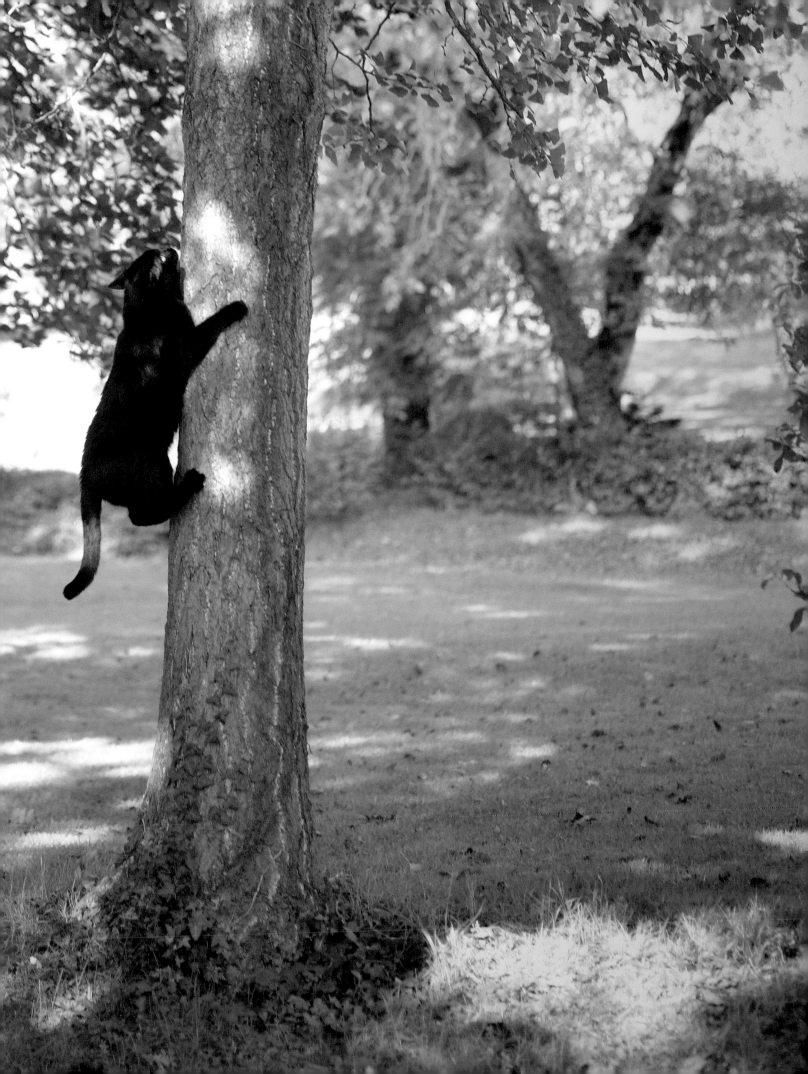

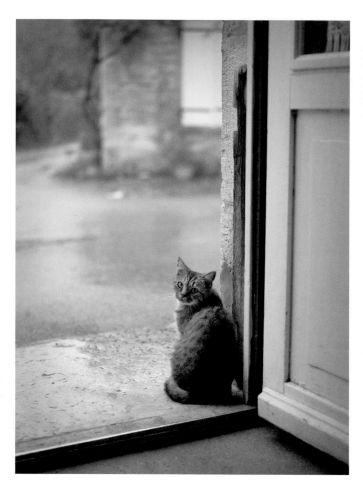

Alexander Dumas (1802–1870, French novelist, playwright, and essayist)

Dumas had three cats: Mysouff I, Mysouff II, and Le Docteur. Mysouff I could always sense when his master was coming home, even if he was late. Mysouff I would jump up from his perch and go outside to meet his owner at the gate. Mysouff II once ate all of Dumas's exotic birds and was sentenced to five years in a cage with the novelist's pet monkeys. She regained her freedom, however, when Dumas sold the monkeys.

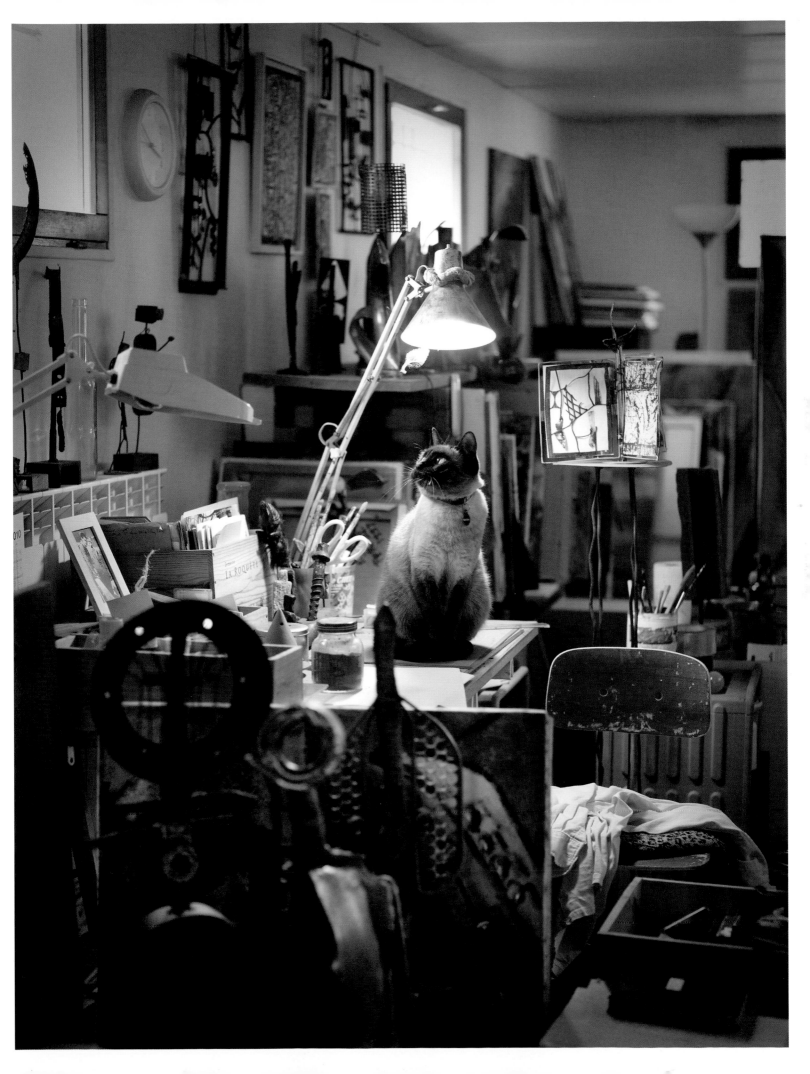

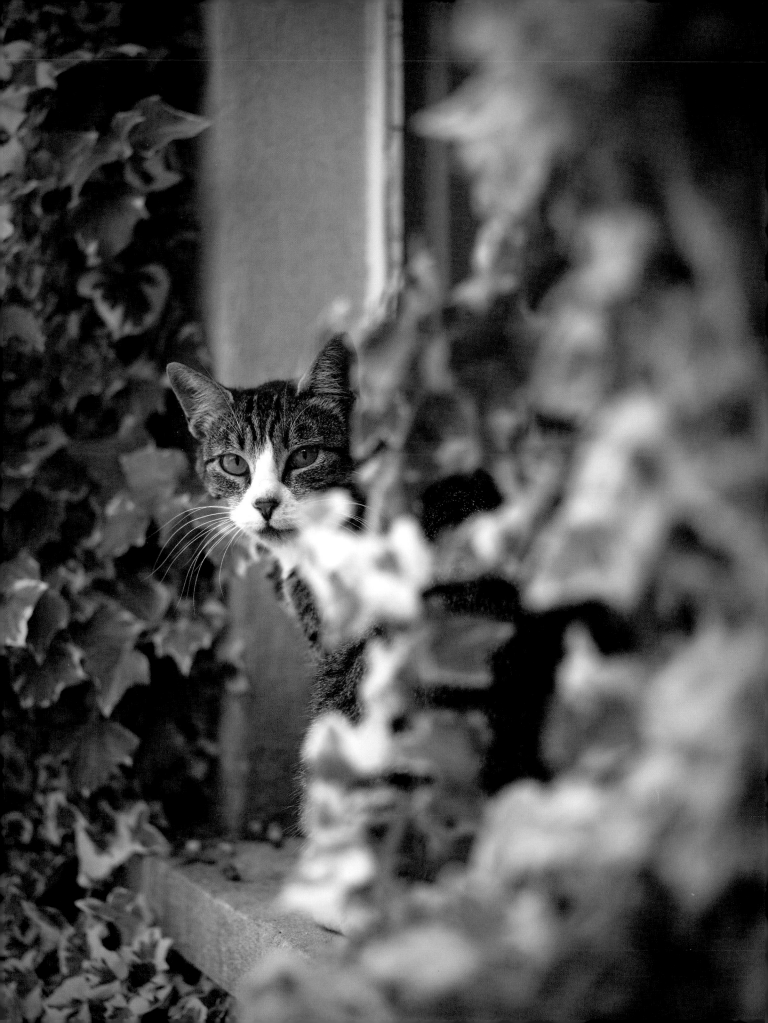

I noticed Mouchette, another of the rather timid cats belonging to Oustau de Baumanière, had slipped away after *petit déjeuner.* I finally found her at the special place where she eats her breakfast, on a windowsill at the back of the building. What I didn't notice, as I sidled toward her with my camera, were the wasps in one of the bushes I was hiding behind. At least my whimpers of pain distracted Mouchette from her breakfast long enough for me to take her photograph—and for five wasps to sting me!

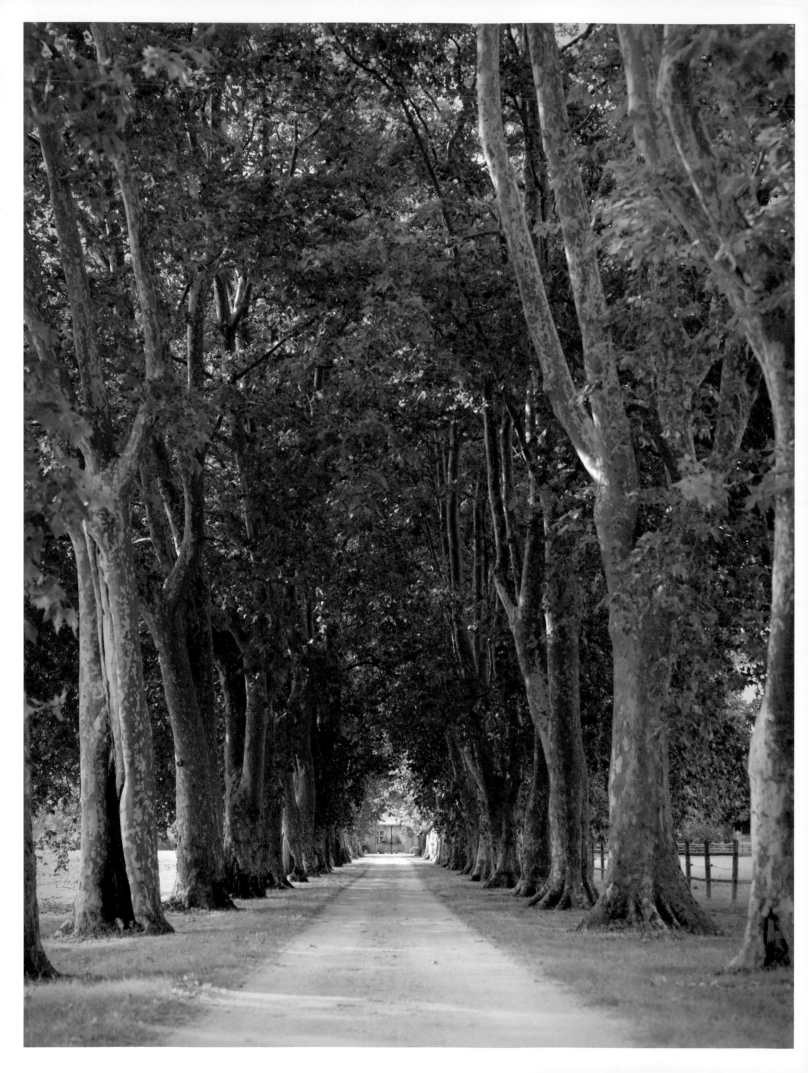

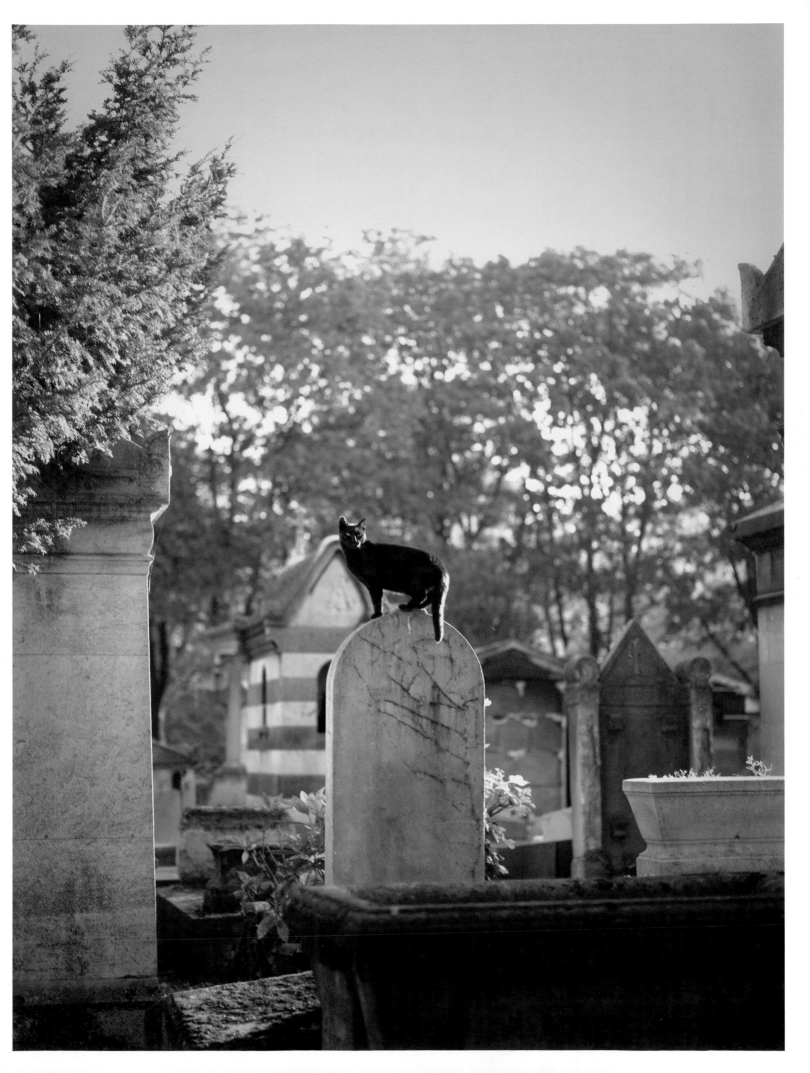

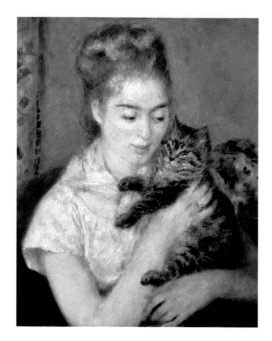

Pierre-Auguste Renoir (1841–1919)
Woman with a Cat
1875

Pierre—Auguste Renoir (1841–1919, French Impressionist painter)

Renoir included cats in many of his paintings, including *Woman with a Cat,
A Boy with a Cat, Sleeping Girl with Cat,* and *Geraniums and Cat.* French
artist Edgar Degas admired Renoir's skills and once exclaimed, "One would
think a cat had painted it!"

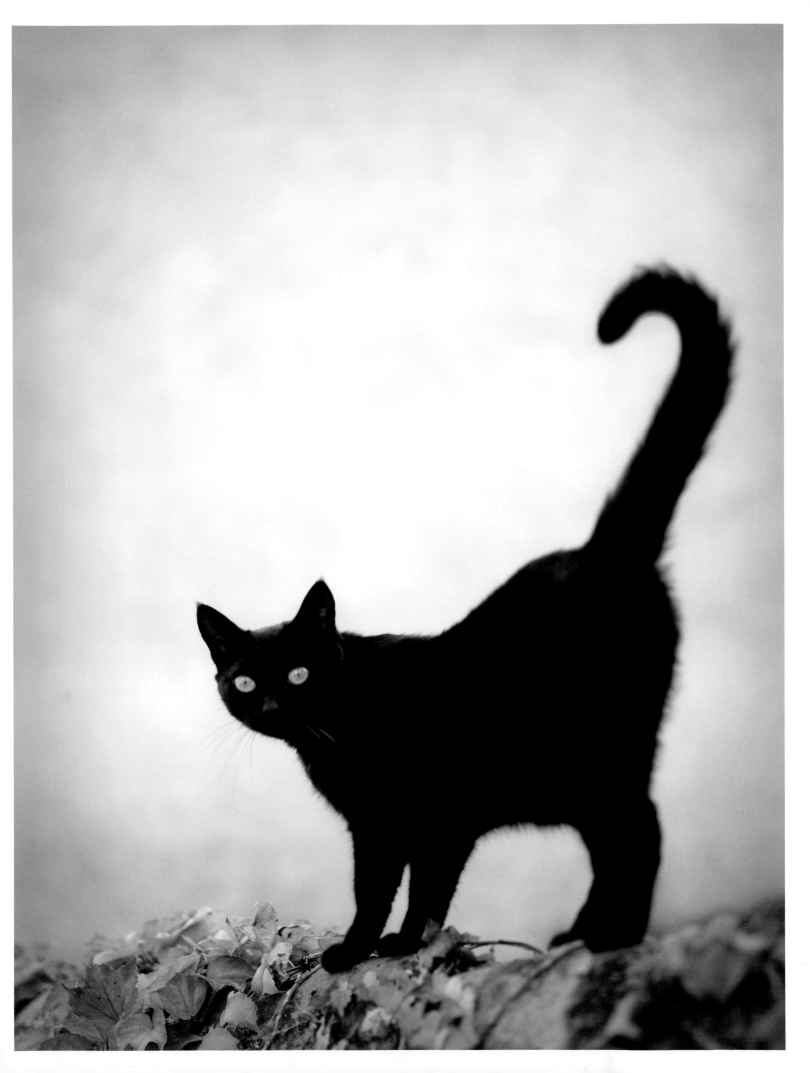

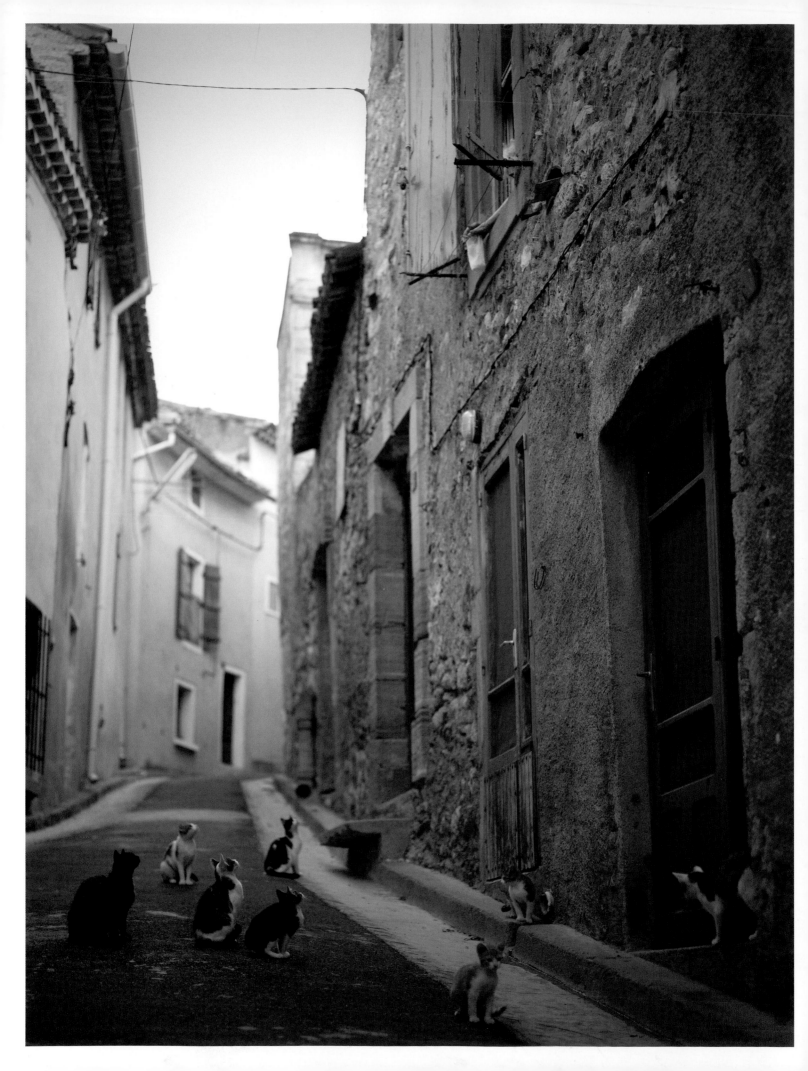

Cardinal Richelieu (1585–1642, French clergyman and prime minister)

Considered to be the world's first prime minister under King Louis XIII, Richelieu was an ardent cat lover. He created a cattery at the Louvre Palace to house dozens of cats and made sure they were taken care of, even after his death.

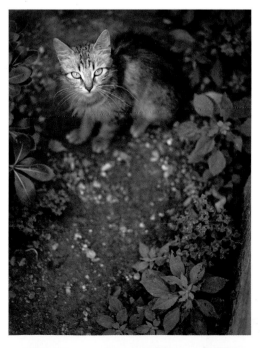
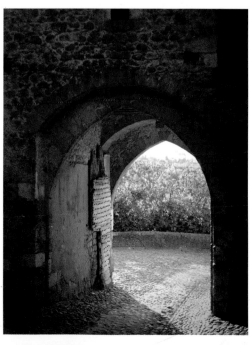

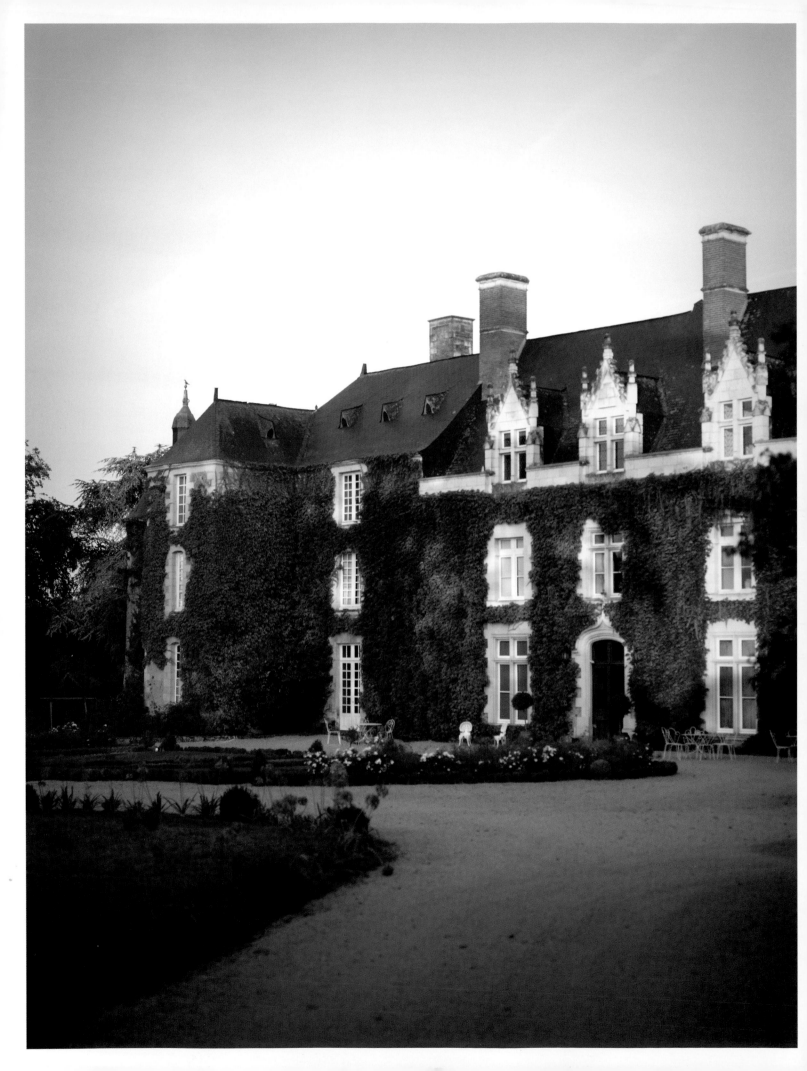

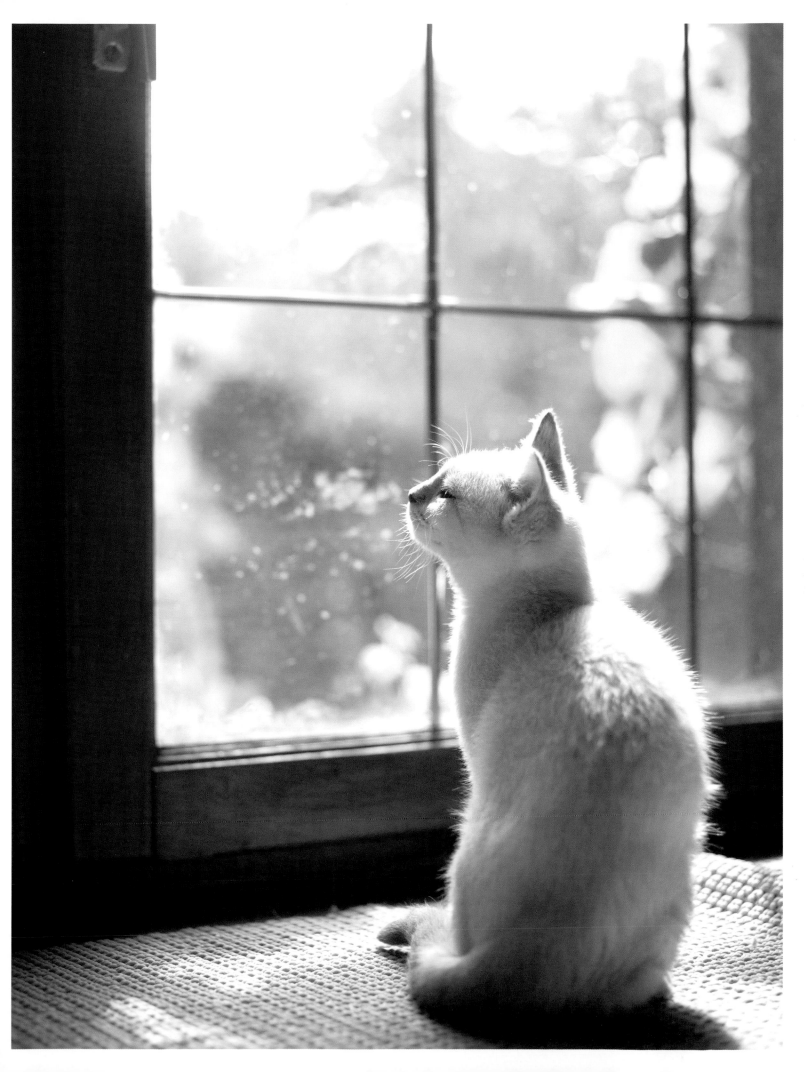

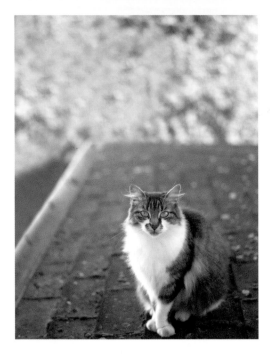
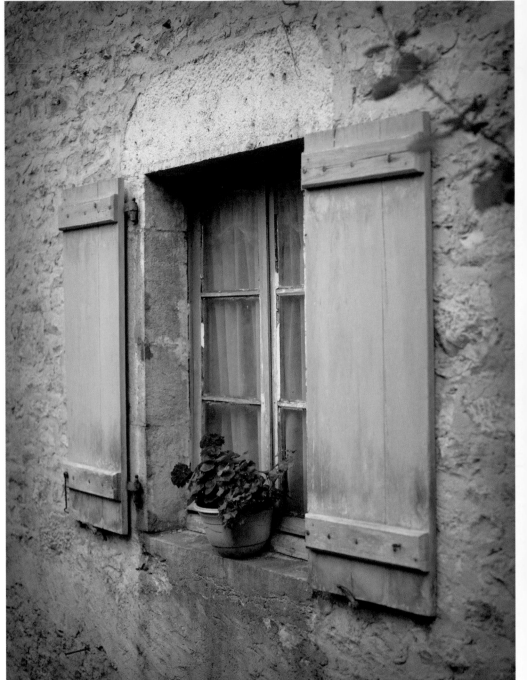

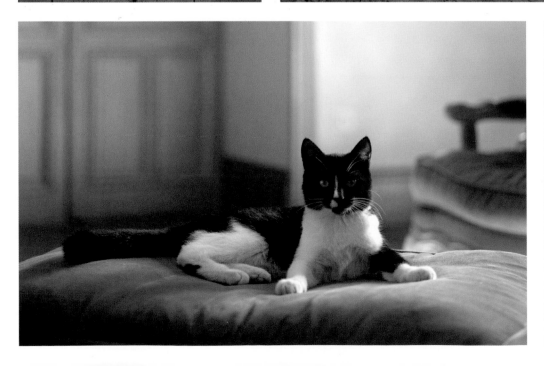
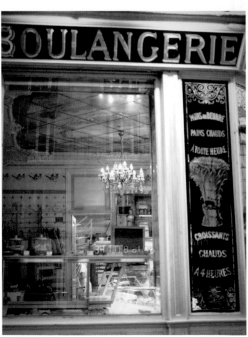

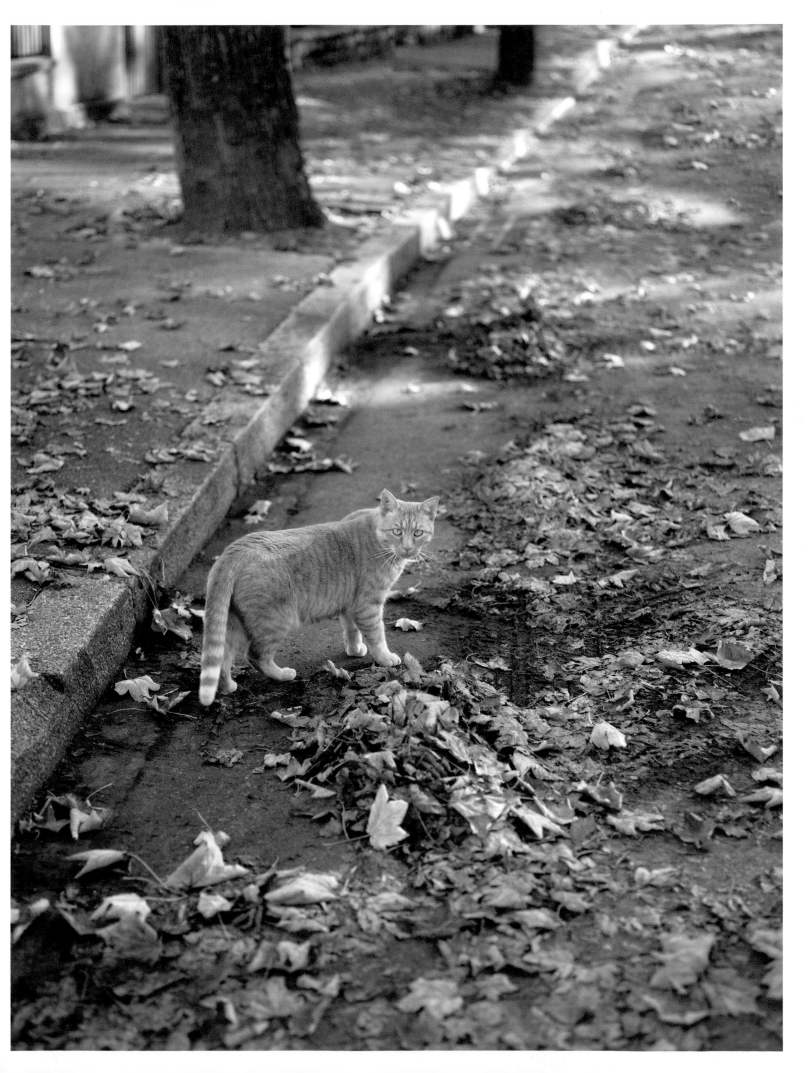

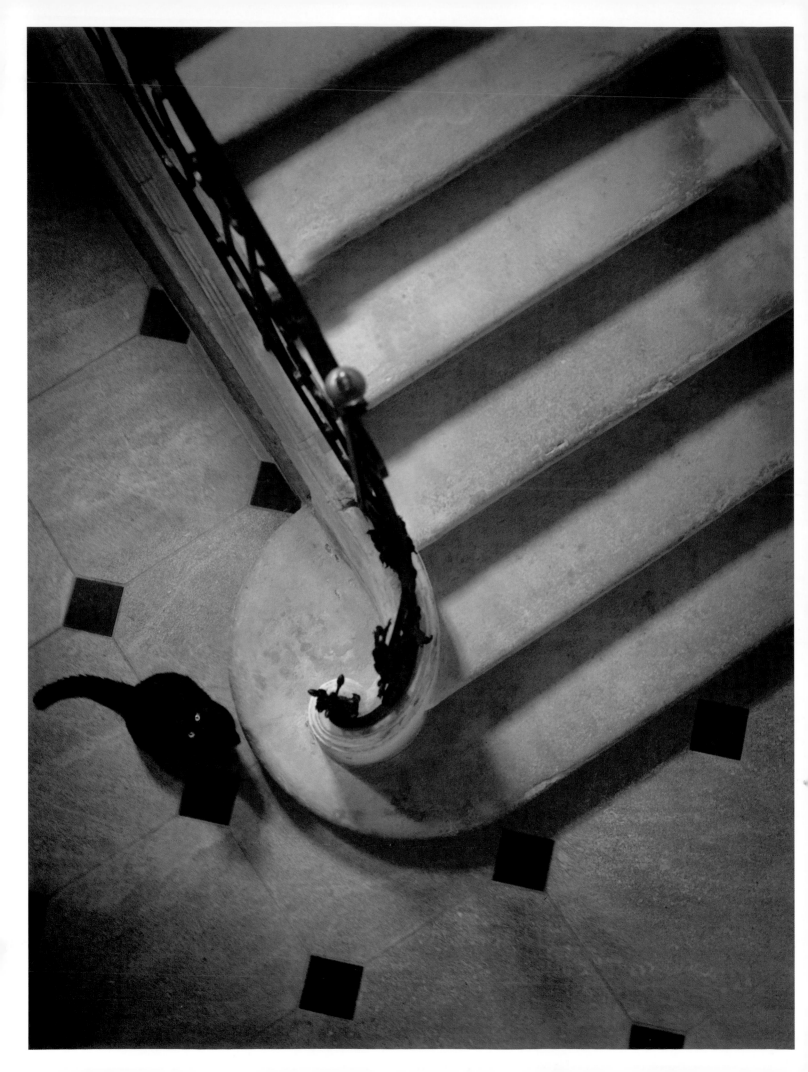

Myrtille

Didier, one of the owners of Château de Varrene, had warned me that Myrtille had attitude, but I completely forgot about it as I watched her observe the comings and goings at the château. She was an older cat who had been adopted with the château when Didier took over a few years before. As I watched, Myrtille simply moved from spot to spot to avoid the guests as they walked up and down the staircase. But when I decided to move her so that I could photograph her on one of Didier's beautiful beds, she wasn't so accommodating. She grabbed my arm with all four paws and sank in her far-from-blunted teeth. Needless to say, as soon as she was back in her chosen spot at the foot of the stairs, Myrtille was happy to oblige—with just a glance to the camera above.

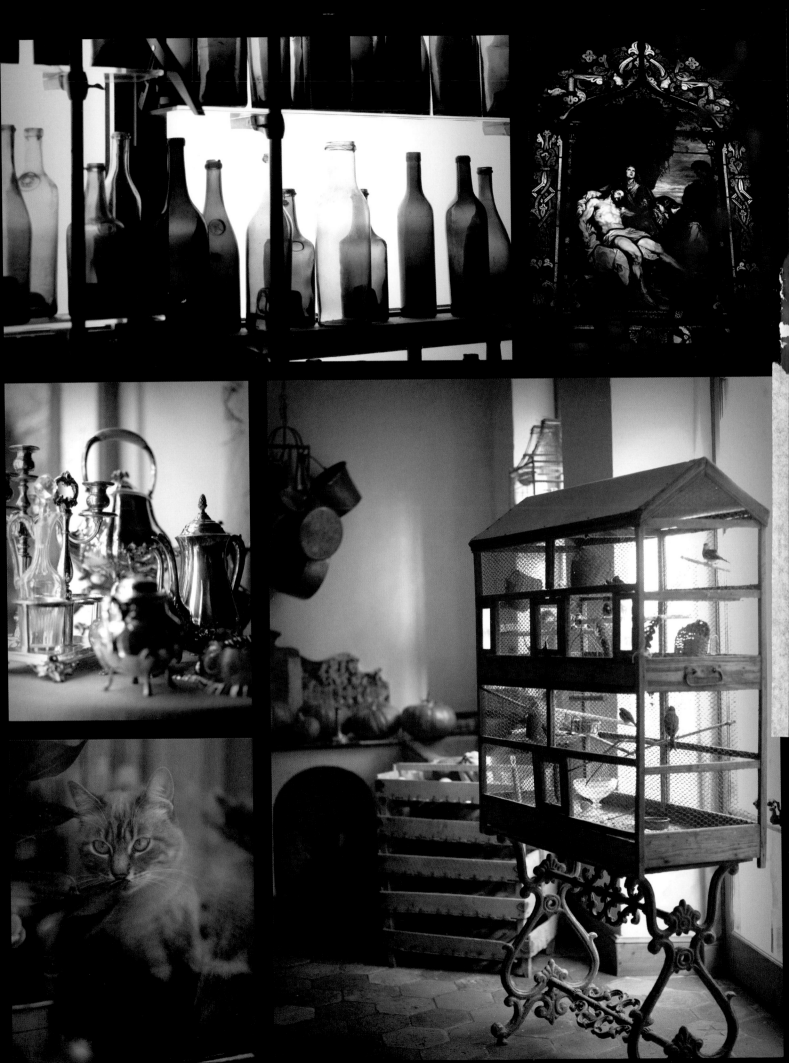

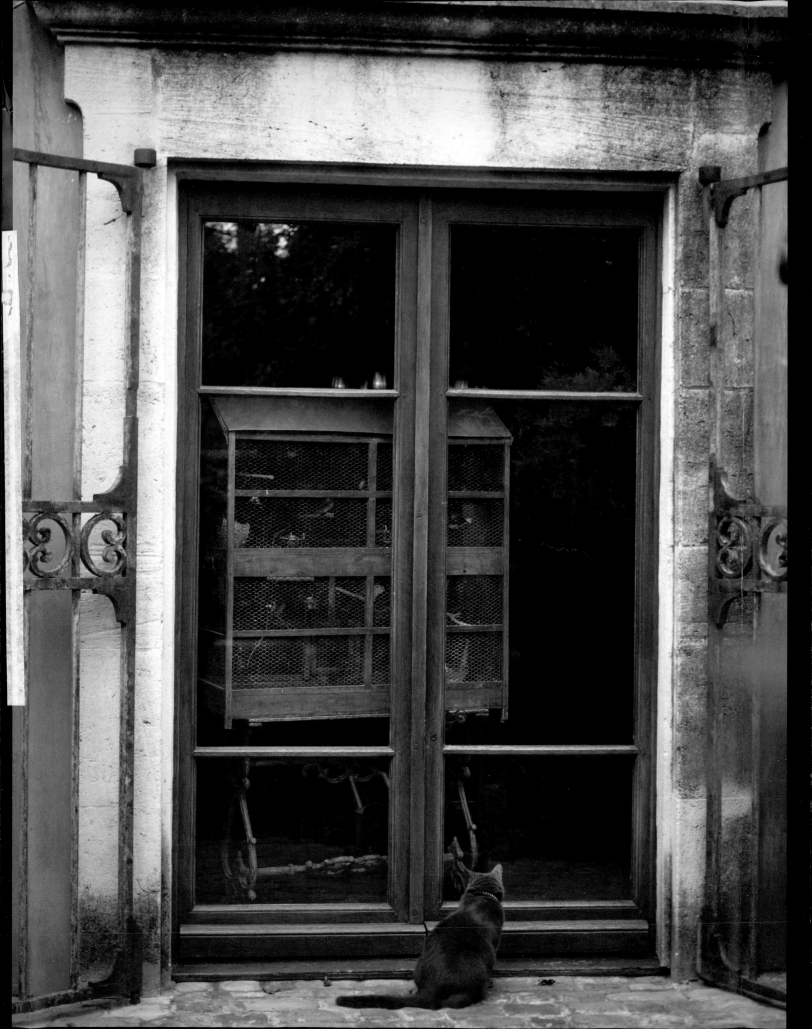

I have studied many philosophers and many cats. The wisdom of cats is infinitely superior.

———————————

Hippolyte Adolphe Taine
(1828–1893, French critic and historian)

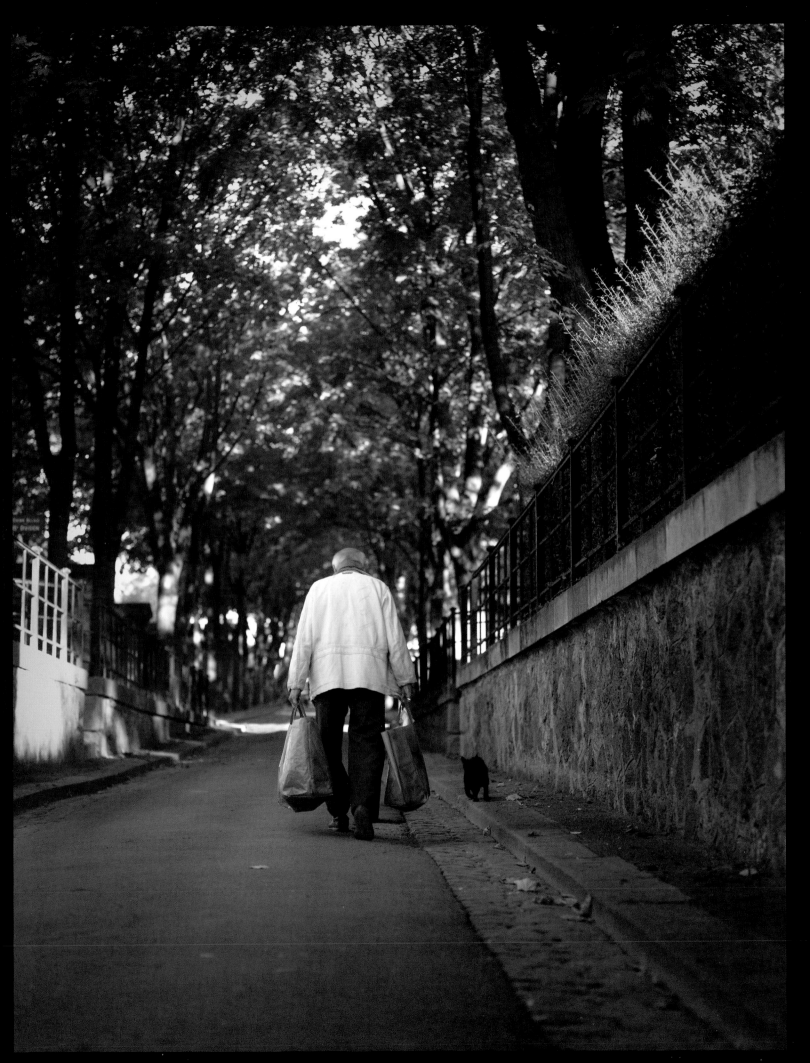

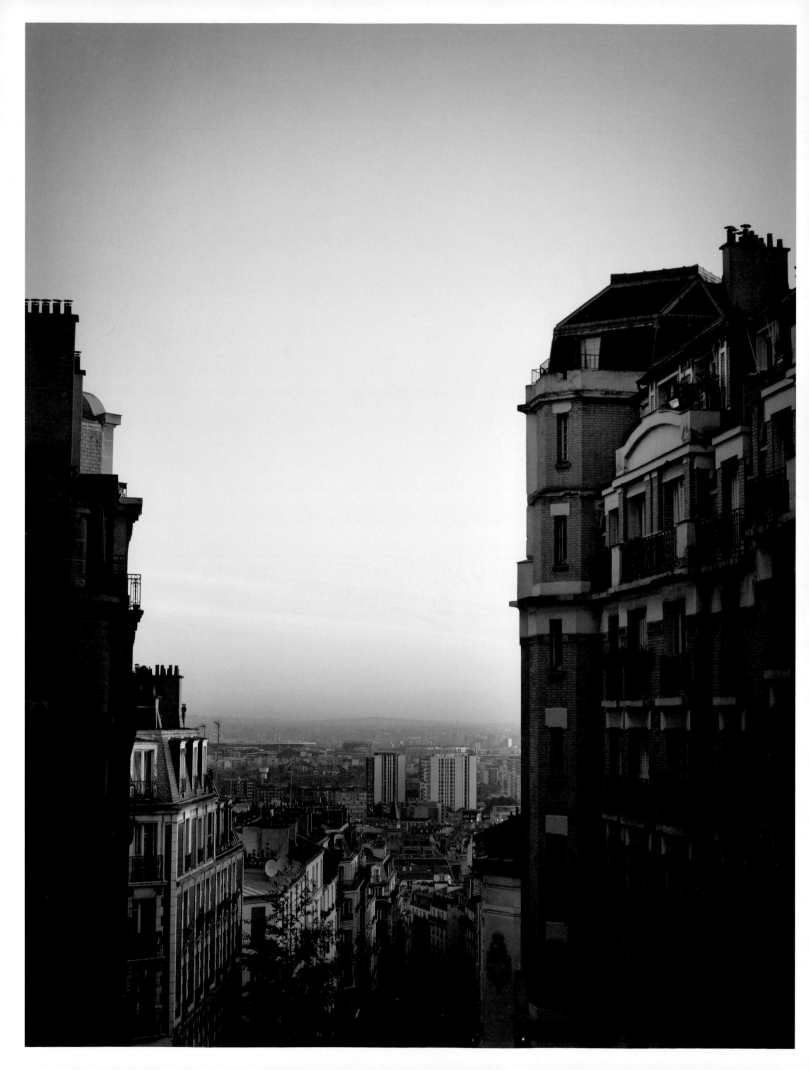

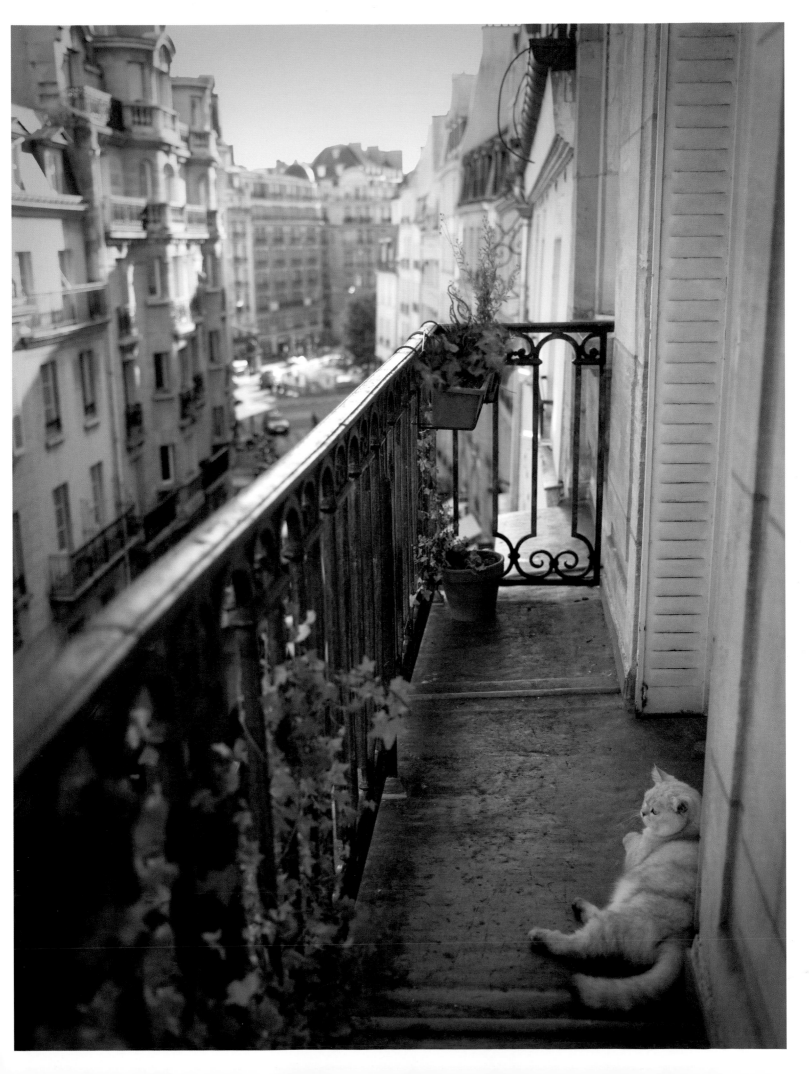

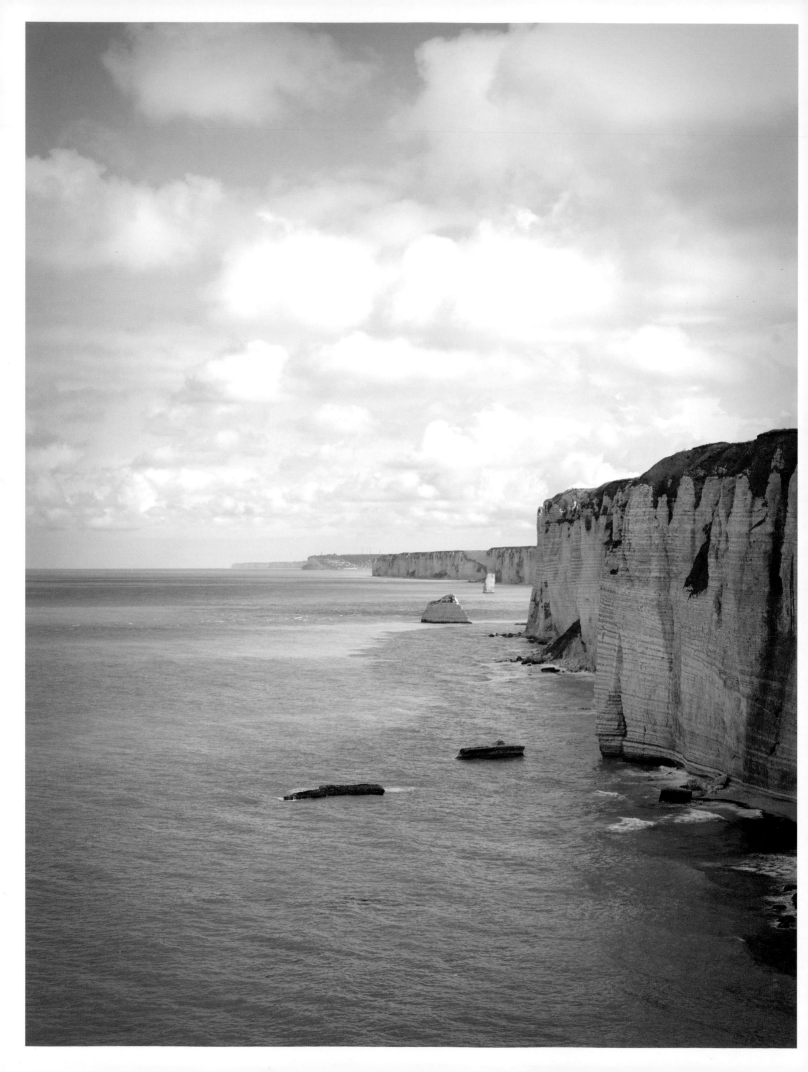

French light, especially in the south, has a shimmering, almost milky quality you don't find in other parts of the world . . . there's the hazy light caused by the sheer heat of summer days; the soft, filtered light of early morning . . .

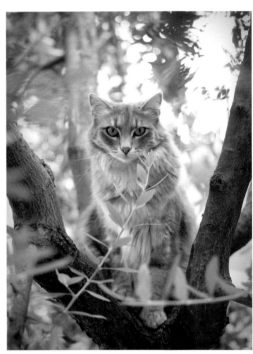

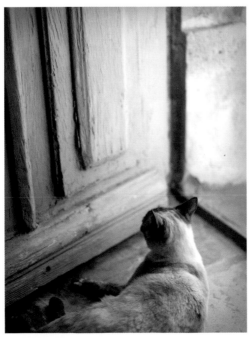

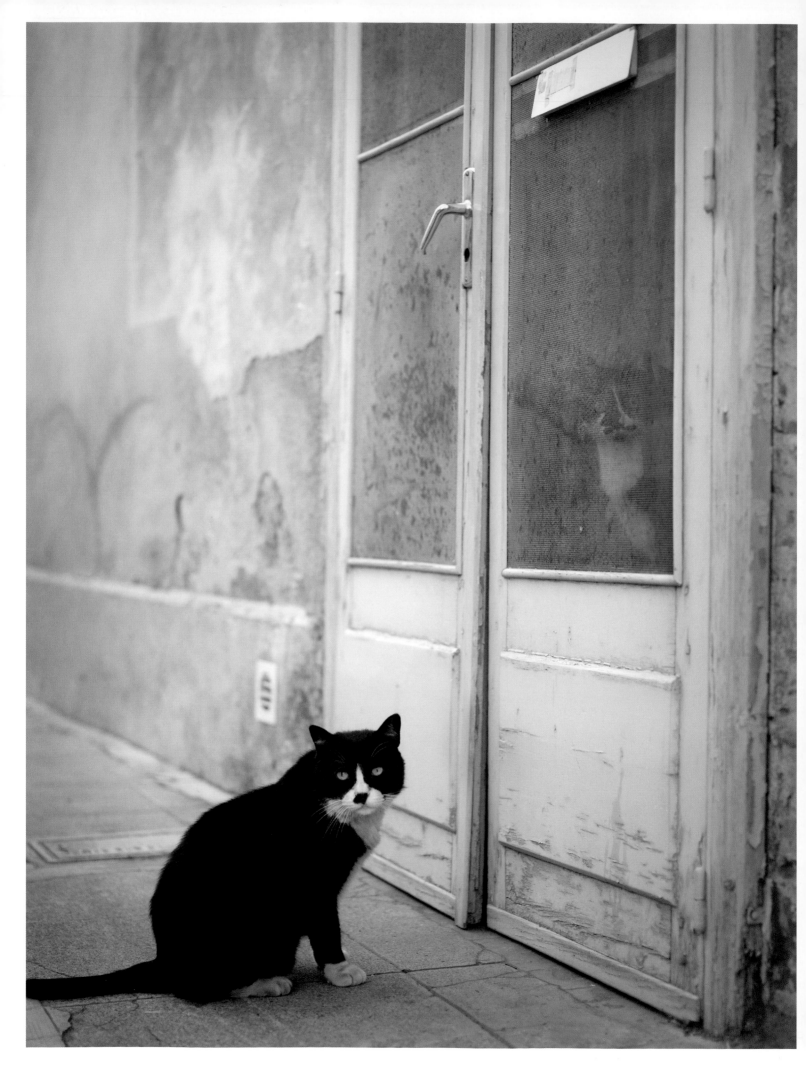

Cats of Pézenas

I'd almost given up hope of finding cats to photograph in the popular tourist village of Pézenas, when I saw a cat waiting patiently at a door with a mesh screen. At first I didn't notice the second cat on the other side of the mesh. Cats, obviously, like their French owners, love to sit and gossip on the street! I asked the woman inside if it was hers: "Non, il attend que je laisse sortir mon chat," she said. (No, he's waiting for me to let my cat out.) After I'd captured this image I walked farther down the road and looked back. Sure enough, the two cats were happily hanging out together.

Est-il dieu?

Is he God?

Charles Baudelaire

(1821–1867, French poet and critic)

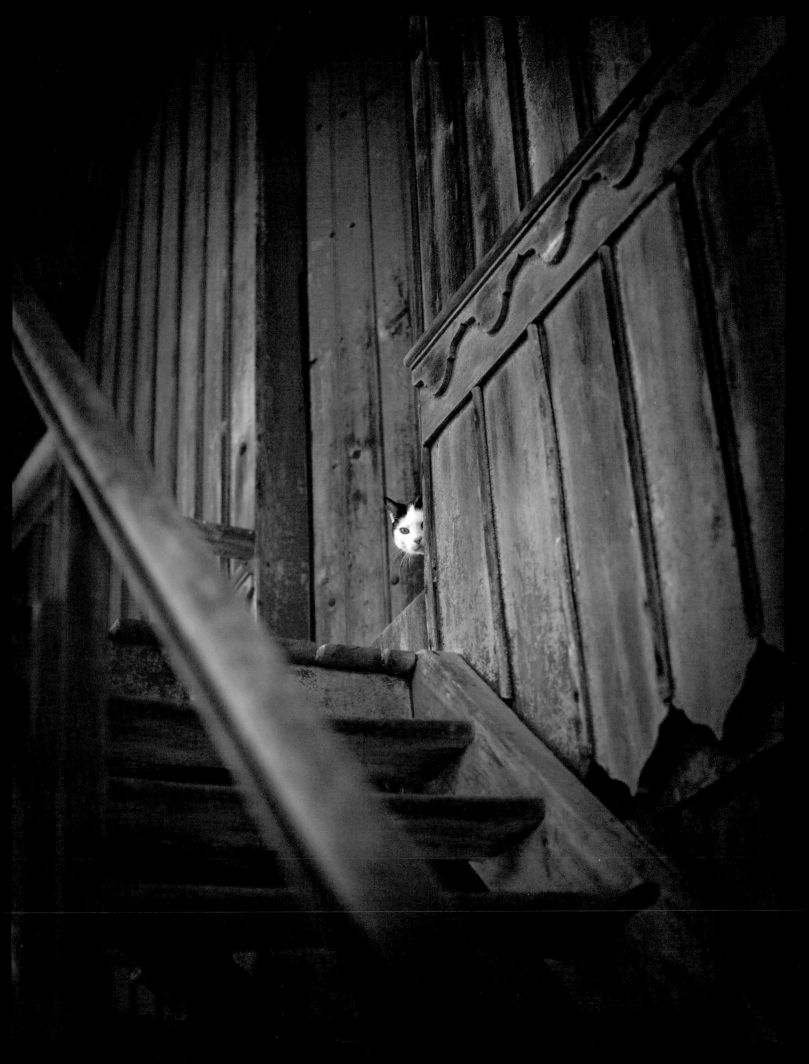

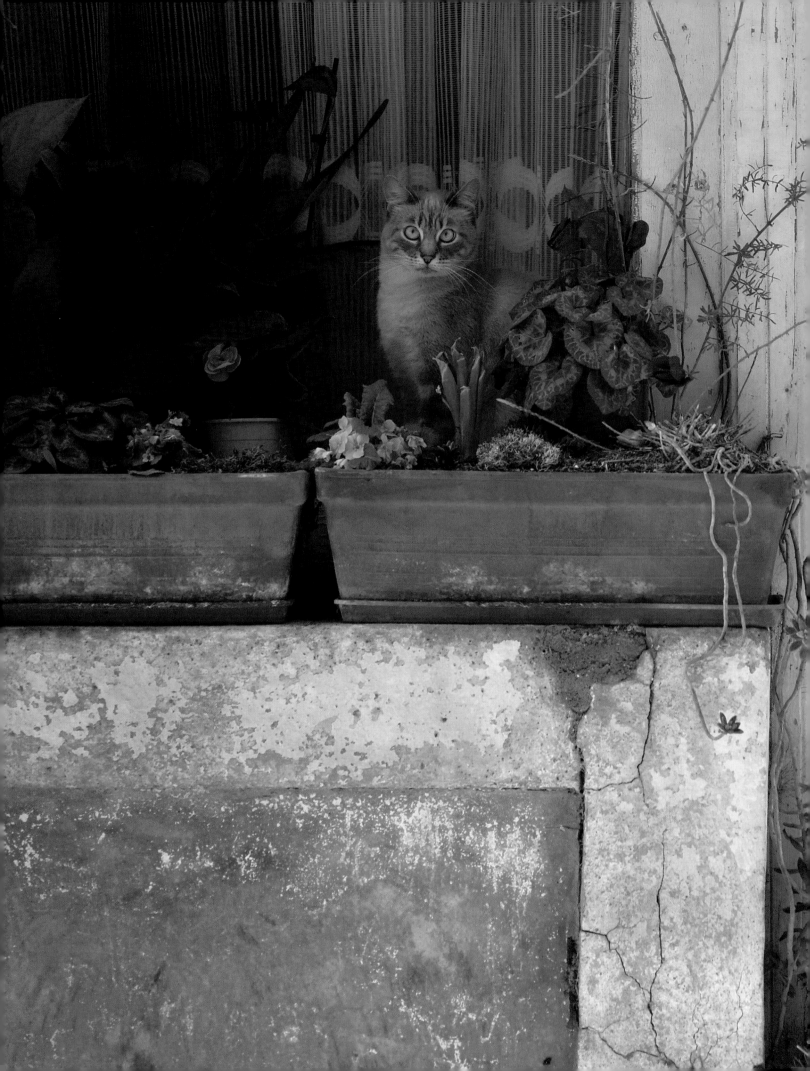

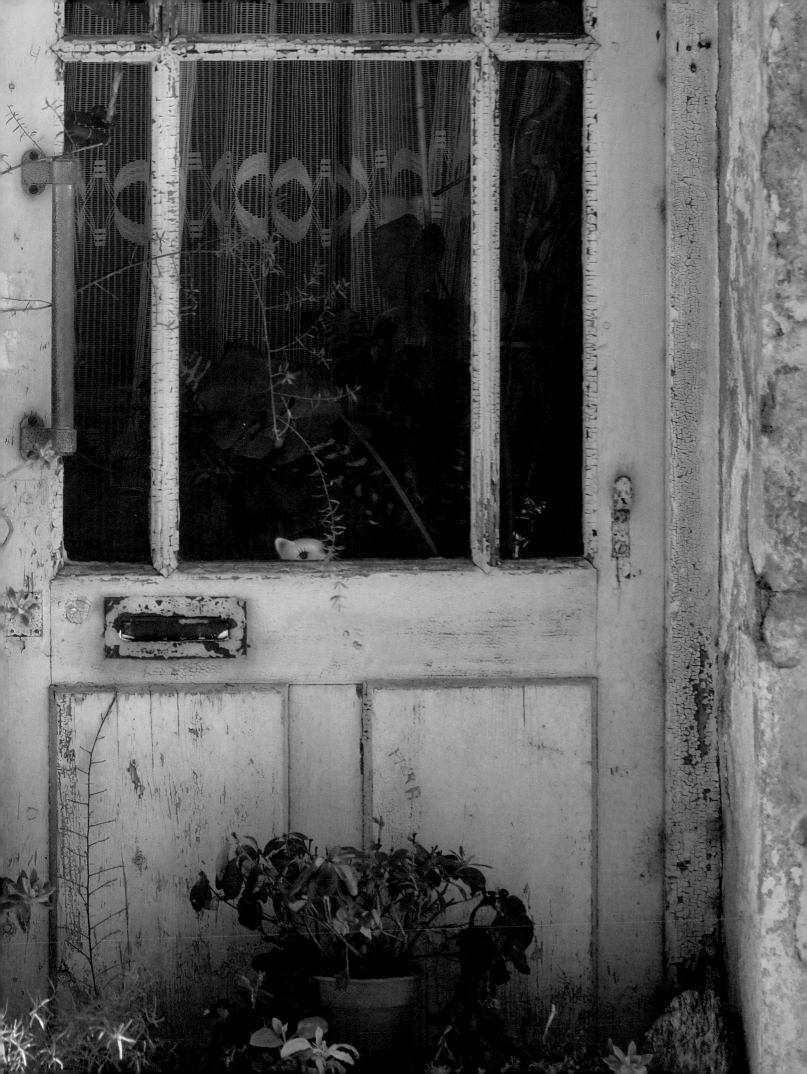

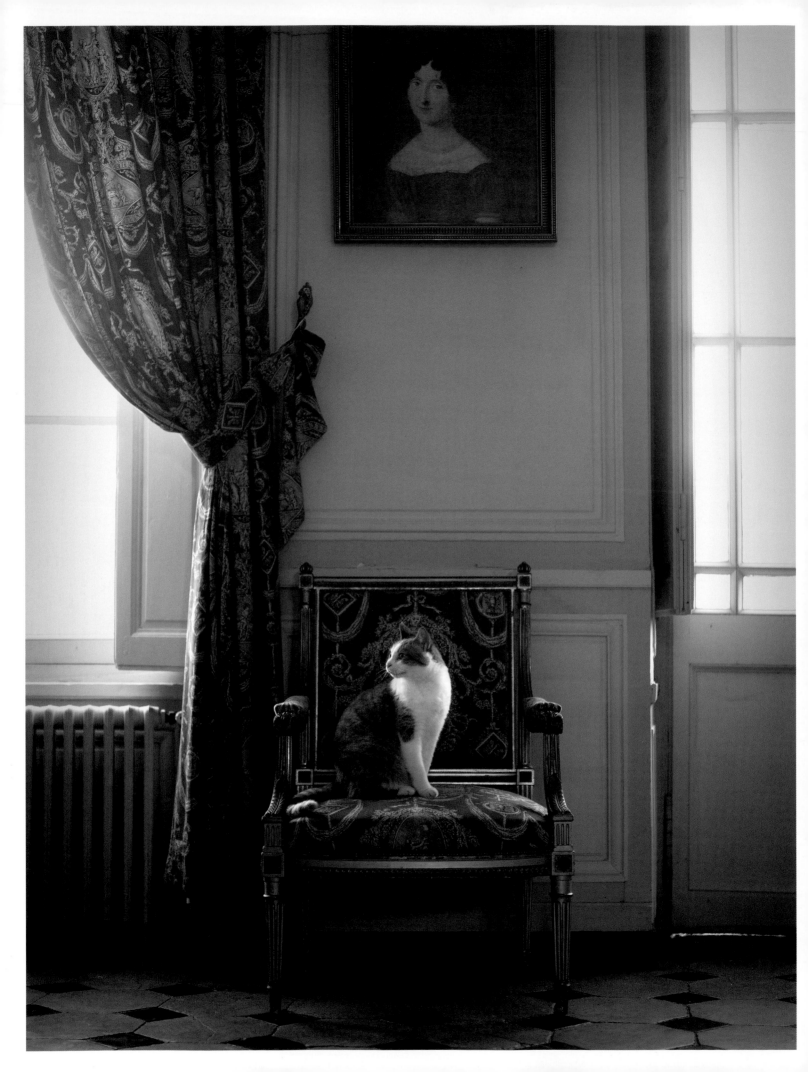

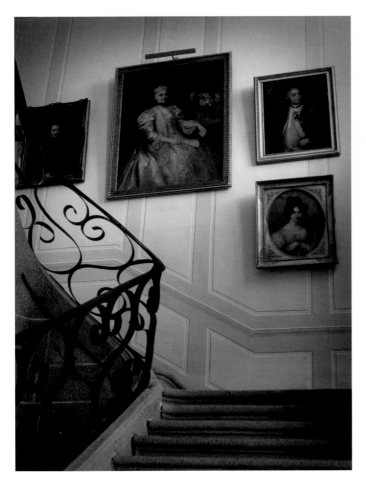

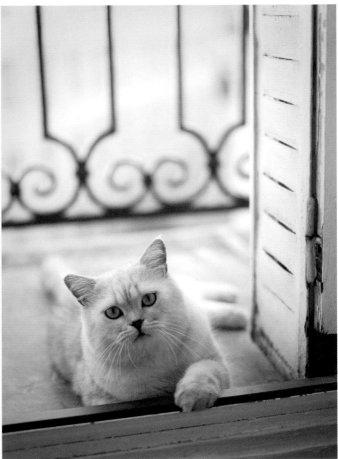

Louis XV (1710–1774, King of France)

Louis XV had a favorite white Persian Angora. It came to his bedroom every morning and was allowed to play on the table during Councils of State.

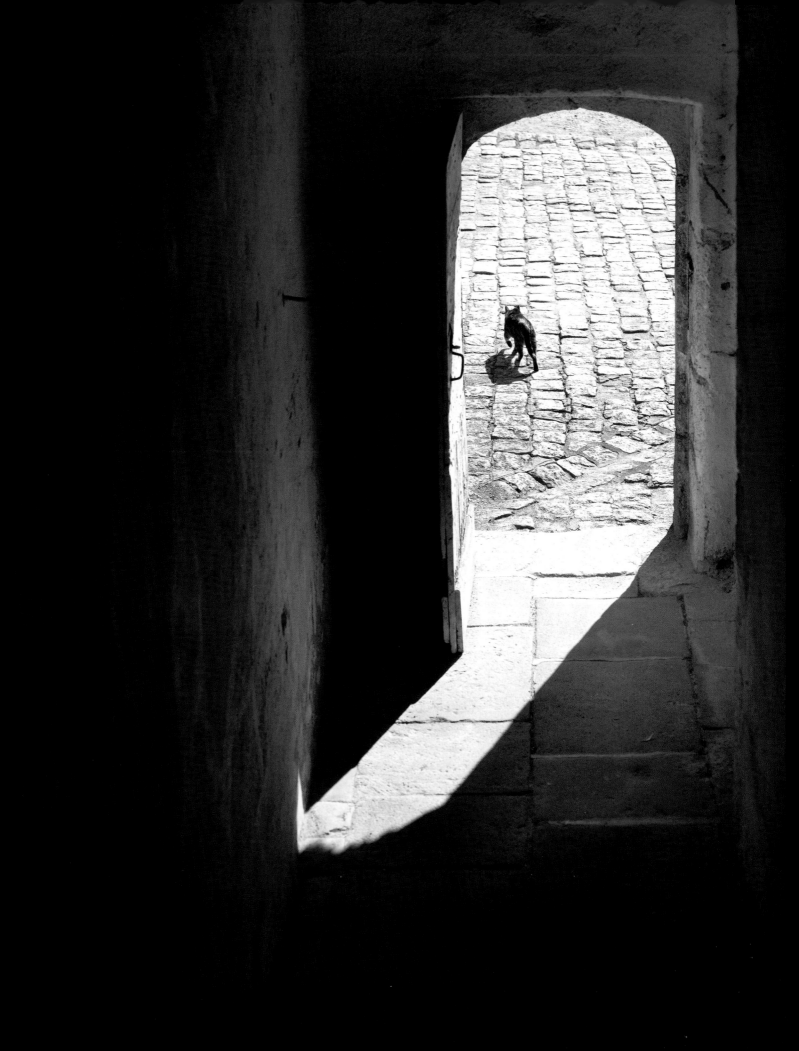

The Cat

In my house I want:
A reasonable woman,
A cat passing among the books,
And friends in every season
Whom I cannot live without.

(Original French version)

Le Chat

Je souhaite dans ma maison:
Une femme ayant sa raison,
Un chat passant parmi les livres,
Des amis en toute saison
Sans lesquels je ne peux pas vivre.

————————————

Guillaume Apollinaire
(1880–1918, French-Italian-Polish poet)
From *Le Bestiaire, ou Cortège d'Orphée*, 1911

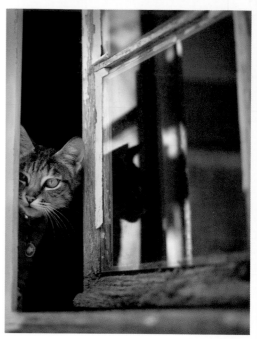

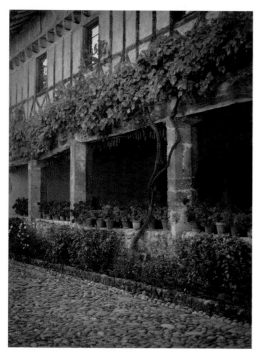

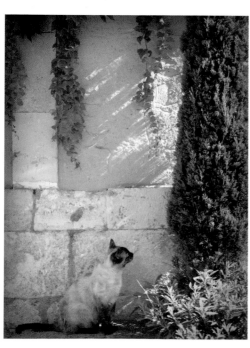

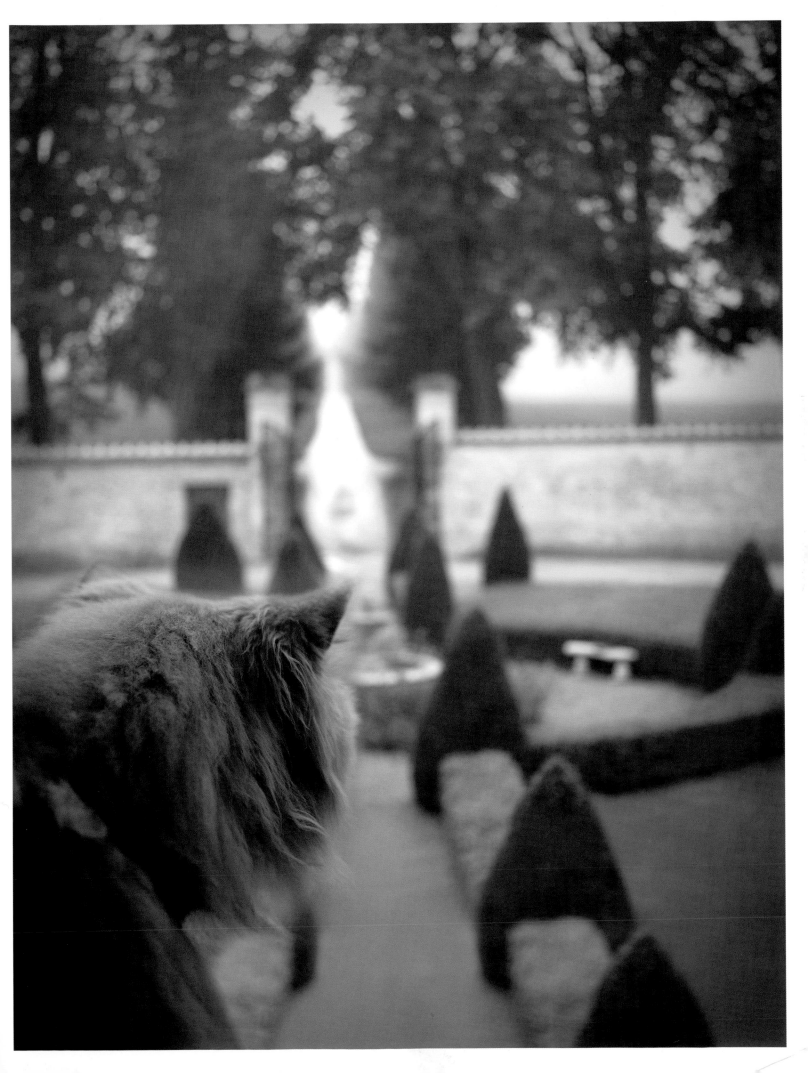

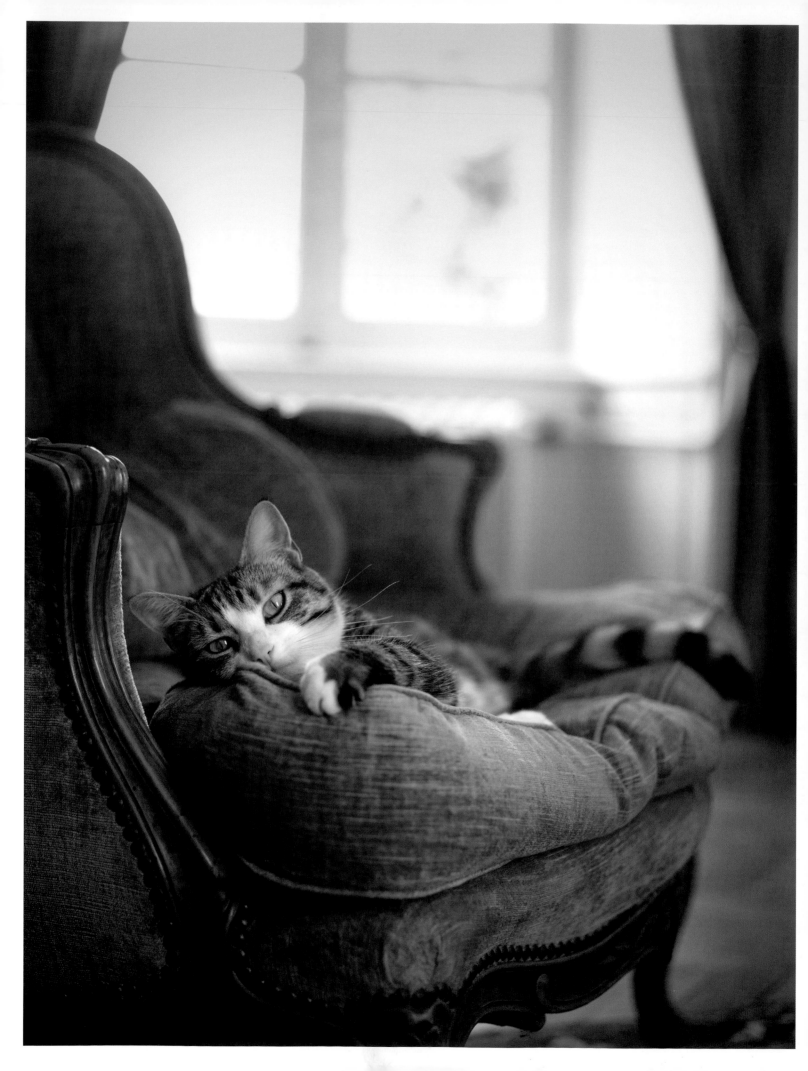

Charles Baudelaire (1821–1867, French poet and critic)

Baudelaire, a dandy with more than a cultivated interest in vanity and the sublime, was said to enjoy the company of cats more than people. He studied them with fascination on the street, stopping to stroke them and gaze into their faces. When visiting friends he caused great offense by greeting the household cat first, holding it up, kissing it fondly, and not paying the least attention to his hosts. Baudelaire's obsession with the feline is certainly palpable in this extract from his poem, *Le Chat*:

When my fingers leisurely caress you,
Your head and your elastic back,
And when my hand tingles with the pleasure
Of feeling your electric body.

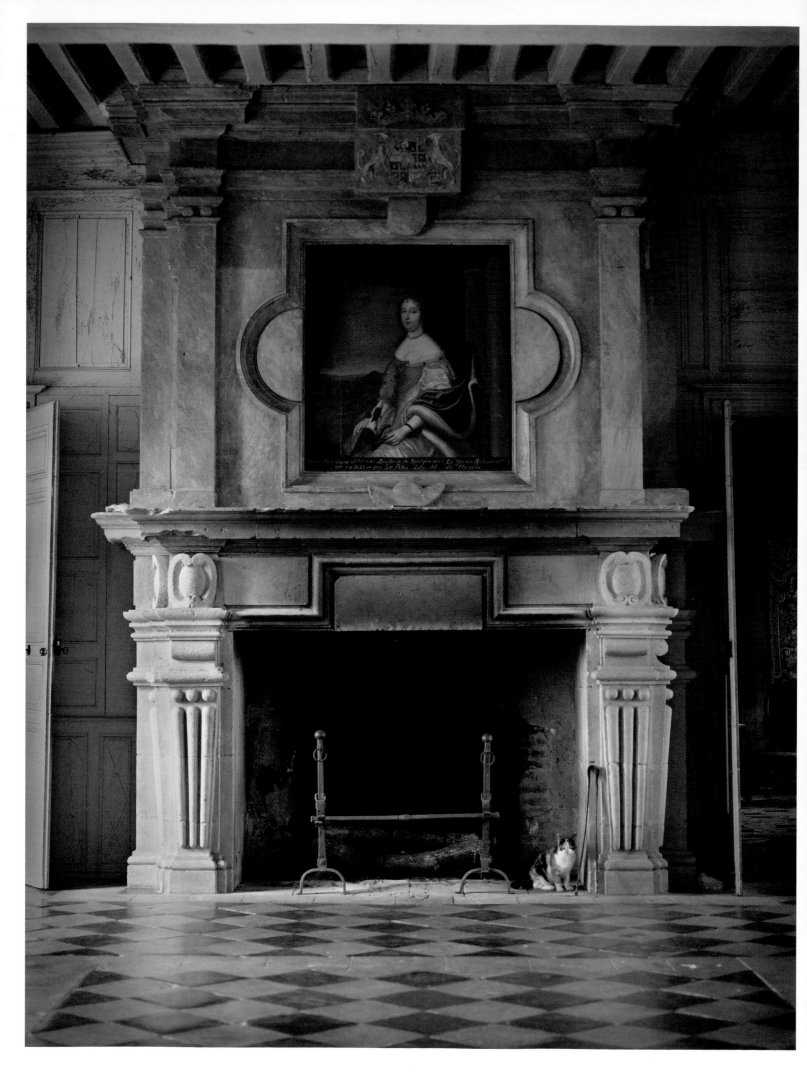

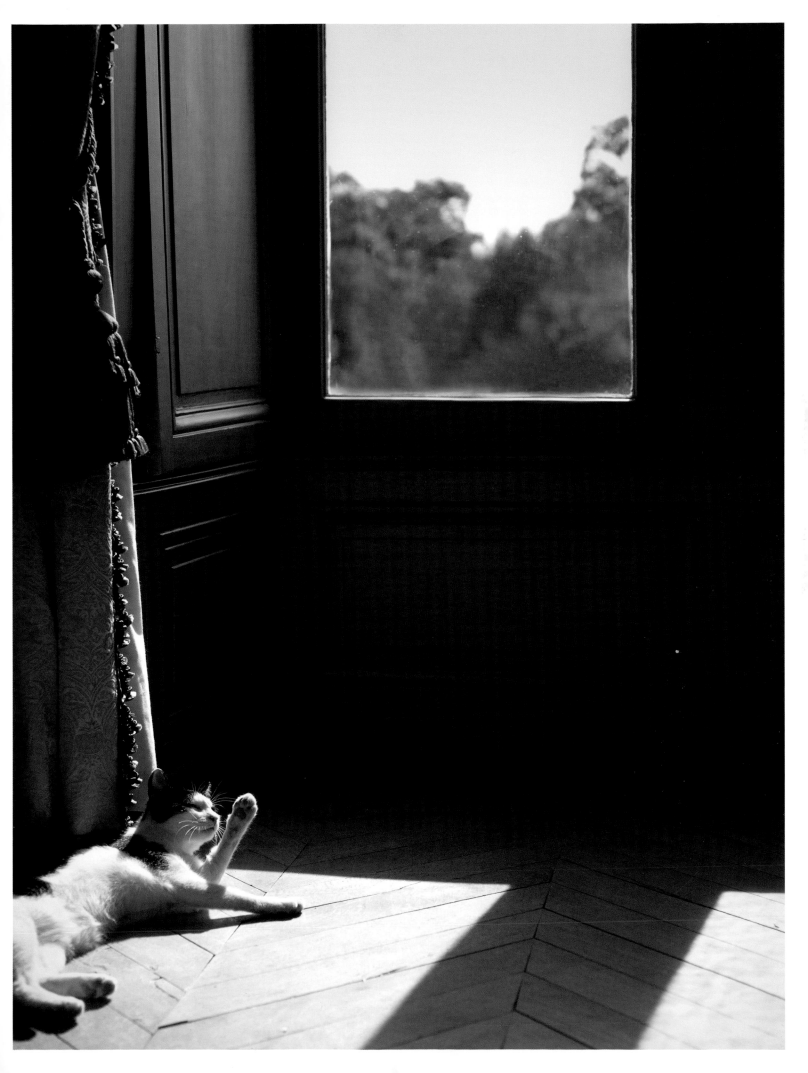

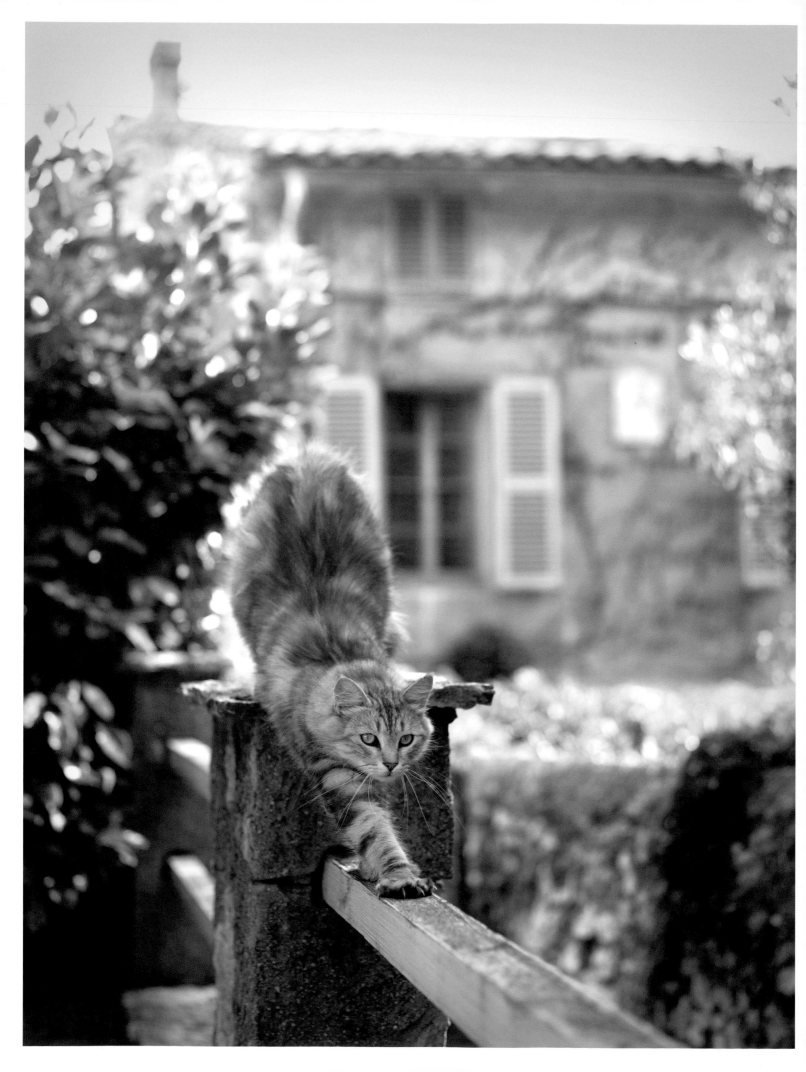

Romeo

On my second visit to Ventabren, I came across Romeo dozing on a fence post. As soon as he saw me he hopped off, stretching, and wandered over, obviously wondering where we were off to this time. He even turned up again later that evening when I returned to see if I'd missed any cats. I wonder if he'll recognize me again when we return later in the year to photograph some of the dogs of Ventabren.

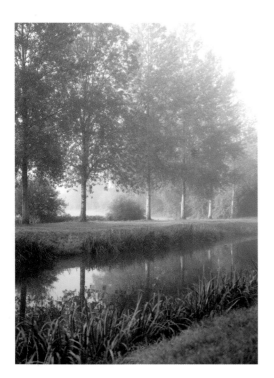 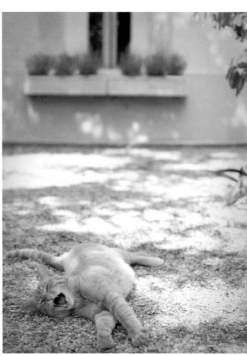

The sheer glory of the French countryside thrills me too. I love the way the mist rises off the Canal du Midi; the sunlight that turns a new-leaf tree into an explosion of lime green; the spindly French forests that cause the light to dapple through the trees; the endless lavender fields of Provence; sunflowers; and, especially, the smell of the sun warming the morning dew, which is so typically French.

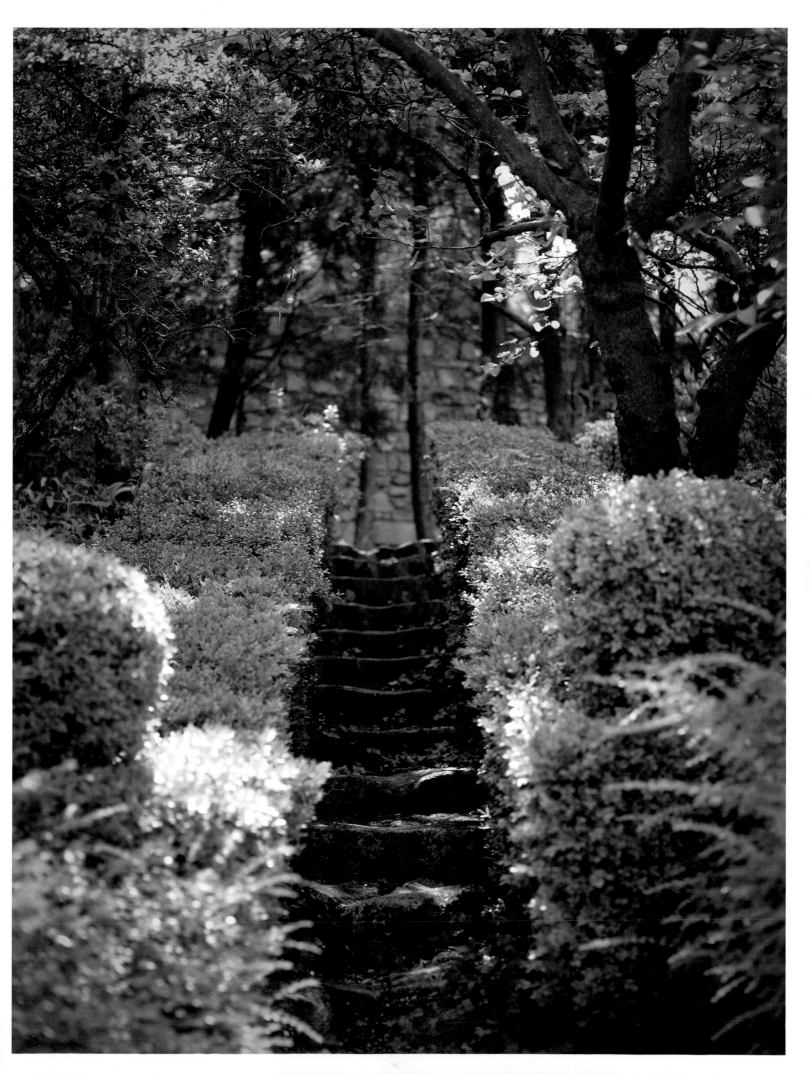

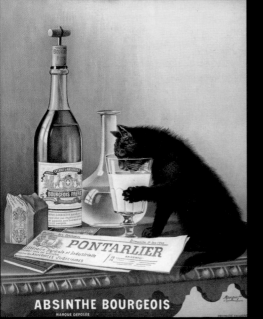

Mourgue Brothers
Advertisement for Absinthe Bourgeois
ca. 1900

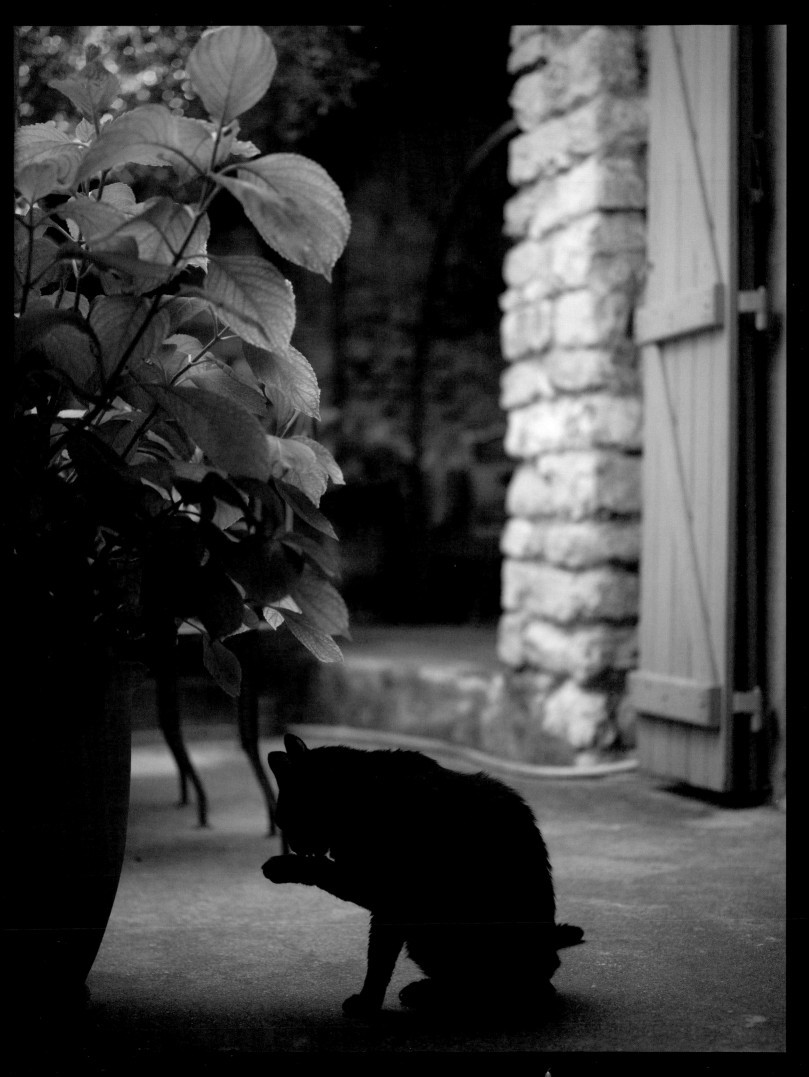

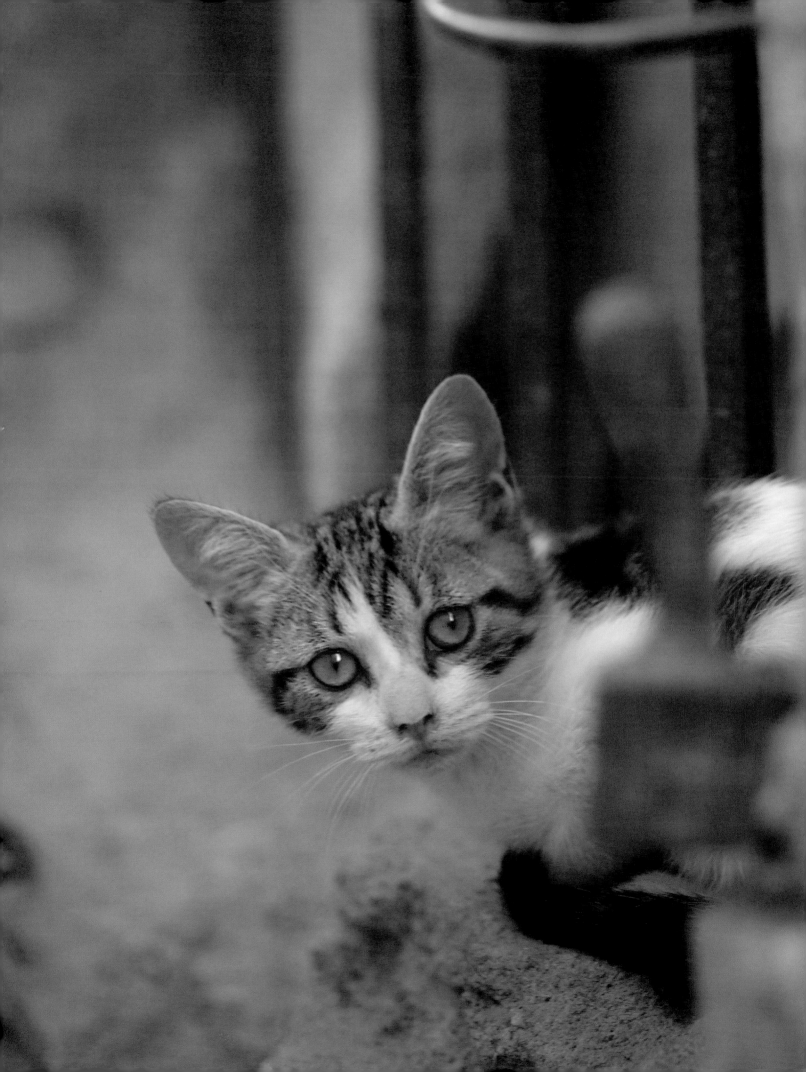

Green eyes inspire grand passions only, and nature, which has refused them to the beauties of this century, has lavished them on the cat species.

———————————

François-Augustin Paradis de Moncrif
(1687–1770, French writer)

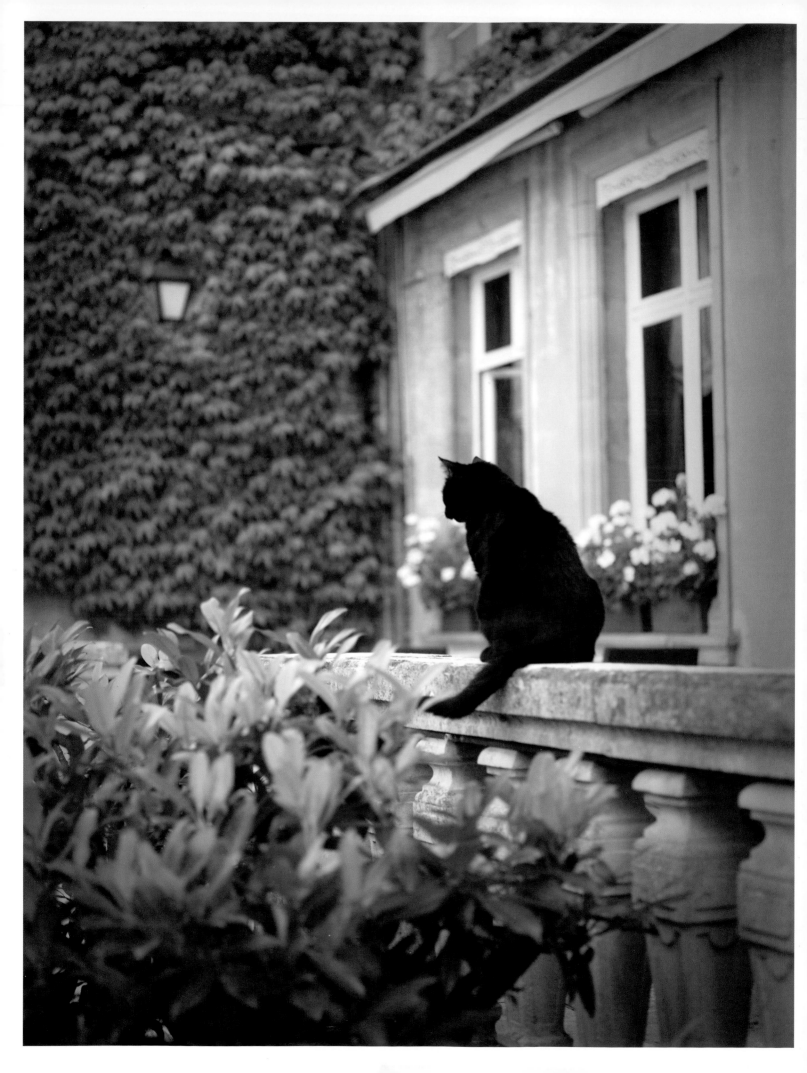

Antoinette Deshoulières (1638–1694, French poet)

Antoinette Deshoulières, an acclaimed poet at the court of Louis XIV, conducted a lively correspondence in the name of her cat, Grisette. The pampered feline exchanged many letters with Cochon, the Duc of Vivonne's dog, and such was the relationship between the cat and dog that Deshoulières wrote a play about their passion.

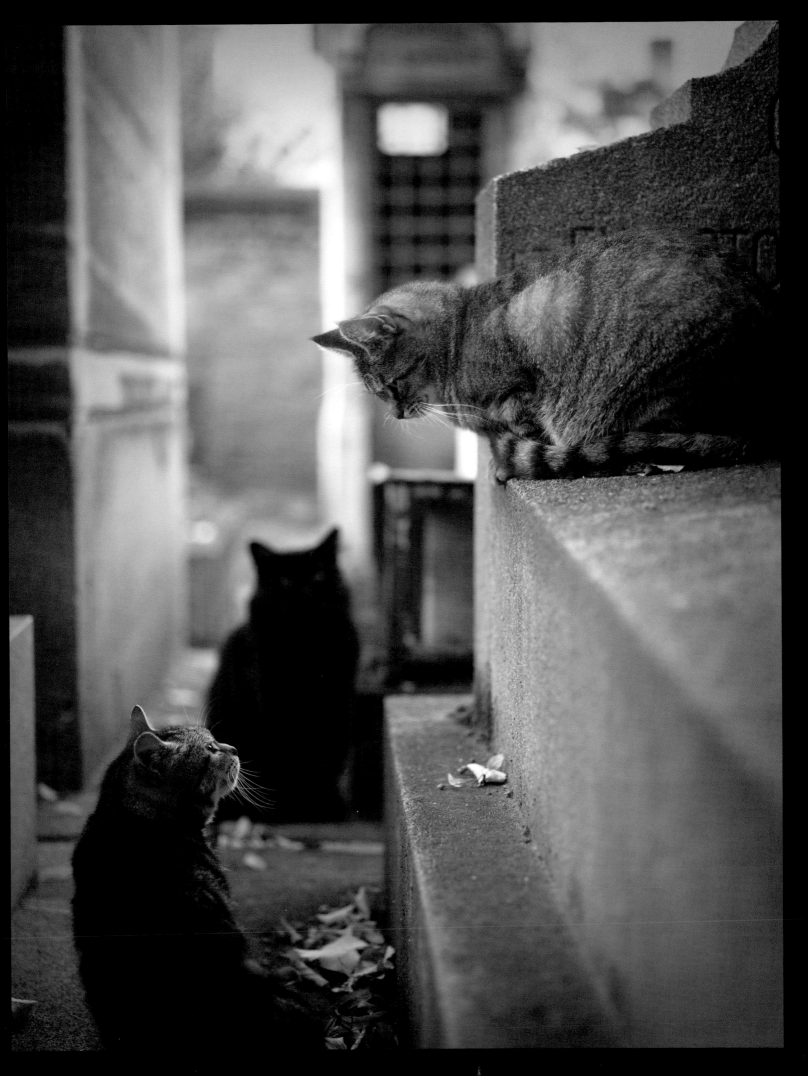

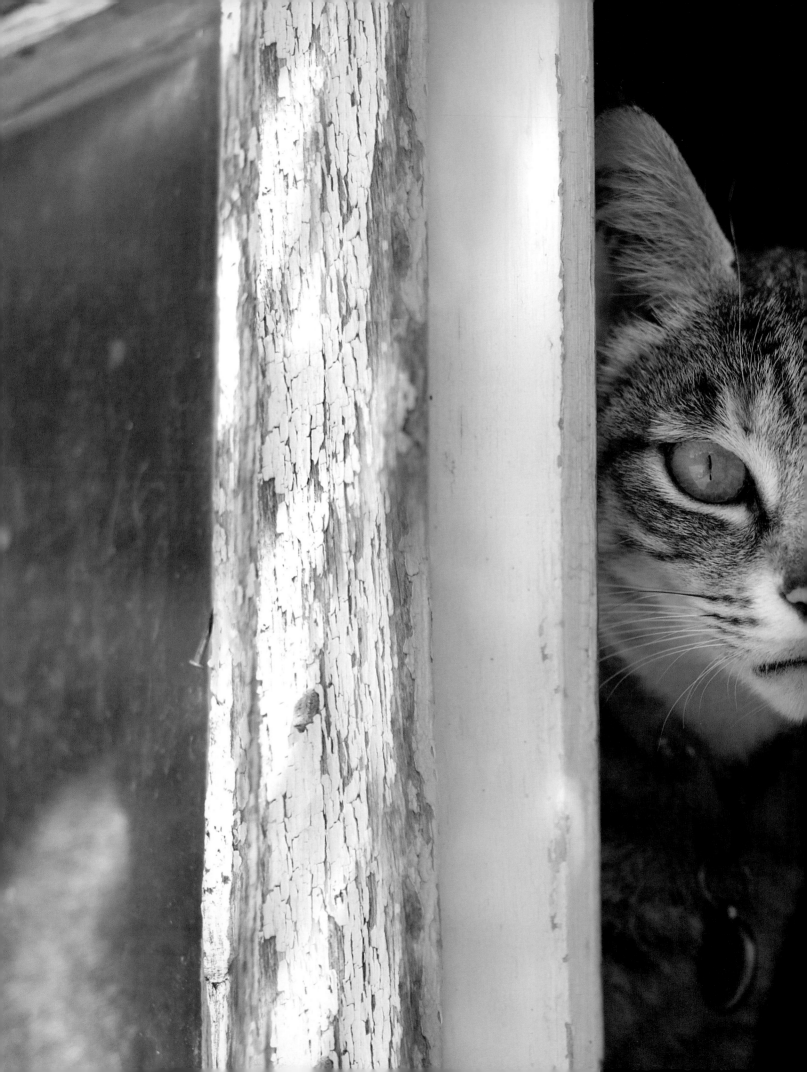

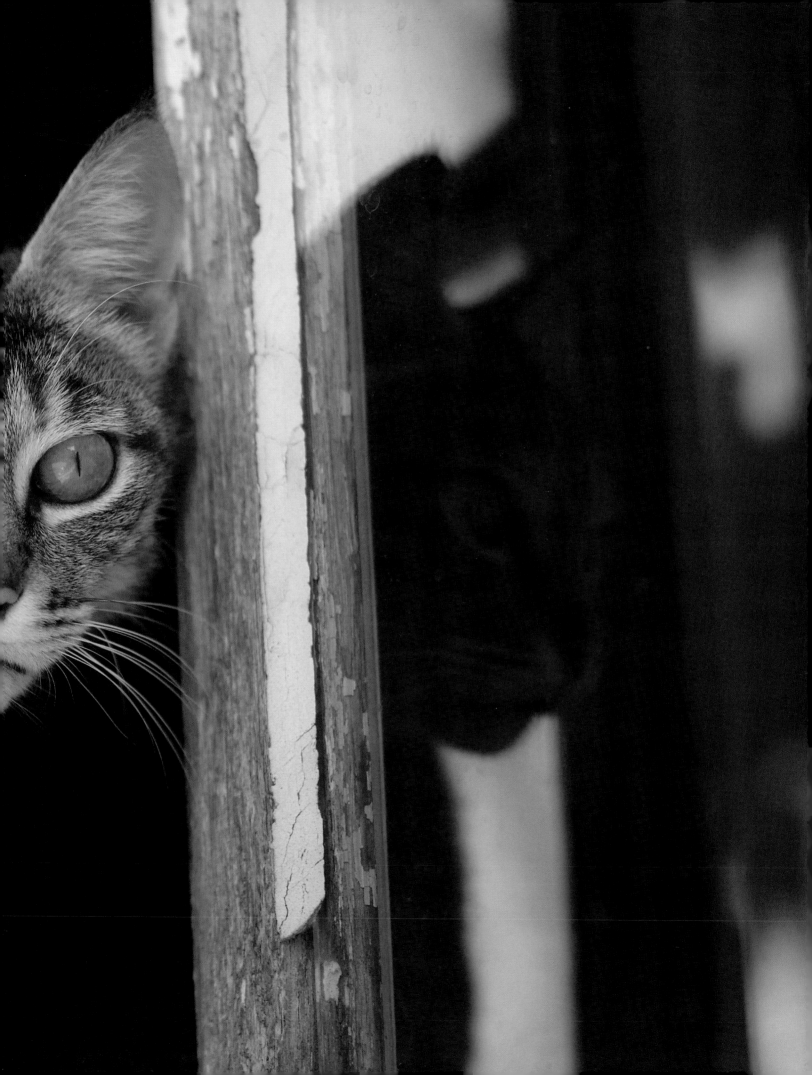

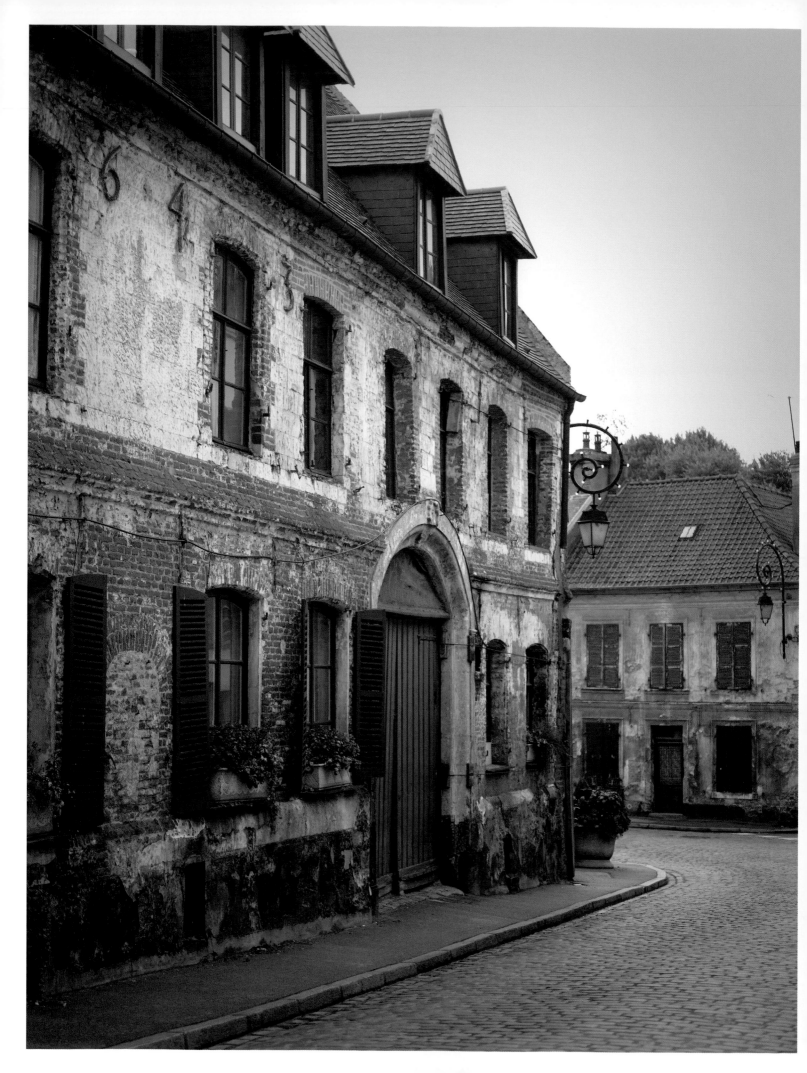

French village cats live much of their lives perched on ramparts above street level. They appear on rooftops and slinking along the windowsills and ledges, looking down imperiously at their canine counterparts roaming the streets.

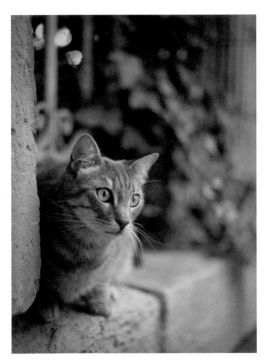

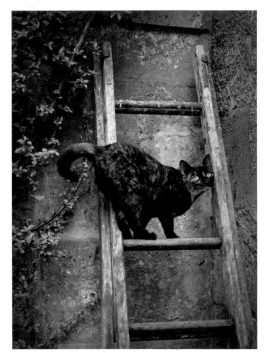

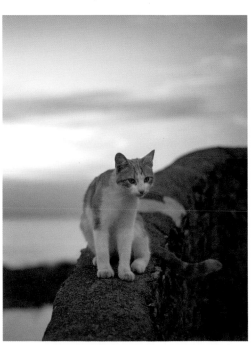

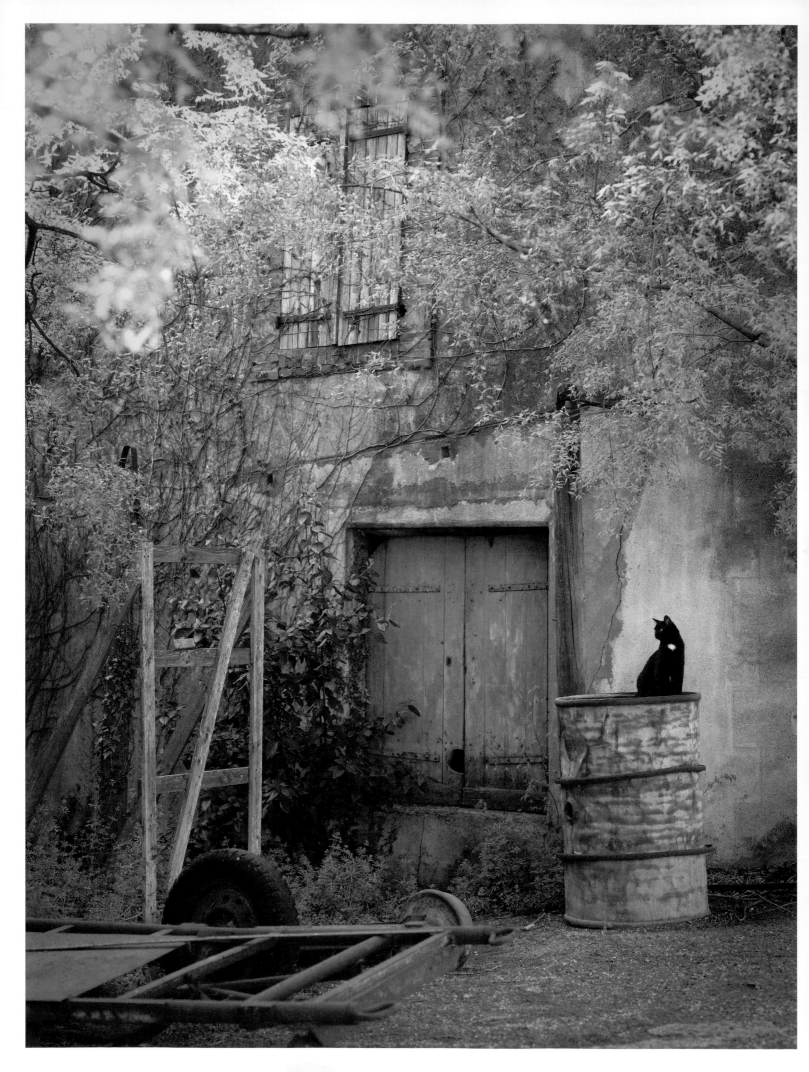

Titus

Every day after walking my dog, Kizzie, I'd pass this building with its crumbling walls, peeling paint, and old drum. After weeks of watching, it was obvious no cat lived nearby, so I asked my neighbor, Karl, if he would bring his young black cat, Titus, around the corner for a photo shoot. Titus was brilliant and sat there attentively, no doubt wondering what on earth was going on, while Karl hid behind the drum in case he did a runner.

I believe cats to be spirits come to earth. A cat, I am sure, could walk on a cloud without coming through.

Jules Verne
(1828–1905, French author)

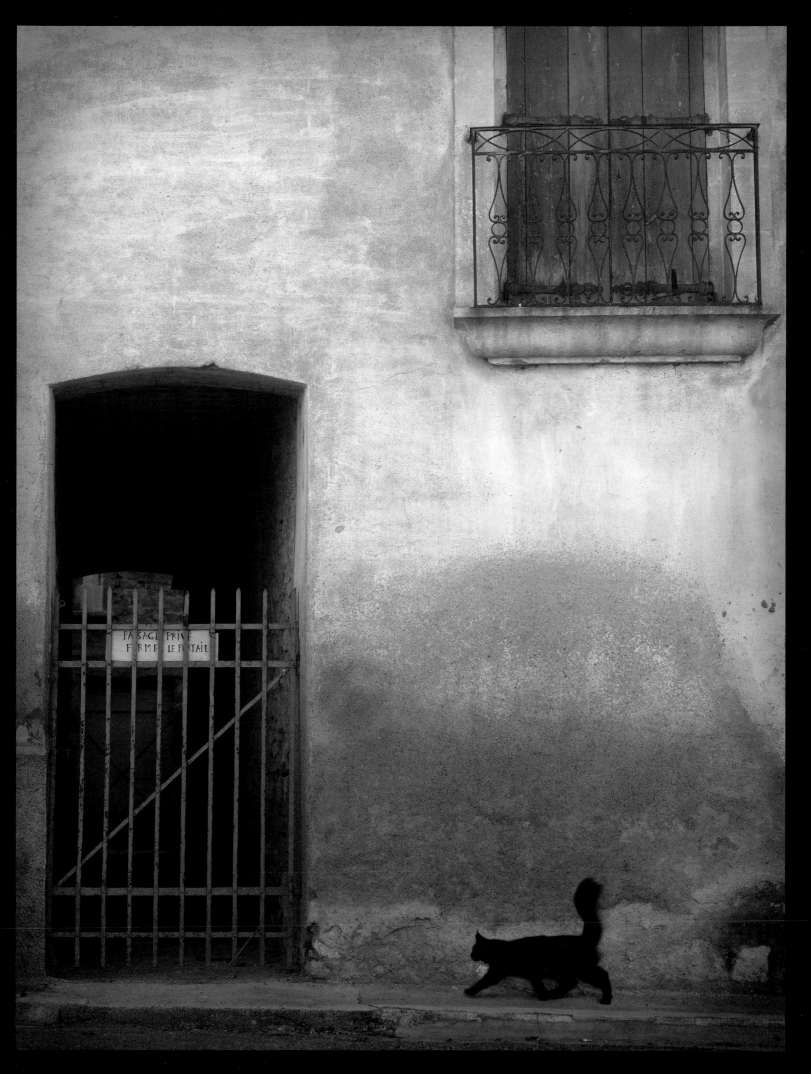

PASSAGE PRIVE
FERMEZ LE PORTAIL

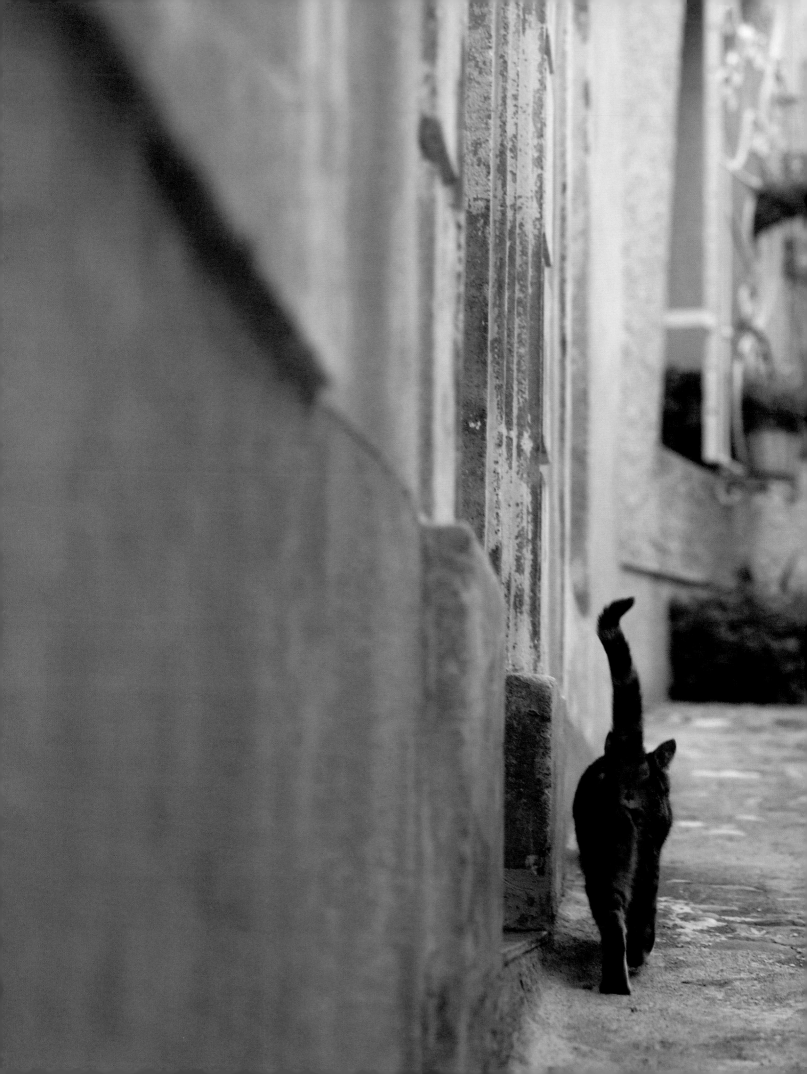

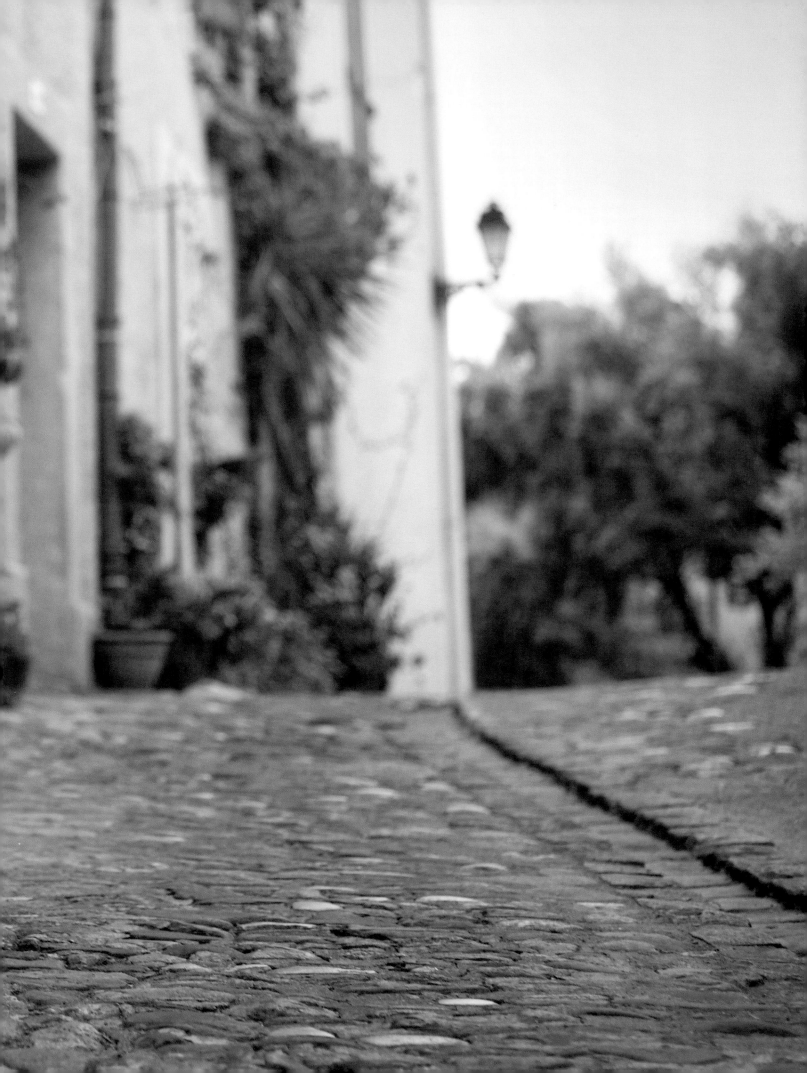

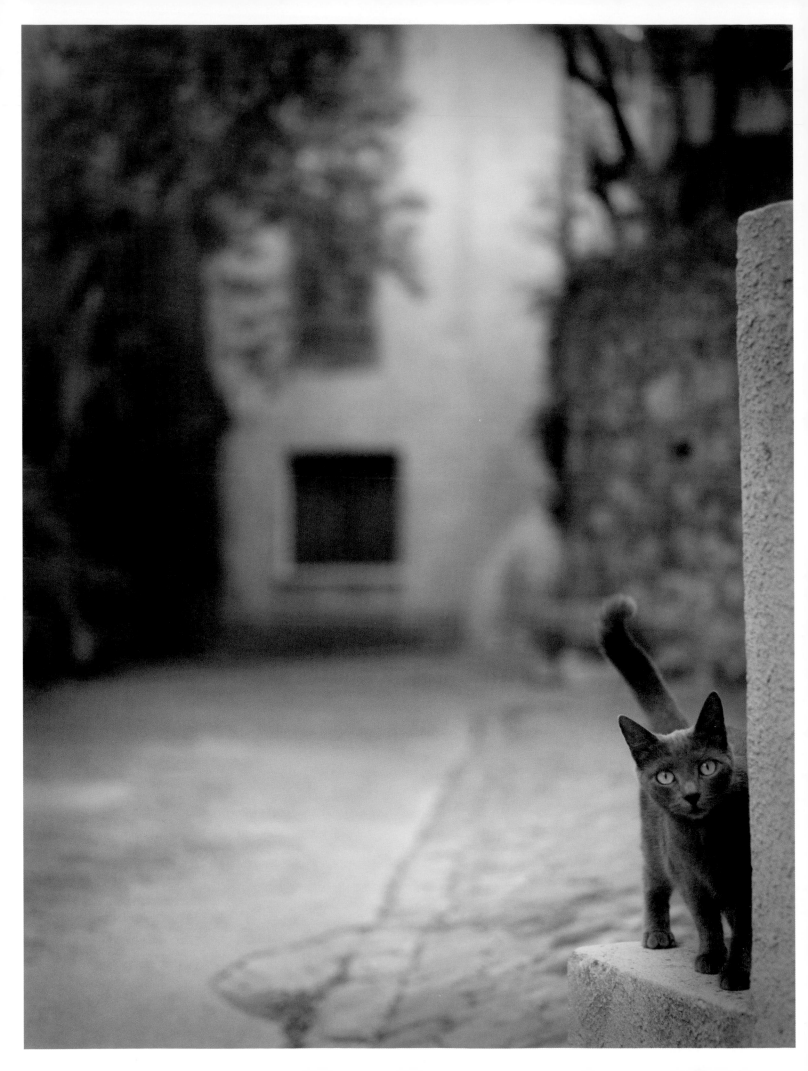

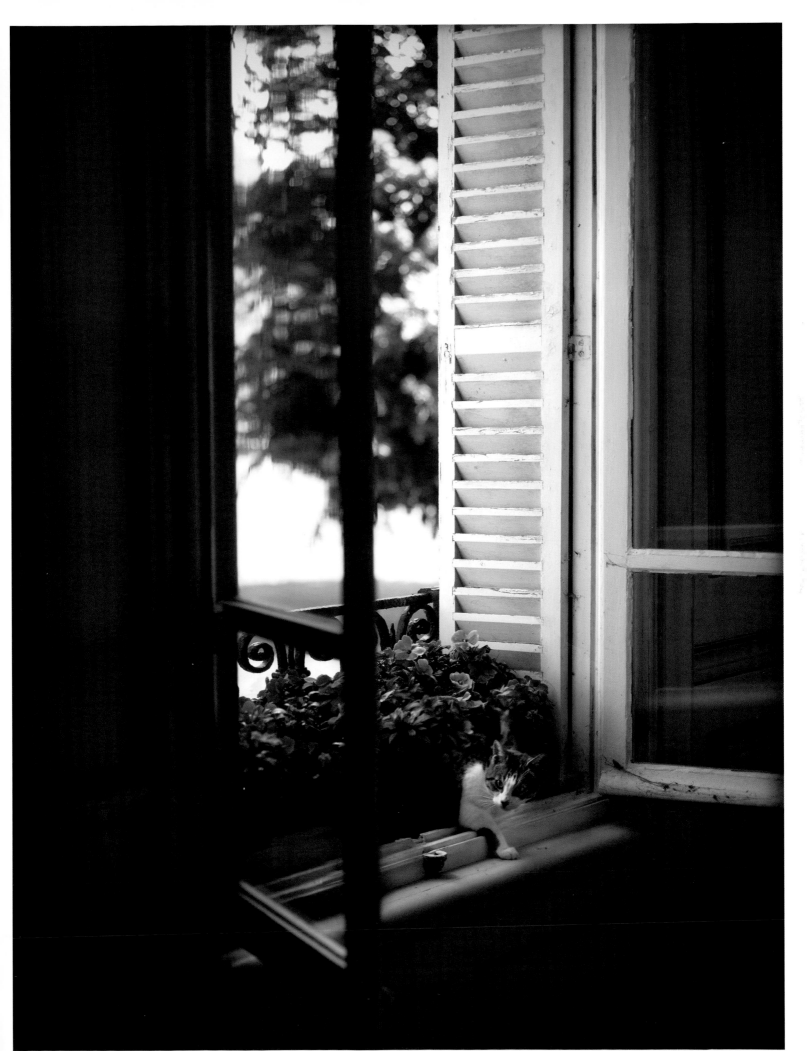

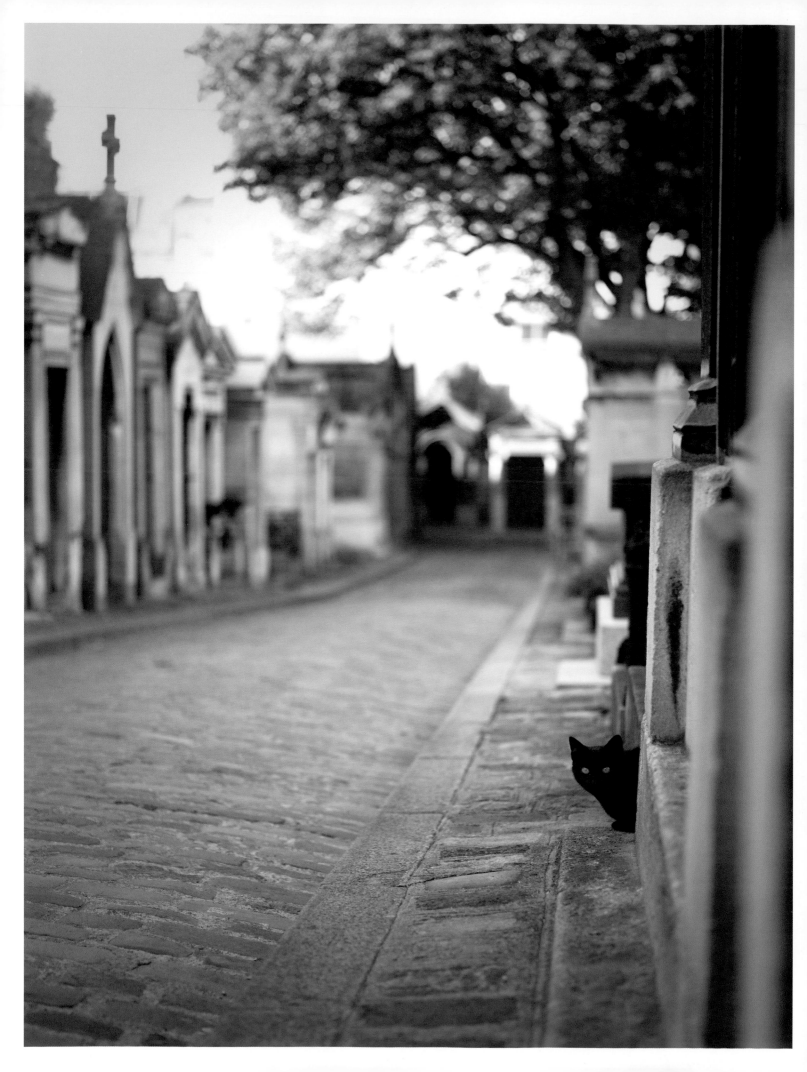

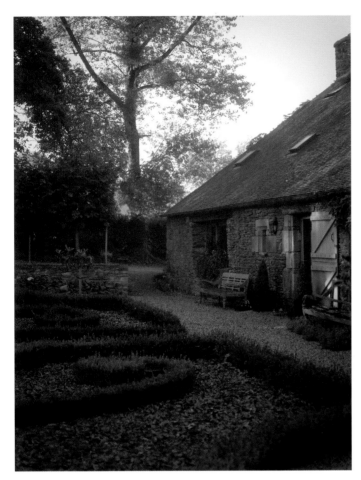
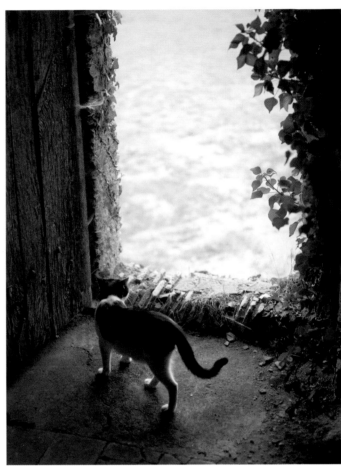

Henri Matisse (1869–1954, French artist)

Matisse's cats, Minouche and Coussi, lived in his Villa le Rêve in Vence. It is said that Minouche had an "M" for Matisse on his forehead. The cats kept the artist company, especially when he was confined to bed due to poor health.

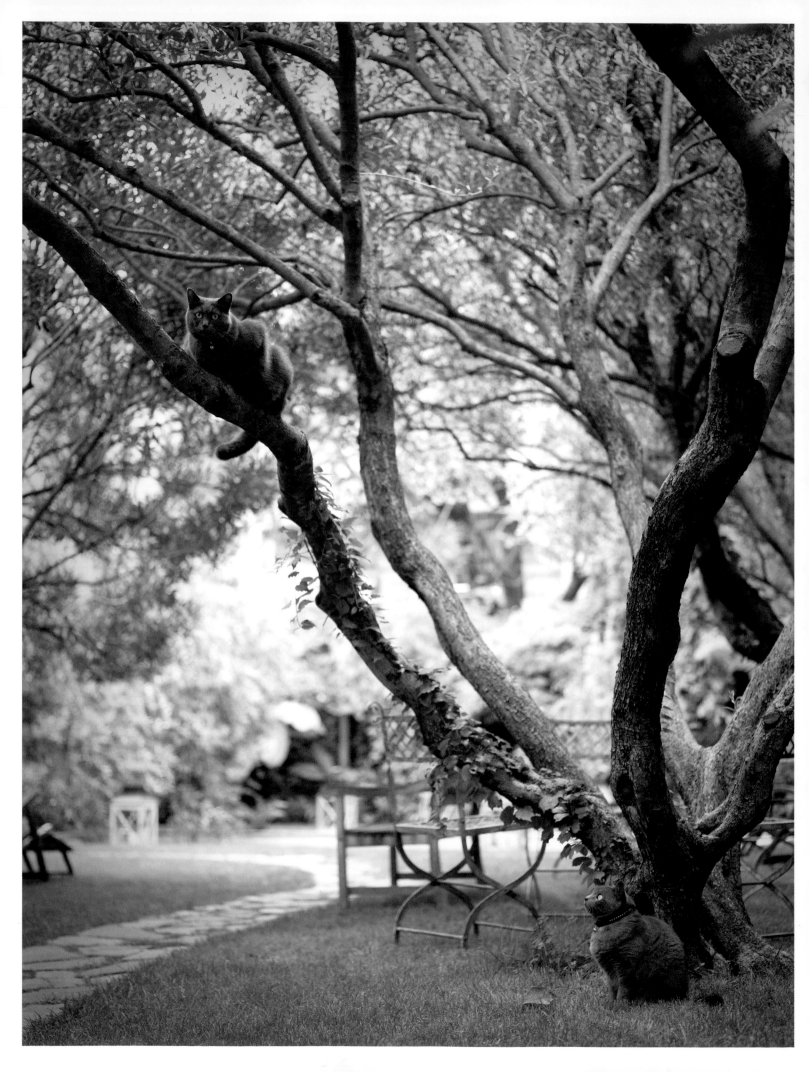

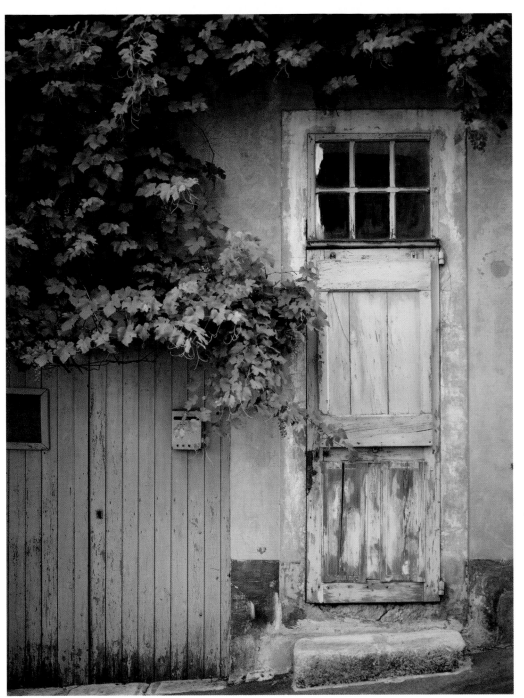

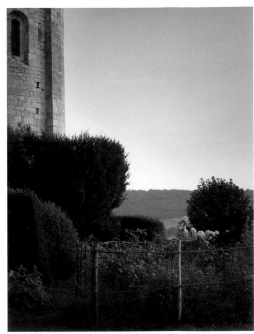

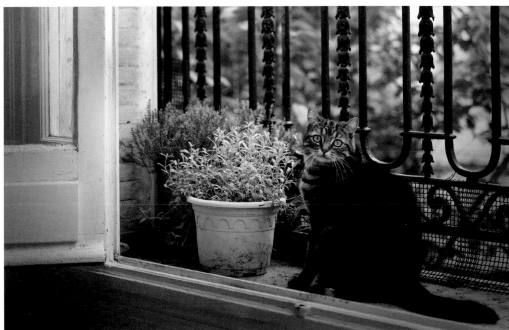

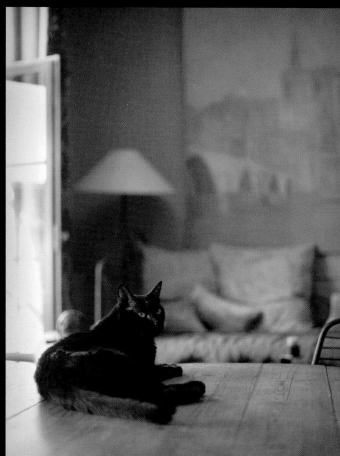

One of Provence's friendliest cats, Bout d'Zan was nestled in a storeroom at the back of Au Ralenti du Lierre's wine cellar when I arrived. Once I'd disturbed him from his morning sleep he was the ideal model, even showing off by leaping onto the bench and drinking out of the kitchen basin. "He's not allowed up there," said Thierry, the friendly proprietor of the adorable B & B in the village of Les Beaumettes near Gordes, with a laugh

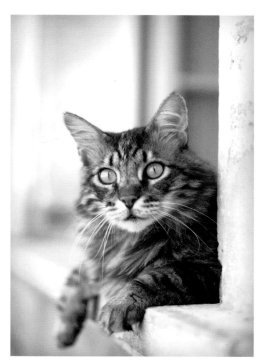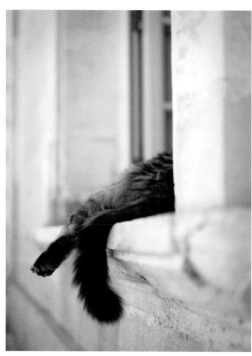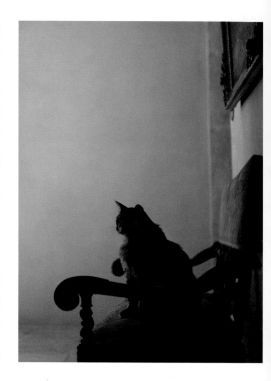

As majestic as the property that surrounds him, Hercules proved to be the perfect performer. It was a treat to be able to photograph him at the grand Château de Beauregard on the outskirts of the village of Jonquières in Provence. Although he had to tread cautiously in the gardens, where he was almost certain to be chased by the château's Jack Russell terrier brothers, Hercules roamed elegantly throughout the interior of the property. He especially liked to adorn windowsills from where he could watch the activities in the garden below.

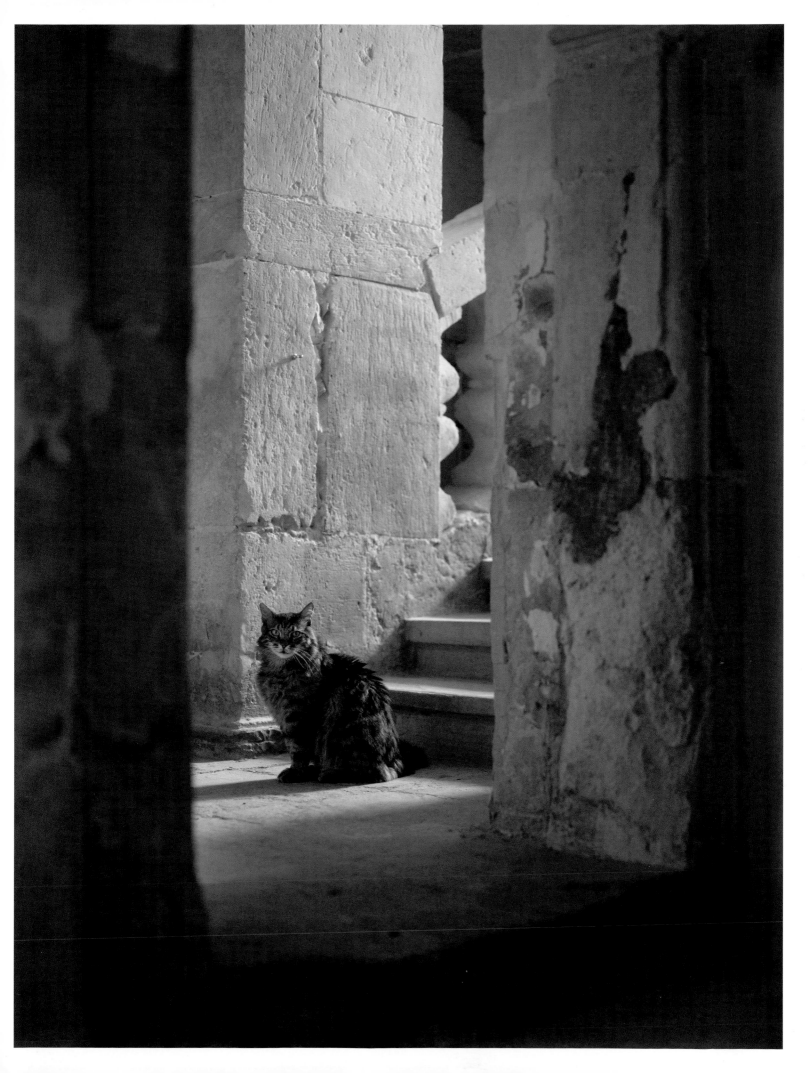

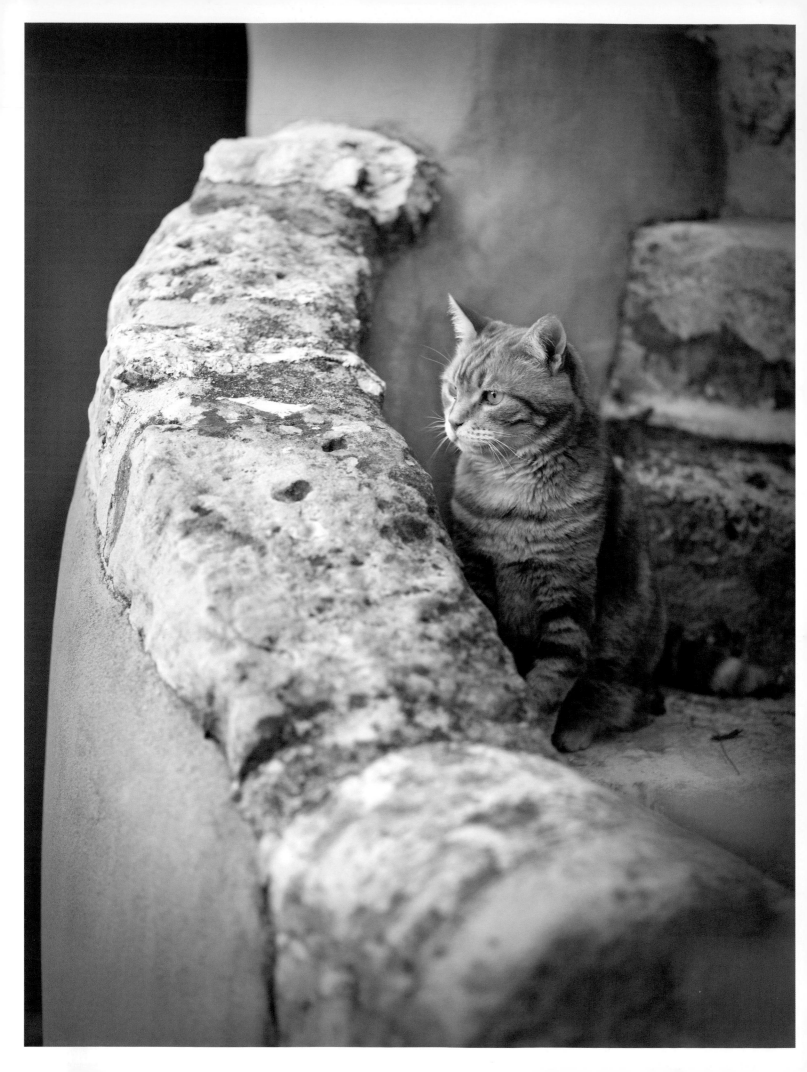

Persian of Ventabren

Persian had the perfect vantage point from which to watch the goings-on in the village square in Ventabren. It was dusk when I discovered him. The locals were out and about walking their dogs or on their way to a popular restaurant around the corner. A couple, intrigued by my activities, stopped to admire Persian as I was photographing him: "Un chat qui ressemble à Garfield," the man said. He was right. The big ginger Persian did indeed resemble Garfield.

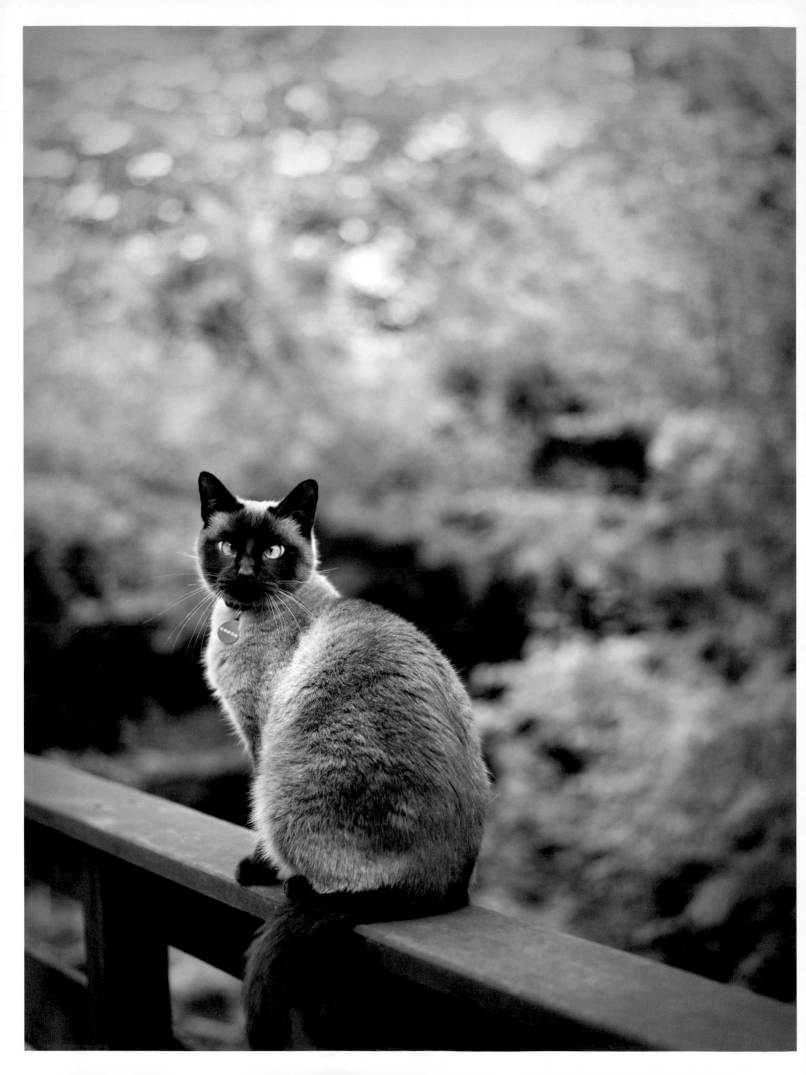

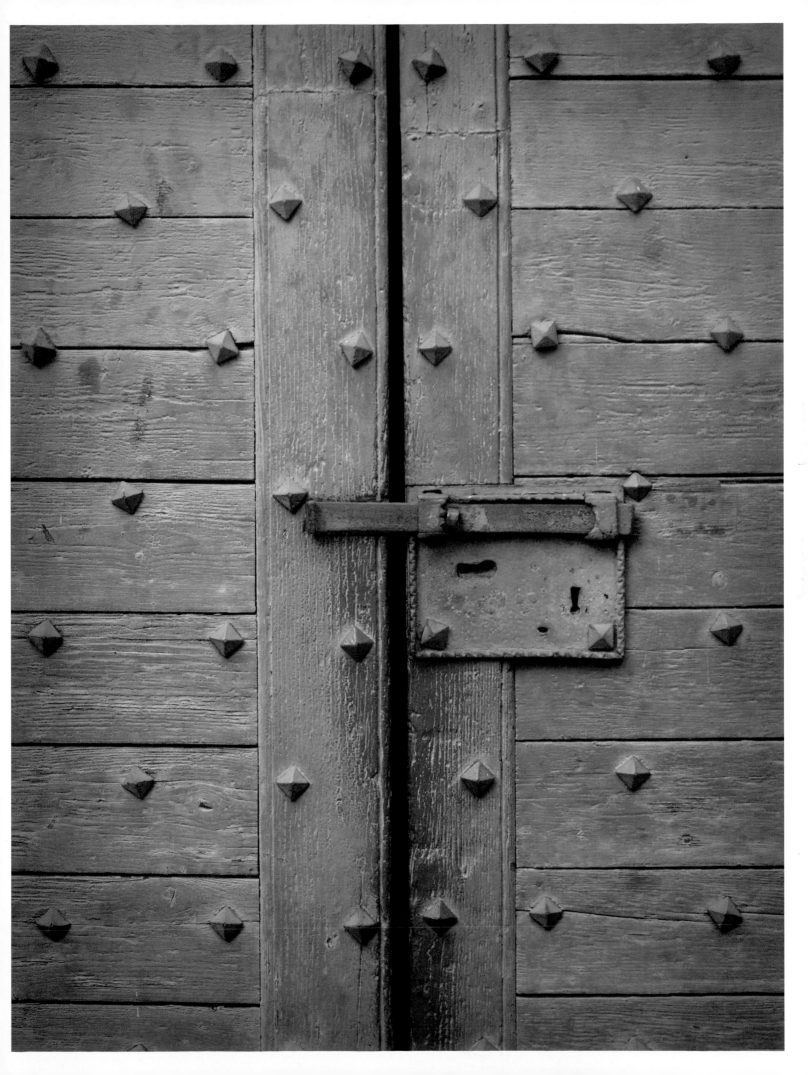

All other animals when they sleep
lie in attitudes of prostration and
fatigue. To the cat alone Nature
vouchsafed the privilege of such sleep
as the poets, without doing too great a
violence to reality, might describe as
meditation and reverie.

————————————————

Marius Vachon
(Historian and art critic, late nineteenth/early twentieth century)

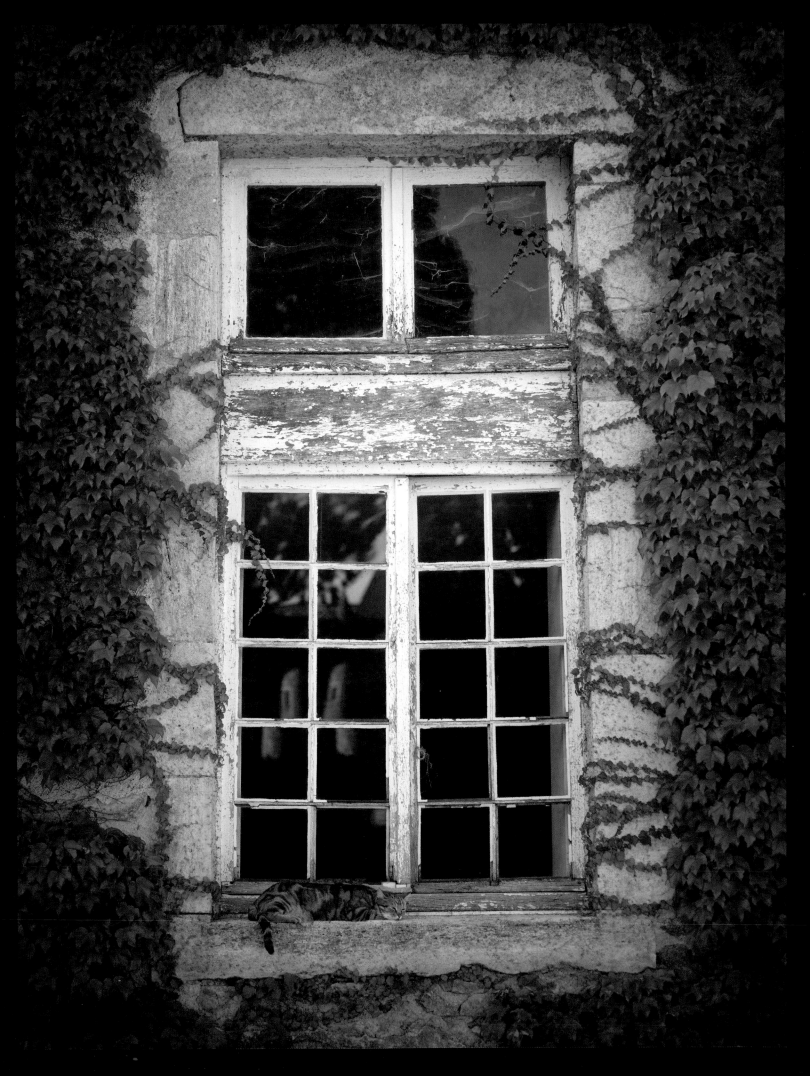

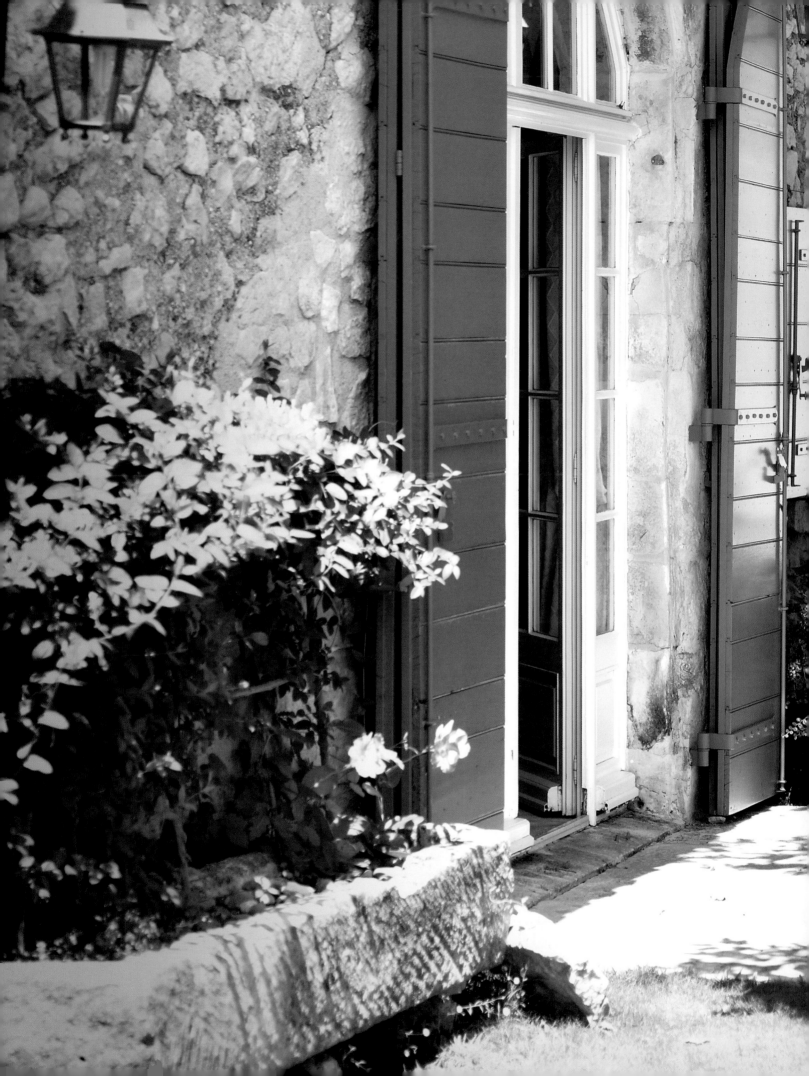

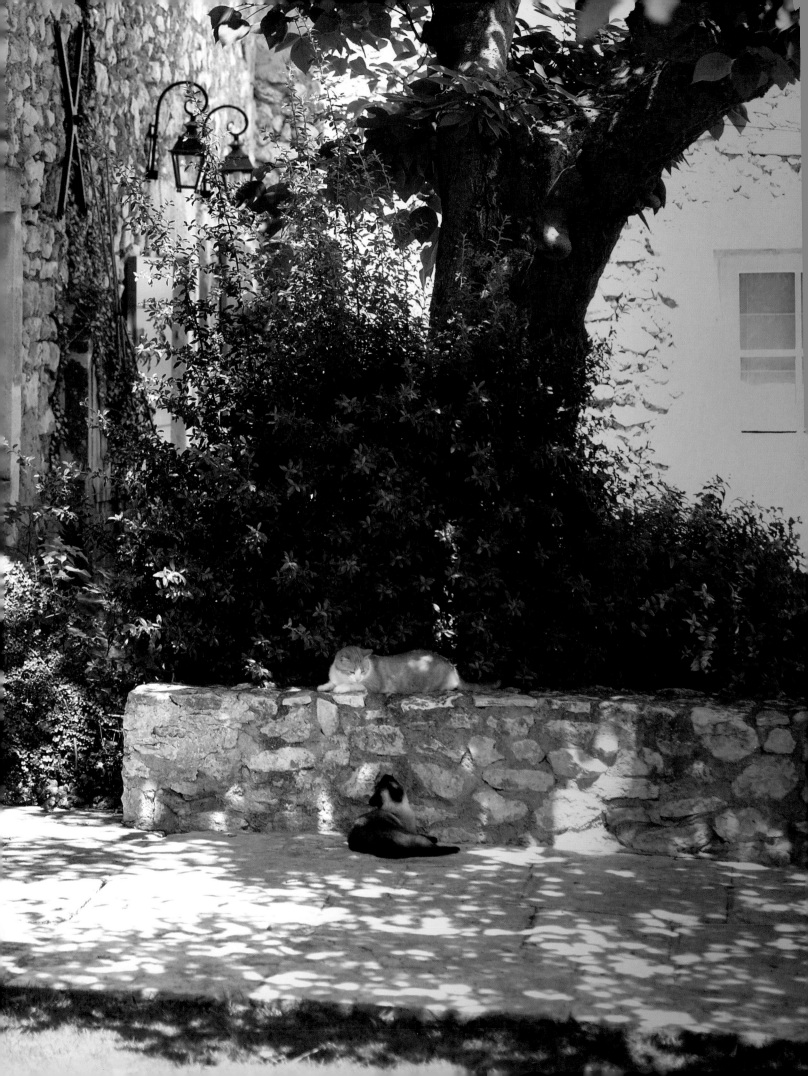

French writers, especially, have made a fetish of the soft and independent little fellow animal. Hardly an author of distinction during the nineteenth century in Paris did not surround himself with harems of long-haired Persian beauties. Prosper Mérimée, Théophile Gautier, Victor Hugo, Charles Baudelaire, Paul de Kock, André Theuriet, Émile Zola, Joris Karl Huysmans, Jules Lemaitre, Pierre Loti, Octave Mirbeau, and Anatole France all loved cats.

Carl Van Vechten
(1880–1964, American writer and photographer)
From *The Tiger in the House*, 1922

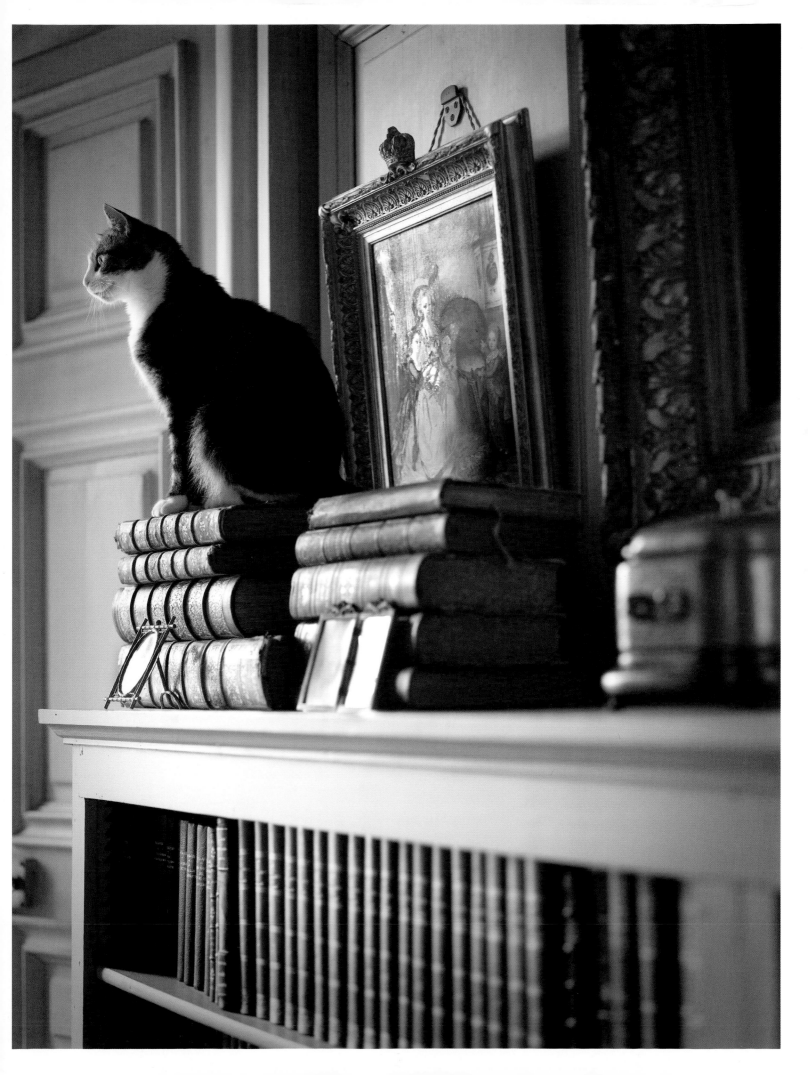

*God made the cat in
order that humankind
might have the pleasure
of caressing the tiger.*

———————————————

Joseph Méry
(1797–1866, French author, poet, and playwright)

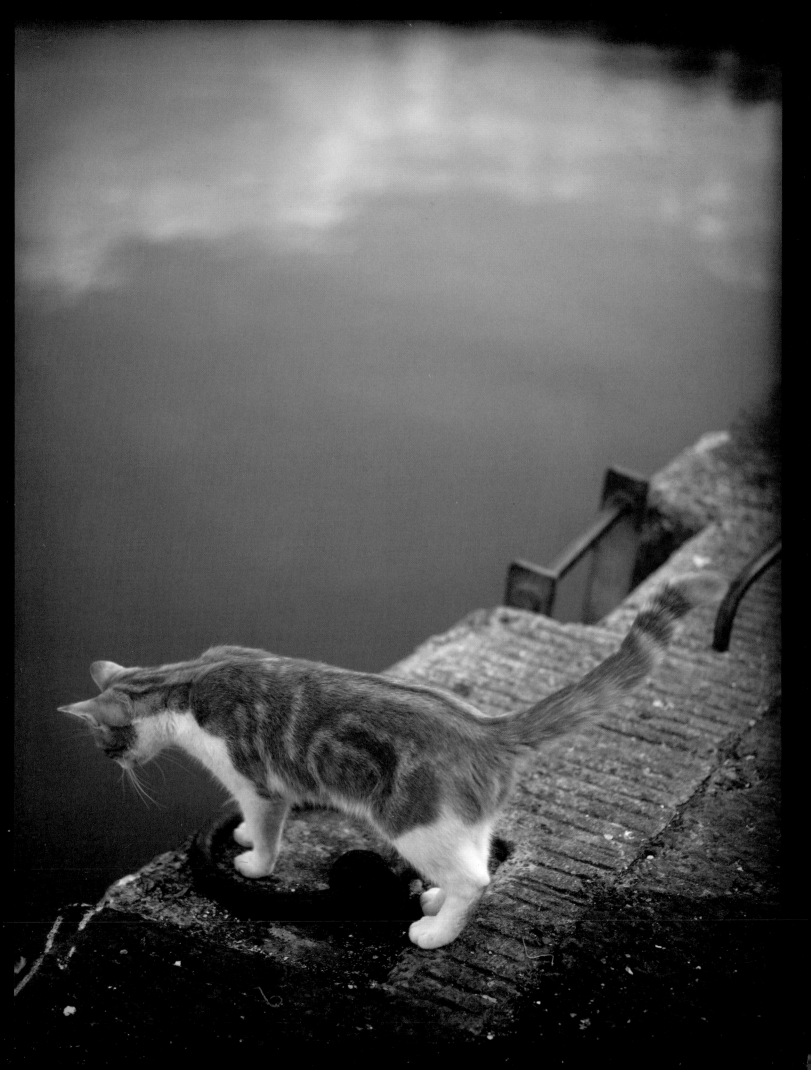

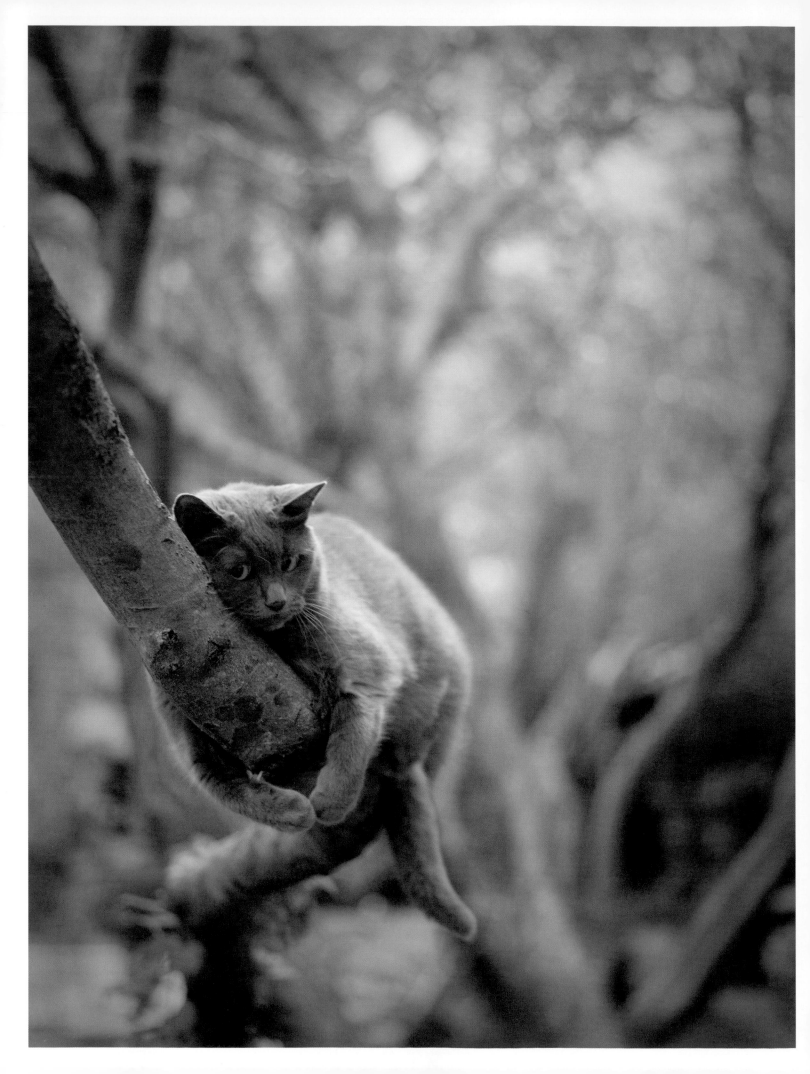

Cats, with their snooty, beautiful faces, their sensuous bodies, their lethal paw swipes, snuggly purrs, and aloof, unreadable natures, are a challenge to any photographer.

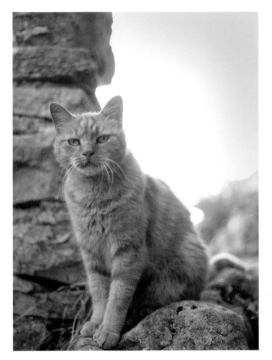

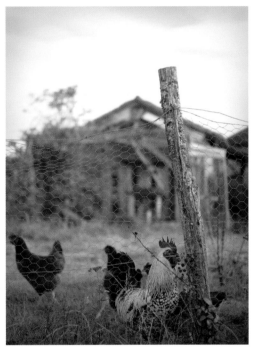

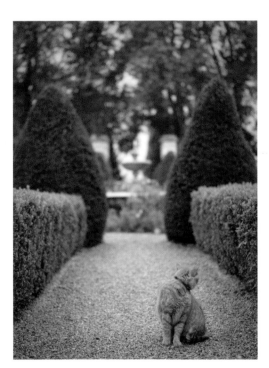

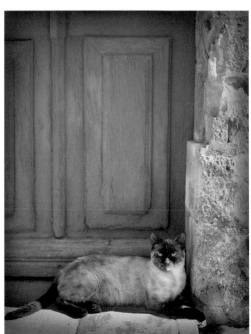

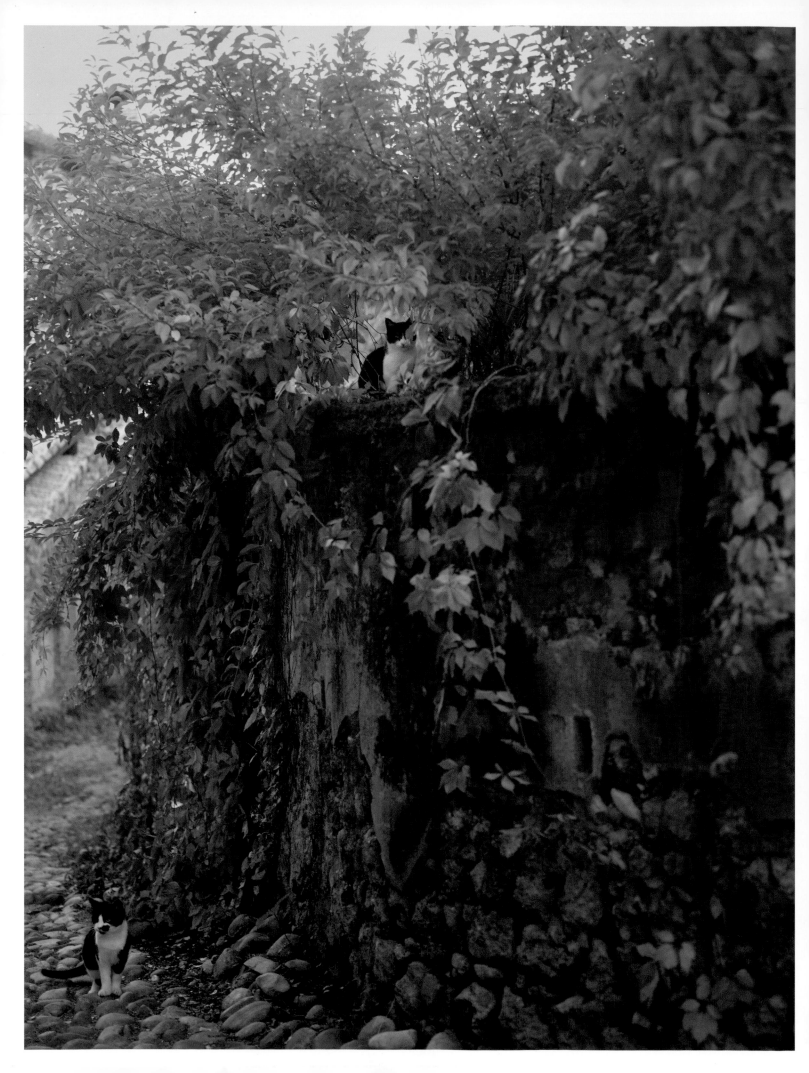

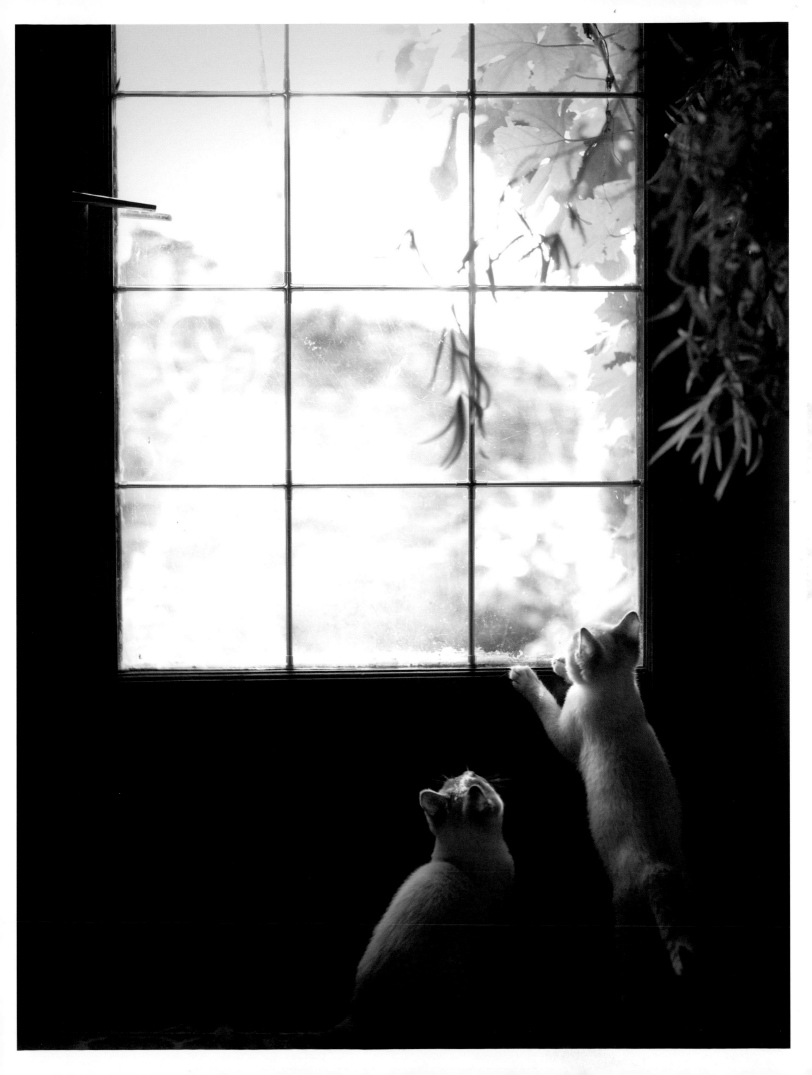

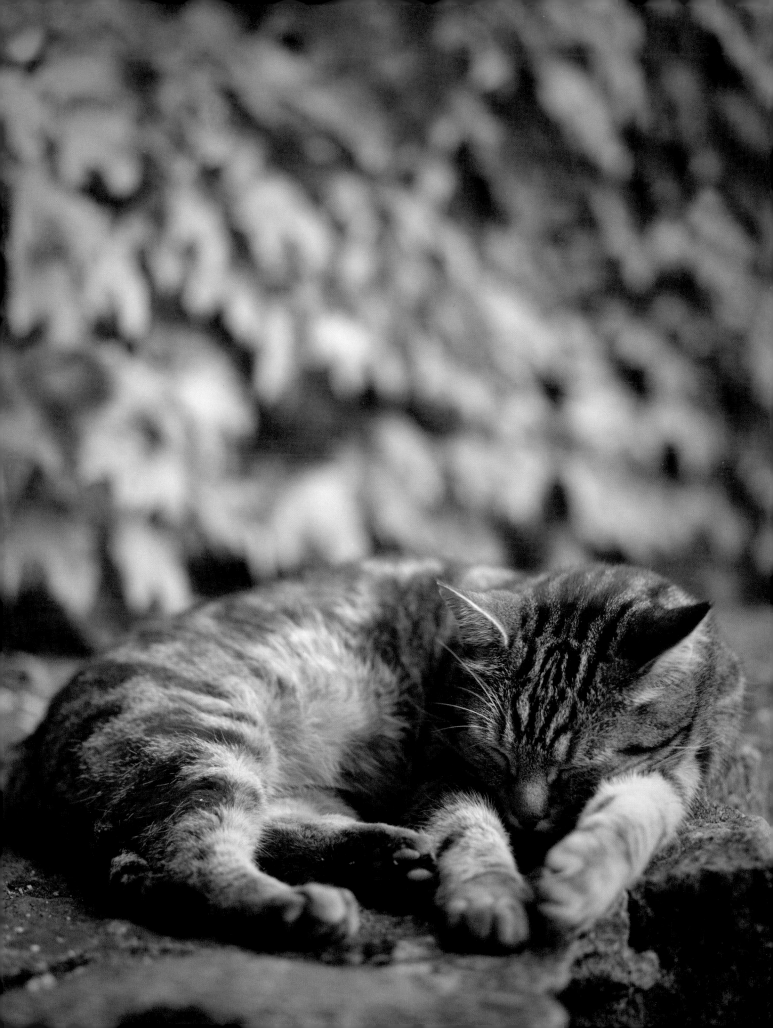

A little
drowsing cat
is an image
of perfect
beatitude.

———————

Jules Champfleury
(1820–1889, French art critic and novelist)

I love cats because I enjoy my home;
and little by little, they become its visible soul.

Jean Cocteau
(1889–1963, French poet, novelist, playwright, and filmmaker)

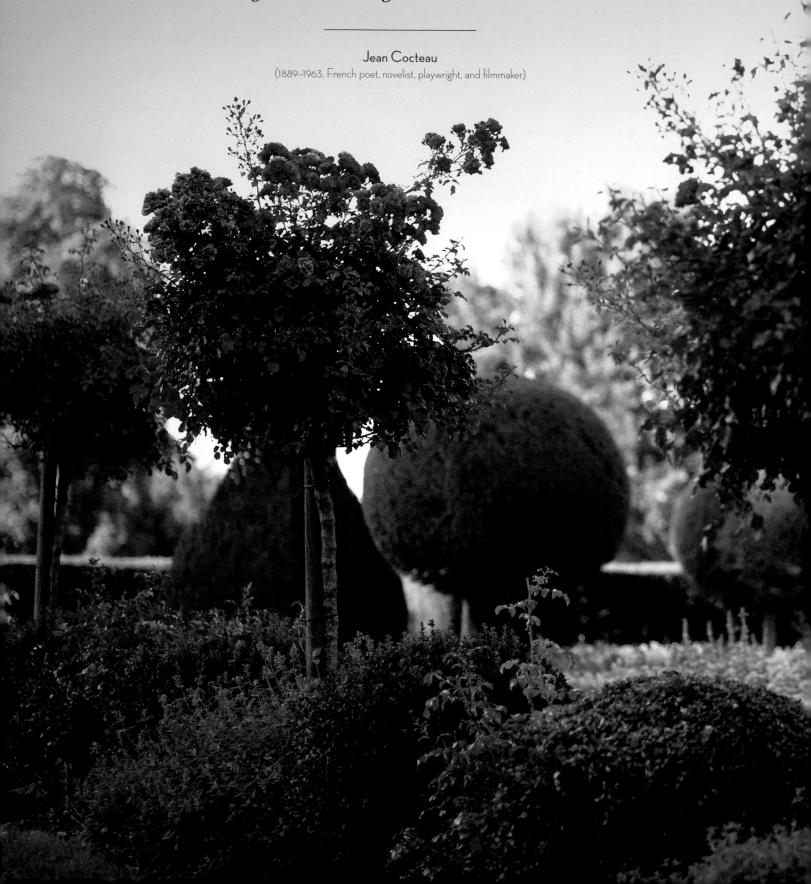

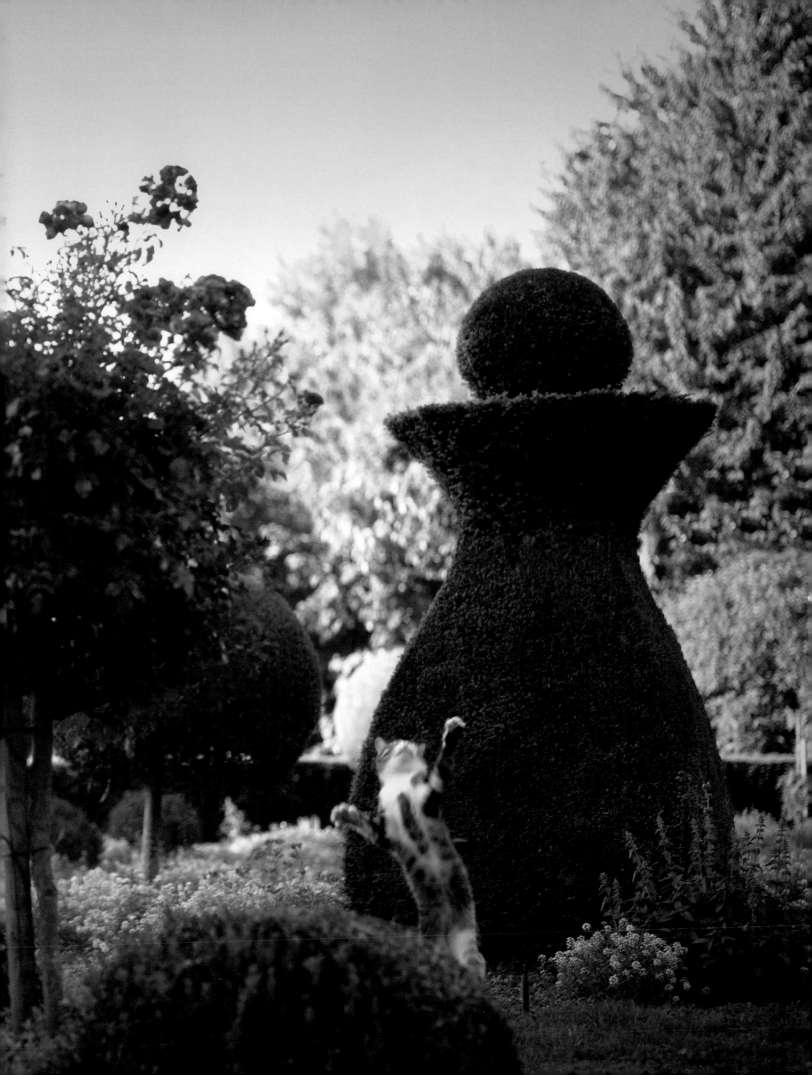

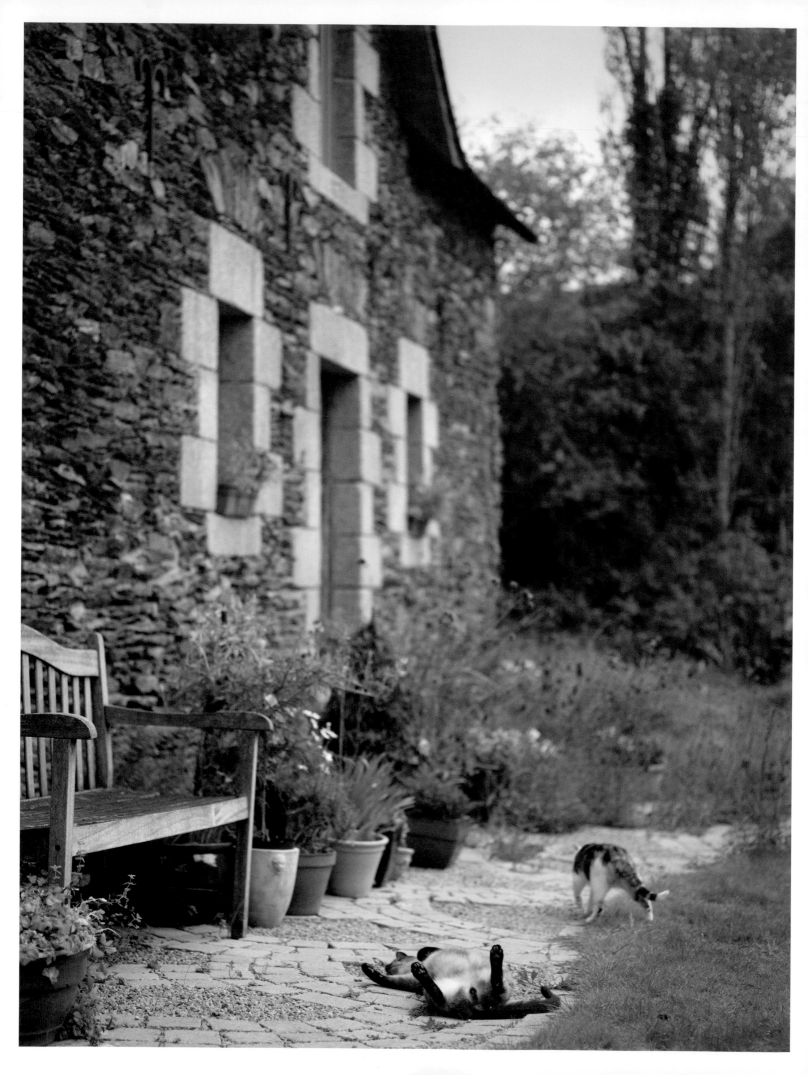

Acknowledgments

To say that I have enjoyed creating this book is an understatement—I have been in heaven—traveling a beautiful country, working with fantastic people, and of course befriending some wonderful, if not slightly timid, cats.

My first enormous thank-you is to my husband, Andy, who, along with our amazing and tolerant daughter, Charlize, has traveled with me, giving me continuous support, guidance, love, and endless encouragement. Thank you from the bottom of my heart. I could not have done it without you. You also need to be acknowledged for your own talents as a photographer; the images that include me have all been taken with your skillful eye.

As always, a big thank-you to Geoff Blackwell and Ruth Hobday at PQ Blackwell for giving me the opportunity to venture into a new environment. Thank you also to Carroll du Chateau for helping me shape my words, and to InHouse Design for creating a masterpiece with my images—the final book is truly beautiful. Thanks also to Jani Shepherd and Alec Ship—your assistance with the initial research and organization is greatly appreciated.

A huge thank-you also goes to: my parents-in-law Carol and Howard McKenna—Andy and I appreciate your assistance with keeping Charlize entertained and supporting the ups and downs of our new life in France immensely. Also Paula le Dao for the three weeks you spent with us on the road—your assistance with befriending and positioning cats was a huge help; and Carol and her sister Pauline—for looking after Charlize while Andy and I roamed the streets of Paris on the prowl for cats.

And, of course, a thousand thanks to the cat owners who so enthusiastically allowed me to enter their homes and photograph their treasured pets. I would especially like to thank Charles and Sophie at Château de Saint-Loup in Saint-Loup Lamairé—the times we spent at your exquisite and character-filled château will live in our memories forever; the stunning Château de Beauregard in Jonquières, Provence, our first port of call on our very first day venturing into the world of *le beau chat Français*—thank you, Delta, for being so welcoming and for allowing us the freedom to work with not only your two beautiful cats, but with what seemed like an endless supply of dog characters; Peter and Penny at Manoir de Kerlédan in Carhaix-Plouguer—for your over-whelming generosity, hospitality, and Penny's mouth-wateringly delicious culinary delights; Malcolm and Dianne—for making us feel so welcome after invading your home for hours photographing your cats; Valerie at Château de L'Epinay in Saint Georges sur Loire—for your kindness and generosity; Monsieur et Madame Valentin at Jardins Secrets in Nimes—for your incredibly generous hospitality, amazing property, and delightful cats; Jean-Louis and Isabelle from my French publishing house, Fetjaine—for your encouragement and enthusiasm, as well as helping me find so many Parisian cats; Maryline and Brigette Cazenave—for your amazing assistance finding and photographing cats on the outskirts of Paris.

And last but not least, a very special thank-you to my Mum and Dad, my sister Becks, and my best friend Jo. Even though you are a few thousand miles away, your support, encouragement, and understanding for my decision to start a new life in France—for now anyway!—is invaluable.

A bientôt!

Rachael McKenna (née Hale)
Causses-et-Veyran, Languedoc, France

Châteaux and Hotels

Au Ralenti du Lierre, Village des Beaumettes, Provence-Alpes-Côte d'Azur: www.auralentidulierre.com

Château d'Adoménil, Lunéville, Lorraine: www.adomenil.com

Château des Alpilles, Saint-Rémy-de-Provence, Provence: www.chateaudesalpilles.com

Château de Beauregard, Jonquières, Provence: www.chateaubeauregard.com

Château Bosgouet, Bosgouet, Haute-Normandie: www.thefrenchtable.com.au

Château de Boucéel, Vergoncey, Basse-Normandie: www.chateaudebouceel.com

Château de Busset, Busset, Auvergne: www.busset.com

Château de L'Epinay, Saint-Georges-sur-Loire, Pays de la Loire: www.chateauepinay.fr

Château de Germigney, Port-Lesney, Franche-Comté: www.chateaudegermigney.com

Château Royal, Saint-Saturnin, Auvergne: www.chateaudesaintsaturnin.com

Château de Saint-Loup, Saint-Loup Lamairé, Poitou-Charentes: www.chateaudesaint-loup.com

Château des Salles, Saint-Fort-sur-Gironde, Poitou-Charentes: www.chateaudessalles.com

Château des Tennessus, Amailloux, Poitou-Charentes: www.tennessus.com

Château de Varenne, Sauveterre, Provence: www.chateaudevarenne.com

Domaine du Château de Barive, Sainte-Preuve, Champagne-Ardenne: www.chateau-de-barive.com

Haras de la Potardière, Crosmières, Pays de la Loire: www.potardiere.com

Jardins Secrets, Nîmes, Languedoc-Roussillon: www.jardinssecrets.net

La Bastide Rose, Le Thor, Provence: www.bastiderose.com

La Cabro d'Or, Les Baux de Provence, Provence: www.lacabrodor.com

Le Mas de la Rose, Orgon, Provence: www.mas-rose.com

Manoir de Kerlédan, Carhaix-Plouguer, Bretagne: www.kerledan.com

Oustau de Baumanière, Les Baux de Provence, Provence: www.oustaudebaumaniere.com

Images

Front cover and p. 108: "Do Do," Haras de la Potardière; Back cover and p. 9: Pérouges, Rhône-Alpes; Case and p. 100–01: "Timotie," Saint-Geniès-de-Fontedit, Languedoc-Roussillon; p. 2–3: Port-Lesney, Franche-Comté; p. 4: "Vodka," Château de Busset; p. 6: Peyrat, Aquitane; p. 8: Andy and Charlize, Jonquières, Provence; p. 10: Top: Carhaix-Plouguer, Bretagne; Middle left: "Birdie," Jardins Secrets; Middle: Murviel-les-Béziers, Languedoc-Roussillon; Middle right: Charlize in car wash, Bretagne; Bottom left: "Vlad," Château de Tennessus; Bottom right: Colmar, Alsace; p. 11: "Mr Mimile," La Bastide Rose; p. 13: Nancy, Lorraine; p. 14: "Franklin," Airvault, Poitou-Charentes; p. 15: Top left: "Tarzan," Château Royal; Top right: Saint-Cirq-Lapopie, Midi-Pyrénées; Middle left: Montmartre Cemetery, Paris; Middle: "Plume," Saint-Saturnin, Auvergne; Middle right: Saint-Loup Lamairé, Poitou-Charentes; Bottom left: Sault, Provence; Bottom right: Crosmières, Pays de la Loire; p. 16: Pérouges, Rhône-Alpes; p. 18: "Kitty" and "Colette," Shakespeare and Company Bookstore, Paris; p. 19: My journals; p. 20: Top left: Port-Lesney, Franche-Comté; Top middle: Ventabren, Provence; Top right: Les Baux de Provence, Provence; Bottom left: Bretagne; Bottom right: "Tina Turner," Nogent-sur-Marne, Val de Marne; p. 21: "Buzz," Château de Tennessus; p. 22–3: "Lili," Château des Alpilles; p. 24: "Abi," Oustau de Baumanière; p. 27: "Kuzia," Château des Salles; p. 28: "Blackie," Château de L'Epinay; p. 30–1: "Grisoville," La Bastide Rose; p. 32: "Craquette," Le Mas de la Rose; p. 34: Left: "Sephora," Orgon, Provence: Right: Colmar, Alsace; p. 35: "Sephora' and "Fan Fan la Mère," Orgon, Provence; p. 37: "Bout d'Zan," Au Ralenti du Lierre; p. 38–9: Carhaix-Plouguer, Bretagne; p. 40: Peyrat, Aquitaine; p. 42: Near Châteauneuf-du-Pape, Provence; p. 43: "Griboville," Château d'Adoménil; p. 44: "Boone," Saint-Germain-des-Prés, Paris; p. 46: Top left: "Tornade' and "Ratatouille," Château des Salles; Top middle: Chocolates, Paris; Top right: "Sweetie," Jardins Secrets; Bottom left: Château Bosgouet; Bottom right: Château Bosgouet; p. 47: Pérouges, Rhône-Alpes; p. 48: "Miss France," Château de Beauregard; p. 50: Montmartre, Paris; p. 51: Carhaix-Plouguer, Bretagne; p. 52–3: Pouzolles, Languedoc-Roussillon; p. 54: Saint-Cirq-Lapopie, Midi-Pyrénées; p. 55: Saint-Cirq-Lapopie, Midi-Pyrénées; p. 56–7: Château de Saint-Loup; p. 59: "Caramel," Château de Saint-Loup; p. 61: "Franklin," Airvault, Poitou-Charentes;

p.62–3: "Titi," Château de Boucéel; p.64: "Bébé Croquette," Matougues, Champagne-Ardenne; p. 65: "Jo Jo' and "Amis," Pléneuf-Val-André, Bretagne; p. 66: "Marilou," Oustau de Baumanière; p. 68–9: "Griboville,' Château d'Adoménil; p. 70: Left: Port-Lesney, Franche-Comté; Right: Château Bosgouet; p. 71: "Filou," on the desk of artist Patrick Foucaud-Royer, L'Étang-La-Ville, Île-de-France; p. 72: "Mouchette," Oustau de Baumanière; p.74: Château de Beauregard; p. 75: Montmartre Cemetery, Paris; p. 77: Airvault, Poitou-Charentes; p. 78: "Tarzan," Château Royal; p. 79: "Pie' and "Samuel," Kerjacob, Saint-Gilles-Vieux-Marché, Bretagne; p. 80: Pouzolles, Languedoc-Roussillon; p. 81: Top left: Château de Varenne; Top right: "Mr Mimile," La Bastide Rose; Bottom left: Montmartre Cemetery, Paris; Bottom middle: "Toffu," Oustau de Baumanière; Bottom right: Pérouges, Rhône-Alpes; p. 82: Château de L'Epinay; p. 83: "Grand Frère," Kerjacob, Saint-Gilles-Vieux-Marché, Bretagne; p. 84: Top left: "Salsa," Nogent-sur-Marne, Val de Marne; Top right: Port-Lesney, Franche-Comté; Middle left: Sault, Provence; Bottom left: "Blackie," Château de L'Epinay; Bottom right: Montmartre, Paris; p. 85: "Loulou," Colmar, Alsace; p. 86: "Myrtille," Château de Varenne; p. 88: Top left: Paris; Top right: Montmartre Cemetery, Paris; Middle left: Jardins Secrets; Bottom left: "Timotie," Saint-Geniès-de-Fontedit, Languedoc-Roussillon; Bottom right: Jardins Secrets; p. 89: "Sweetie," Jardins Secrets; p. 91: Saujot (the friend of the cats), Montmartre Cemetery, Paris; p. 92: Montmartre, Paris; p. 93: "Raoul," Saint-Germain-des-Prés, Paris; p. 94: Étretat, Haute-Normandie; p. 95: Top left: Sault, Provence; Top right: "Tom," Ventabren, Provence; Bottom left: Airvault, Poitou-Charentes; Bottom middle: "Mango," Au Ralenti du Lierre; Bottom right: Sault, Provence; p. 96: Pézenas, Languedoc-Roussillon; p. 99: "Clawed van Weel," Maison de Guardian, Château Bosgouet; p. 102: "Madame Mouche," Château de Boucéel; p. 103: Left: Château de Boucéel; Right: "Raoul," Saint-Germain-des-Prés, Paris; p. 104: "Charles-Edouard," Château du Busset; p. 106: Top left: Château de Varenne; Top right: "Vodka," Château de Busset; Middle left: Pérouges, Rhône-Alpes; Bottom left: "Manga," Au Ralenti du Lierre; Bottom right: Pérouges, Rhône-Alpes; p. 107: "Charlie," Domaine du Château de Barive; p.110: "Caramel," Château de Saint-Loup; p.111: "Leo," Château de L'Epinay; p. 112: "Romeo," Ventabren, Provence; p. 114: Left: Carhaix-Plouguer, Bretagne; Middle: "Bobs," Lieuran-lès-Béziers, Languedoc-Roussillon; Right: Auvergne; p. 115: Oustau de Baumanière; p. 117: "Bout d'Zan," Au Ralenti du Lierre; p. 118–9: Autignac, Languedoc-Roussillon; p. 120: "Griboville," Château d'Adoménil; p. 121: Jardins Secrets; p. 123: Montmartre Cemetery, Paris; p. 124–5: "Vodka," Château de Busset; p. 126: Montreuil-sur-Mer, Nord-Pas-de-Calais; p. 127: Top left: "Tigrou," Autignac, Languedoc-Roussillon; Top middle: Malcolm's garden seat, Kerjacob, Saint-Gilles-Vieux-Marché, Bretagne; Top right: "Marnie," Le Maine Brun, Asnières-sur-Nouère, Poitou-Charentes; Bottom right: Les Baux de Provence, Provence; Bottom left: "Jo Jo," Pléneuf-Val-André, Bretagne; p. 128: "Titus," Causses-et-Veyran, Languedoc-Roussillon; p. 131: "Eclypse," Causses-et-Veyran, Languedoc-Roussillon; p. 132–3: Murviel-les-Béziers, Languedoc-Roussillon; p. 134: "Chartreux," Murviel-les-Béziers, Languedoc-Roussillon; p. 135: "Napoleon," Château Bosgouet; p. 136: Montmartre Cemetery, Paris; p. 137: Left: Manoir de Kerlédan; Right: "Leo," Château de L'Epinay; p. 138: "Sweetie' and "Birdie," Jardins Secrets; p. 139: Top left: Sault, Provence; Top right: Saint-Cirq-Lapopie, Midi-Pyrénées; Middle right: Pérouges, Rhône-Alpes; Bottom left: Haras de Saint-Loup, Saint-Loup Lamairé, Poitou-Charentes; Bottom right: "Krapoutchi," Saint-Mandé, Val de Marne; p. 140–1: "Bout d'Zan," Au Ralenti du Lierre; p. 142–3: "Hercules," Château de Beauregard; p. 144: "Persian," Ventabren, Provence; p. 146: "Filou," L'Étang-la-Ville, Île-de-France; p. 147: Pérouges, Rhône-Alpes; p. 149: "Charles-Edouard," Château de Busset; p. 150–1: "Craquette' and "Paulette," Le Mas de la Rose; p. 153: "Titi," Château de Boucéel; p. 155: "Jo Jo," Pléneuf-Val-André, Bretagne; p. 156: "Sweetie," Jardins Secrets; p. 157: Top left: Calvignac, Midi-Pyrénées; Top middle: Peyrat, Aquitaine; Top right: "Mignardises," Domaine du Château de Barive; Bottom left: "Sweetie," Jardins Secrets; Bottom right: "Manga," Au Ralenti du Lierre; p. 158: Pérouges, Rhône-Alpes; p. 159: "Petit Frère' and "Grand Frère' Kerjacob, Saint-Gilles-Vieux-Marché, Bretagne; p. 160: "Charles-Edouard," Château de Busset; p. 162–3: "Do Do," Haras de la Potardière; p. 164: "Samuel' and "Tortue," Kerjacob, Saint-Gilles-Vieux-Marché, Bretagne; p. 167: Top left: Saint-Loup Lamairé, Poitou-Charentes; Top right: "Jo Jo," Pléneuf-Val-André, Bretagne; Middle left: Le Château des Chats, Kerjacob, Saint-Gilles-Vieux-Marché, Bretagne; Bottom left: Pérouges, Rhône-Alpes; Bottom right: Fécamp, Haute-Normandie; p. 168: "Sweetie," Jardins Secrets.

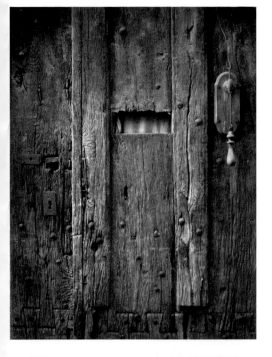

Le château Des Chats

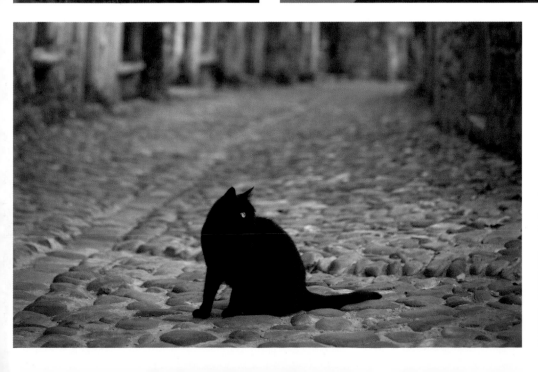

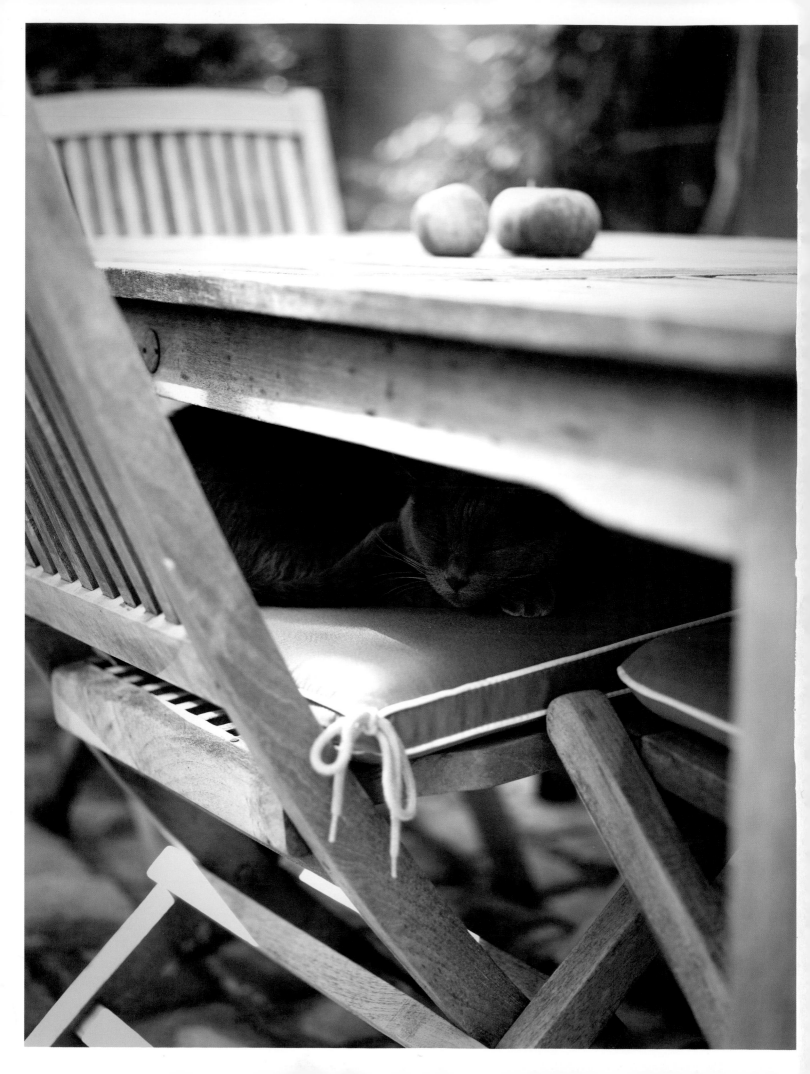

Library of Congress Cataloging-in-Publication Data:

Hale, Rachael.
 The French cat / Rachael Hale.
 p. cm.
 Summary: "Famed animal photographer Rachael Hale has turned her lens toward France, her newly
adopted home, and the charismatic cats that inhabit this picturesque backdrop. Rachael also tells the
story of her move to France and experience discovering the beauty of her surroundings, the culture,
and, of course, the cats, with her husband and new baby in tow"—
Provided by publisher.
 ISBN 978-1-58479-950-4 (hardback)
 1. Photography of animals—France. 2. Cats—France—Pictorial works. I.
Title.
 TR729.C3H354 2011
 779'.329752—dc22
 2011015080

Produced and originated by PQ Blackwell Limited
116 Symonds Street, Auckland 1010, New Zealand
www.pqblackwell.com

Text Rachael Hale-McKenna and Carroll du Chateau
Book design www.inhousedesign.co.nz
Jacket and additional design Sarah Anderson

All images by Rachael Hale-McKenna except: p. 36, p. 58, p. 76 and p. 116, Getty Images; Puss in boots
image on insert, Photolibrary; Endpaper map image, Cambridge University Press.

Every effort has been made to trace the copyright holders and the publisher apologizes for any
unintentional omissions. We would be pleased to hear from any not acknowledged here and undertake
to make all reasonable efforts to include the appropriate acknowledgment in any subsequent editions.

Puss in Boots by Charles Perrault, 1697, from *The Blue Fairy Book*, edited by Andrew Lang, Dover,
© 1965; From *The Tiger in the House* by Carl Van Vechten, 1922, Kessinger Publishing, © 2010.

Printed and bound in China
10 9 8 7 6 5 4 3 2 1

115 West 18th Street
New York, NY 10011
www.abramsbooks.com

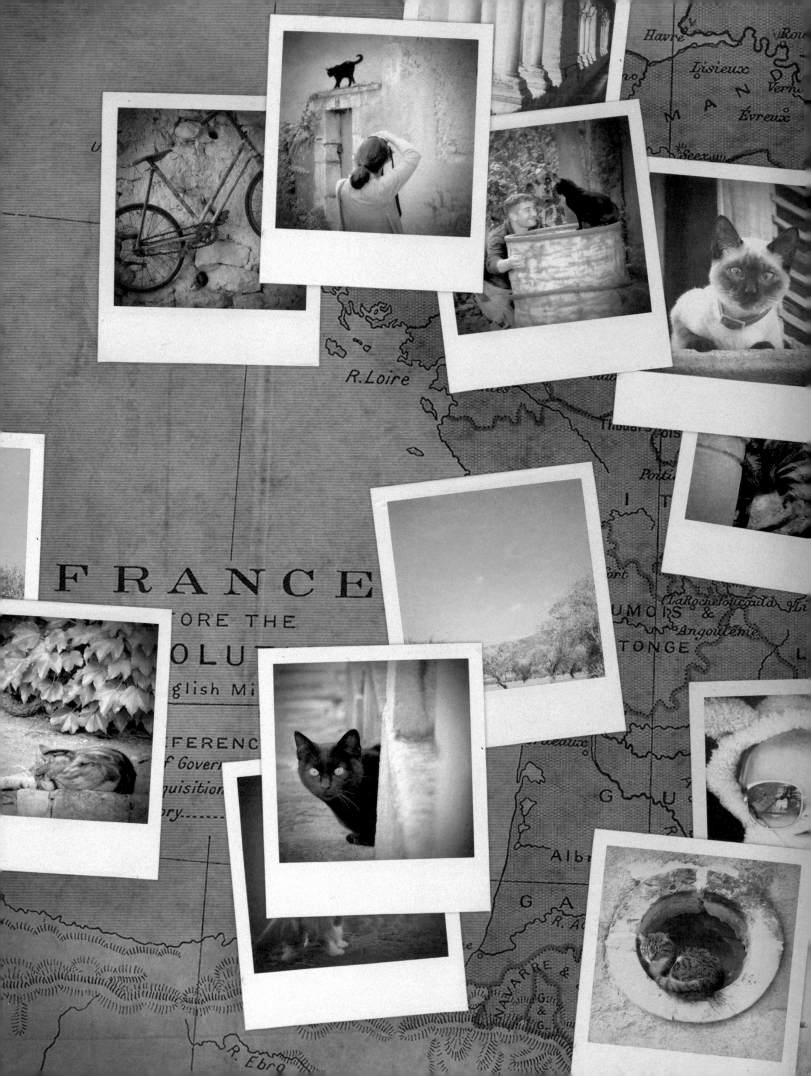